The Dancer's World, 1920–1945

DOI: 10.1057/9781137439215.0001

Other Palgrave Pivot titles

Michael Longo and Philomena Murray: **Europe's Legitimacy Crisis: From Causes to Solutions**

Mark Lauchs, Andy Bain and Peter Bell: **Outlaw Motorcycle Gangs: A Theoretical Perspective**

Majid Yar: **Crime and the Imaginary of Disaster: Post-Apocalyptic Fictions and the Crisis of Social Order**

Sharon Hayes and Samantha Jeffries: **Romantic Terrorism: An Auto-Ethnography of Domestic Violence, Victimization and Survival**

Gideon Maas and Paul Jones: **Systemic Entrepreneurship: Contemporary Issues and Case Studies**

Surja Datta and Neil Oschlag-Michael: **Understanding and Managing IT Outsourcing: A Partnership Approach**

Keiichi Kubota and Hitoshi Takehara: **Reform and Price Discovery at the Tokyo Stock Exchange: From 1990 to 2012**

Emanuele Rossi and Rok Stepic: **Infrastructure Project Finance and Project Bonds in Europe**

Annalisa Furia: **The Foreign Aid Regime: Gift-Giving, States and Global Dis/Order**

C. J. T. Talar and Lawrence F. Barmann (editors): **Roman Catholic Modernists Confront the Great War**

Bernard Kelly: **Military Internees, Prisoners of War and the Irish State during the Second World War**

James Raven: **Lost Mansions: Essays on the Destruction of the Country House**

Luigino Bruni: **A Lexicon of Social Well-Being**

Michael Byron: **Submission and Subjection in Leviathan: Good Subjects in the Hobbesian Commonwealth**

Andrew Szanajda: **The Allies and the German Problem, 1941–1949: From Cooperation to Alternative Settlement**

Joseph E. Stiglitz and Refet S. Gürkaynak: **Taming Capital Flows: Capital Account Management in an Era of Globalization**

Steffen Mau: **Inequality, Marketization and the Majority Class: Why Did the European Middle Classes Accept Neo-Liberalism?**

Amelia Lambelet and Raphael Berthele: **Age and Foreign Language Learning in School**

Justin Robertson: **Localizing Global Finance: The Rise of Western-Style Private Equity in China**

Isabel Dulfano: **Indigenous Feminist Narratives: I/We: Wo(men) of An(Other) Way**

DOI: 10.1057/9781137439215.0001

palgrave▶pivot

The Dancer's World, 1920–1945: Modern Dancers and Their Practices Reconsidered

Michael Huxley

De Montfort University, Leicester, UK

palgrave
macmillan

DOI: 10.1057/9781137439215.0001

© Michael Huxley 2015

First published 2015 by
PALGRAVE MACMILLAN

Palgrave Macmillan in the UK is an imprint of Macmillan Publishers Limited, registered in England, company number 785998, of Houndmills, Basingstoke, Hampshire RG21 6XS.

Palgrave Macmillan in the US is a division of St Martin's Press LLC, 175 Fifth Avenue, New York, NY 10010.

Palgrave Macmillan is the global academic imprint of the above companies and has companies and representatives throughout the world.

Palgrave® and Macmillan® are registered trademarks in the United States, the United Kingdom, Europe and other countries.

ISBN: 978-1-137-43922-2 EPUB
ISBN: 978-1-137-43921-5 PDF
ISBN: 978-1-137-43920-8 Hardback

A catalogue record for this book is available from the British Library.

A catalog record for this book is available from the Library of Congress.

www.palgrave.com/pivot

DOI: 10.1057/9781137439215

For Jayne and John

DOI: 10.1057/9781137439215.0001

Contents

Preface vii

Acknowledgements x

1 Introduction: Early Modern Dancers and Their Practices Reconsidered 1

2 The World of the Dancer 15

3 We (Dancers) Are Standing at the Beginning 30

▶ 4 German and American Modern Dance: Constitutional Differences 50

5 A New World for the Dancer 68

6 Conclusion: A Dancer's World 85

Epilogue: A Historical Sense of a Dancer's World 96

Select Bibliography 104

Index 114

DOI: 10.1057/9781137439215.0001

Preface

In essence, *The Dancer's World* is a consideration of danc-
ers' experiences in their time. It sets out to reconsider such
experiences historically with a view to illuminating both
past and present more clearly. Its central thesis is that a
detailed examination of dancers' writings can contribute
a new, additional perspective to the history of modern
dance. It places dancers, in their own terms, at the centre
of their own narrative and shows how they have contrib-
uted to history in its widest sense.

▶ There is already a substantial and growing body of
research about early modern dance from 1900 through
to the 1950s, and I refer to this in my Introduction and
throughout this book. Dancers and their practices are
central to the historiography of modern dance. It is
also true that dancers' writings are referred to in these
accounts. *The Dancer's World* differs from all these accounts
by making dancers' writings the focus of study. The extent
to which these writings are drawn on offers a new account
of a historical period with a view to making it relevant to
dancers, dance artists, choreographers, dance students and
researchers in the twenty-first century.

I have been researching modern dance for many years.
It has been a pleasure to share some of the results of this
research with students on the BA Dance course at De
Montfort University. These students have prompted me to
reconsider how to engage most effectively with a period
so different from the present. I have been guided by them,
by recent research into the pedagogy of dance history and
by a sustained reading of a historian of the period, R.G.
Collingwood.[1]

In my teaching, especially in my third-year undergraduate option 'Dance as History', I have increasingly sought to help students think historically to address problems of the present. I have found that dancers' writings from 1920 to 1945 provide a means for dancers and dance students to engage with the past. The commonality of being a dancer, one who is trying to articulate what the dancer's world entails, provides an entry point whereby less familiar matters of values and politics can be better understood. This provides a different, complementary and sometimes more immediately accessible viewpoint to those of the critics of the time. It also helps towards an understanding of dances recorded nearly a century ago that on first viewing can be both baffling and off-putting in their strangeness. My enquiry is to do with the thinking that produced such work; the point of entry is what the dancers had to say about themselves in their time and this calls for an understanding of the period itself to reveal the context in the thought. Collingwood put this most cogently in his autobiography when he said:

> You are thinking historically…when you say about anything, 'I see what the person who made this (wrote this, used this, designed this, etc.) was thinking'.[2]

The Dancer's World engages with modern dancers' thinking through an examination of what they wrote.

The majority of writings that serve as source material for this book are published and in the public domain. Some are very familiar and have been quoted often. Others are more obscure, and some rarely used. Most texts used were written in English but a number of key ones were first published in German. It is hoped that the published texts used, and listed in Select Bibliography, will provide a comprehensive list of sources. The idea is to open up access to these writings to enable further research and study by those who are interested. A selection of archival sources has been explored to give greater depth to certain issues that have arisen, notably those to do with a dancer's experience of his/her training. In *The Dancer's World* there is an emphasis on published work, primarily in books and journals. The very ease with which dancers in the twenty-first century can see their thoughts in the public domain, on Facebook and Twitter and in blogs, puts the achievements of dancers of the early modern dance period into relief. What a richness of material there is in their writings and how prolific were some dancers. It goes without saying that the quality of the writings shows huge variations: there is a major

DOI: 10.1057/9781137439215.0002

difference between a short piece of writing for a short-lived journal or in-house magazine and a book for an established publisher, but dancers were published in both.

What connects dancers then and now is an enthusiasm for dancing. The dance remains the central point of interest for dance maker, teacher, watcher and participant. However, what is explored through the word can also be revealing and can help our understanding of what constitutes the dancer's world.

Notes

1 In particular, my research and writing have been informed by these:
 Collingwood, R.G. *An Essay on Philosophical Method.* (Oxford: Clarendon Press, 1933).
 Collingwood, R.G. *The Principles of Art.* (Oxford: Clarendon Press, 1938).
 Collingwood, R.G. *An Autobiography.* (London: Oxford University Press, 1939).
 Collingwood, R.G. *The New Leviathan: Or, Man, Society, Civilization, and Barbarism.* (Oxford: Clarendon Press, 1942).
 Collingwood, R.G. *Essays in the Philosophy of Art.* Edited by Alan Donagan. (Indiana: Indiana University Press, 1964).
 Collingwood, R.G. *The Principles of History and Other Writings in Philosophy of History.* Edited by Dray, W.H. and van der Dussen, W.J. (Oxford: Oxford University Press, 1999).
 Collingwood, R.G. and van der Dussen, W.J. *The Idea of History.* Rev. ed. (Oxford: Clarendon Press, 1993).

2 Collingwood, R.G., Boucher, David and Smith, Teresa. *R. G. Collingwood: An Autobiography and Other Writings; With Essays on Collingwood's Life and Work.* (Oxford: Oxford University Press, 2013), 110.

DOI: 10.1057/9781137439215.0002

Acknowledgements

Dancers past and present have been, and continue to be, central to my professional and personal life: none more so than Jayne Stevens, without whose support this book would not have been possible. I teach dance history, but I teach students who are dancers, and I have worked with hundreds over the years. In the past few years I have researched and written of the student learning experience. It became clear to me, both in my pedagogic research and my teaching, that dancer's writings helped establish a discourse for students for whom the past was indeed a foreign country. The common experience of being a dancer allowed for a starting point that was more immediate than the writings of critics, however lucid, or archival documents, however important. Thus this book brings together my research interests and my interest in dancers, and particularly dance students.

I am indebted to the many students whom I have been fortunate to know during my time at De Montfort University. They really are too numerous to mention. My dance colleagues at the university have all contributed to this discussion. Much of the thinking behind this book has been generated by discussions with students as part of my 'Dance as History' option. They have given me fresh perspectives on material and narratives with which I thought I was familiar and have asked the difficult questions that needed asking. My special thanks go to Emily Bolton, Rachel Bhanu and Jennifer Hutton. My thanks also to Prarthana Purkayastha, now at University of Plymouth, for helping me question the received narrative of modern dance when we taught the option together.

DOI: 10.1057/9781137439215.0003

This is a historical account. June Layson introduced me to dance history; Ramsay Burt has, for the past many years, kept me in touch with the most recent developments, especially those in dance studies, and has kept interrogating my thinking. I am also indebted to many people who have challenged me and opened up new approaches, in particular, Brian Door and Martin Leach. Colleagues, including those in the Congress on Research in Dance, have contributed to my growing interest in the historiographies of dance and its pedagogy, not least Cara Gargano, Ann Dils, Alexandra Carter and Mark Franko. Over the years I have been influenced by many who have researched and written accounts about modern dance. I owe a particular debt to Horst Koegler, Hedwig Müller, Selma Jeanne Cohen, Alexandra Carter, Marion Kant and Susan Manning. All the people mentioned so far have contributed to my understanding of dance and its history in ways that contribute to the ideas that underpin this book. I have met some of them but briefly; others have been in dialogue with me for decades, to my benefit. I never met the British historian and philosopher R.G. Collingwood (1889–1943), but his writings have had a considerable impact on my thinking. He was a man of the period, writing at the same time as the dancers who are studied here.

I am most grateful to De Montfort University for its continued support for my research, most recently through the School of Arts and the Performance Research Group. I have benefited from support to enable the formulation of the ideas behind this book, support for pedagogic research into dance history and for travel to archives in the United Kingdom. The Arts and Humanities Research Board (now Council) funded a visit to the New York Public Library Dance Collection, and some of the results of that visit have informed this current text. My visits to the National Resource Centre for Dance (NRCD) Archive at the University of Surrey, the Dartington Trust Archive and the New York Public Library Dance Collection have left me inspired thanks to efforts of the supportive colleagues who work there, especially Sharon Maxwell of the NRCD.

A number of people have read and commented on the writing that now constitutes *The Dancer's World*. I am most grateful to Ramsay Burt for detailed comments on various drafts. Dance colleagues at De Montfort University have commented on early iterations. I thank my students on my 'Dance as History' option 2013–2015 for giving me their feedback. To them, and to the many other colleagues whom I have

DOI: 10.1057/9781137439215.0003

drawn into conversation, I warmly acknowledge their help. Much of the research and writing for this book have been undertaken in a convivial home with the encouragement of Jayne, who knows about dance, and John, who knows how to study. Any errors in this book are entirely my own responsibility.

I acknowledge, with many thanks, permission to quote from archival materials by Leslie Burrowes, Diana Jordan and Louise Soelberg from NRCD at the University of Surrey. All text is still in copyright and must not be reproduced without permission. Every effort has been made to identify copyright owners and I apologise if infringement has occurred. If you have information regarding copyright owners please contact the archives at the University of Surrey. I am grateful to Gordon Curl for his kind permission to quote from S. Goddard's (1966) translation for him of Rudolf Laban's *Die Welt des Tänzers*.

DOI: 10.1057/9781137439215.0003

1

Introduction: Early Modern Dancers and Their Practices Reconsidered

Abstract: *This chapter sets out the case for examining the dancer's world as expressed in dancers' writings. The historiography of modern dance between 1920 and 1945 in Europe and the United States of America tends to stress the role of the choreographer in the sense that we use the term today. I argue that this is a revisionist interpretation and that during the period modern dancers wrote of themselves as dancers even when talking of choreography. A case is made to reconsider early modern dancers and their practices by a re-reading of their writings. Dancers' writings referred to include those from both continents and those involved in both performance and education including that of Leslie Burrowes, Isadora Duncan, Martha Graham, Doris Humphrey, Rudolf Laban and Elizabeth Selden.*

Keywords: dancers' writings; historiography; modern dance

Huxley, Michael. *The Dancer's World, 1920–1945: Modern Dancers and Their Practices Reconsidered.* Basingstoke: Palgrave Macmillan, 2015. DOI: 10.1057/9781137439215.0004.

My aim in this account is to recover the writings of both European and American modern dancers in order to reconsider their practices internationally and to reposition ideas of the dancer and the choreographer in the period 1920–1945. I should stress that this is not a new history of modern dance; rather it is a historical account of dancers' practices as made evident in their writings. It was the dancers themselves whose experience became the substance of the dances that encapsulated the period. It was also dancers who attempted to define the new modern dance form that they were creating, on their own terms. It is in this sense that I use the phrase 'dancer's world'. In this period, as we shall see, it was a *dancer's* world where the focus was on the dancer. The change of emphasis from dancer to choreographer is one that comes much later and this development, and how it has been obscured by later writings, is one that I will discuss later in this chapter.

A new generation of dancers first began to talk of dance in a new way in the early years of the twentieth century. Isadora Duncan is perhaps the most celebrated of these but what she had to say about the dancer's world is worthy of re-examination as an example of how a dancer made sense of the world through her writing about dance.

In 1903, Duncan's speech[1] on the dance of the future was published. It has become part of the canon of writings about modern dance. Today there is nothing particularly remarkable about a dancer speaking about what matters to them. In 1903, Duncan was one of the few to give voice to ideas outside the established classical ballet. Duncan's speech is often referred to and analysed from a late twentieth- and twenty-first-century perspective, but it is worth reconsidering both as a statement in its time and as an introduction to the topic of this book – the dancer's world.

Duncan spoke as a dancer and spoke for herself and for other dancers. She did not talk of the choreographer of the future. For her the *dancer* of the future will be a woman who, through her dancing, will embody a freedom that will be an inspiration for all women. She said of the 'dancer of the future' that 'the dancer will not belong to a nation but to all humanity…. From all parts of her body shall shine radiant intelligence, bringing to the world the message of the thoughts and aspirations of thousands of women. She shall dance the freedom of women'.[2] She was, of course, speaking for herself and what she wished to achieve. Nonetheless, it remains a powerful statement. Over a century ago, a woman dancer aspired to a global outlook where freedom was the goal. She spoke out at a time when in both Europe and the United States of America there was

DOI: 10.1057/9781137439215.0004

a rising chorus of women's voices to redefine their place in the world, not least in the political campaigns for universal suffrage.[3] What marks Duncan out is that she was a dancer and her words had considerable impact. It was unusual at the time for a woman dancer to make such aspirations so public and for her to be taken seriously. Readers can decide for themselves how much has changed in the intervening years.

Duncan's concerns are very similar to those of the many modern dancers who chose to put their thoughts into words in the early decades of the twentieth century. They talk of the dancer's world, as dancers, from dancers' perspectives. We are fortunate that many of the dancers of the period wrote about their work.[4] When these dancers wrote, they did so to propose alternative dance practices to existing forms, notably classical ballet. These new practices eventually became so established as to present a technical orthodoxy that would itself be challenged in the 1960s. However, the virtuosity and formalism of the modern dance as presented in, say, Martha Graham's 1957 film of *A Dancer's World*, is different from the dancer's world of the years before World War II.[5]

By returning to the written ideas of modern dancers from both Europe and the United States of America, I suggest that the very formation of modern dance as dance practices can be looked at afresh. The dancers' world of the 1920s and 1930s was one where modern dancers individually and together began to mark out a new territory. Many of them were able to articulate what was new about their own dancing and that of their peers in a way that captured the primacy of the dancing itself.

During the early part of the twentieth century, modern dance was discussed in terms of modern dancers, with the emphasis on the dancer. Not only did the practitioners talk of themselves as dancers, but also so did the critics and the first historians of the modern dance. John Martin, in his seminal work *The Modern Dance* of 1933,[6] defines the new form in terms of its dancers and this was the predominant way of talking about the modern dance in this period. This can be found in British, German and American publications from John Ernest (J.E.) Crawford Flitch's *Modern Dancing and Dancers*[7] through Rudolf Laban's[8] *Die Welt des Tänzers*[9] to Elizabeth Selden's *The Dancer's Quest*.[10] Indeed, as late as 1965, Olga Maynard was still writing of *American Modern Dancers: The Pioneers*.[11] The revisionism that created histories that included early modern dance based on a late-twentieth-century idea of the *choreographer* led to histories and surveys of choreographers rather than dancers. For instance, there is a huge leap from the genealogy set out by Maynard in 1965 which includes

DOI: 10.1057/9781137439215.0004

both American and European dancers to that of Don McDonagh in 1976 with his exclusively American 'extended choreographic families' and his survey of choreographers.[12]

In the twenty-first century we are far more likely to write about what is now known as contemporary dance in terms of significant choreographers, even when they dance themselves. This is a perfectly valid description for much of the work of late-twentieth-century/twenty-first-century artists. However, the blanket attribution of the term 'choreographer' to dancers of a past period, which does not acknowledge fully how they saw themselves, poses a significant historiographical problem. For instance, Martha Bremser's widely used textbook refers to *Fifty Contemporary Choreographers*.[13] Deborah Jowitt gives Martha Bremser's collection of 'choreographers' a fine, broad, well-informed historical introduction and starts with the period before 1940, which is her chronological starting point for the idea of 'contemporary'. She begins by talking about a number of dancers of the early twentieth century including Martha Graham, Doris Humphrey and Charles Weidman, whom she refers to as 'American dancers'. Yet, within a page these same people are referred to, without further elaboration, as '*choreographers*' [my emphasis].[14] They thus became part of the same narrative as the 'choreographers' of the book's title, such as Richard Alston and Matthew Bourne whose main contribution has indeed been as choreographers rather than dancers. Sally Banes does something very similar in her book *Dancing Women: Female Bodies on Stage*. The book's title draws attention to the activity that these women were engaged in – dancing. In her chapter on 'early modern dance' she introduces the 'first generation of American modern dancers, including Loie Fuller, Isadora Duncan, and Ruth St Denis'. When considering 'modern dance' in a later chapter she refers back to this early period and talks of 'these women, and many other, less famous *choreographers* [my emphasis] of their generation – like the Canadian Maud Allan and the Austrian Wiesenthal sisters'. She then introduces the dancing women whom she will consider as 'the four *choreographers* [my emphasis] whose works I will analyze in this chapter – Mary Wigman, Doris Humphrey, Katherine Dunham, and Martha Graham'.[15] Interestingly, the elision between dancer and choreographer refers to a similar period to Jowitt's (the 1920s/1930s) and some of the same dancing women. These are just two examples of many where dancer and choreographer are used interchangeably in the literature without elaboration. Much other recent writing privileges choreographers over dancers even when the author is

DOI: 10.1057/9781137439215.0004

clearly focused on the activity of dancing. If you consider these women as they saw themselves in the period, as dancers, you find something different from what emerges from thinking of them as choreographers in a twenty-first-century sense.

This is a historical problem which has a number of facets. For instance, taken at its simplest, if you search for the word 'choreographer' in the writings of dancers and dance critics in the period 1920–1945 you will find very few mentions. This does not mean that artists of the period did not engage in choreography, nor that they were not recognised for their choreography: a search for 'choreography' or 'composition' will evidence this. At a more fundamental level, the fact that the majority of modern dance artists of the period talked of themselves as dancers indicates a way of thinking about the activity of dancing and how this is created for performance that *is* different from the way many think of the dancer/choreographer relationship in the twenty-first century. There is no doubt that modern dancers of the period made profound and substantial works that could be created only with highly developed choreographic skills. But these skills were used to create performances where dancing was paramount and where the dancer's skills set them apart from their audience and enabled them to communicate with the same audience. To take just one instance, Martha Graham, who became renowned as one of the pre-eminent artists of the twentieth century and became known retrospectively as a choreographer, wrote some quarter century after Duncan, in 1939, on her idea of the 'future of the dance'. In a brief statement, she spoke of herself and her peers as 'dancers':

> The future of the dance lies not alone in the hands of the dancer; it is equally in the hands of the public. Real 'theatre' is that moment of contact between performer and audience. Always there has been some dancer who was dissatisfied with the existing forms, some dancer for whom the traditional style became too sterile and who broke it open.[16]

She reasons that it is technique that underlies both the dancer's art and her capacity to bring about these changes:

> Technique is the craft which underlies the art. Many excellent craftsman are not great dancers, but *every* great dancer is an excellent craftsman. It does not matter in which school of technique a dancer is trained, the essential thing is that he *be trained*. The future of the dance lies – as the great past of the dance lay – in the continuance of the line of dancers who, trained and skilled, are not afraid to bring fresh values to their work.[17]

DOI: 10.1057/9781137439215.0004

She does not use the words choreographer or choreography at all here. So Graham, writing at a time when she was making some of her most significant choreographic works, such as *American Document* (1938), writes of dancers rather than choreographers and indeed places emphasis on technique as a means of change. This is but one example of how artists saw themselves and their work differently during this period.

A second problem with the historiography of modern dance, highlighted by both Maynard's and McDonagh's books, is that of canonical, generational accounts. The problems are highlighted by Sally Banes in her first, 1980, identification of the 'sources' of 'Post-Modern' dance. In attempting to explain the 'modern dance' that had preceded the 'postmodern dance' of the 1960s, she gave a telling categorisation:

> The history of modern dance is rapidly cyclical: revolution and institution; revolution and institution. The choices for each generation have been either to enter the new academy (but inevitably, to dilute and trivialize it in doing so), or to create a new establishment.

She then goes on to explain how such a situation actually demands a choreographer:

> In this system, the importance of the choreographer over the dancer is obvious. The 'tradition of the new' demands that every dancer be a potential choreographer.[18]

As we shall see, in Chapter 4, one or two dancers do begin to refer to themselves as choreographers, but they were the exception.

One of the problems with a 'generational' account is that of agreeing on how the generations are defined. There is a notable lack of consistency when it comes to writing a history of modern dance in a way that emphasises the 'generations'. Margaret Lloyd's *The Borzoi Book of Modern Dance* was one of the first to give a generational account, in 1949. She characterises the modern dance, by 'dancers', along the following broad lines: 'Forerunners', 'The Three Creative Revolutionists', 'Other Creative Moderns' and 'New Leaders – New Directions'. It is interesting to follow, for instance, the use of the term 'pioneer' in hers and subsequent accounts. Lloyd's first chapter is about the 'Forerunners' who include Duncan and Wigman and where Ruth St Denis and Ted Shawn are 'American Pioneers'. Maynard's book is about *American Modern Dance: The Pioneers,* but includes Wigman and German Modern Dance in the first chapter on 'The Beginnings'. The 1966 film about the Bennington Summer Schools

DOI: 10.1057/9781137439215.0004

of the 1930s, featuring Graham, Humphrey, Weidman and Holm is titled *Dance: Four Pioneers* (without the definite article). McDonagh's 1970 account has a 'brief history of modern dance', which begins with 'The Pioneers' (with the definite article), being Duncan, Fuller and St Denis (but no Germans). 'The Historic Generation', – Graham, Humphrey, Weidman and José Limón – follows it. In his 1976 account he has Allan, Duncan, Fuller, St Denis and Shawn as 'The Forerunners', followed by a group of 'Founders' including Graham, Holm and Humphrey. Brown's compilation of writings has 'The Forerunners', 'The Four Pioneers', where the definite article has appeared, 'The Second Generation' including Limón and 'The New Avant Garde'. This description alone should give an indication of the problems with a canonical, generational account.[19] Thus, the following consideration of modern dancers and their practices eschews a generational account and also attempts an inclusive transatlantic view.

Recently, there has been a return to talking of modern dancers as dancers, notably by Gay Morris.[20] Sally Gardner has taken issue with writers such as Foster, Amy Koritz and Randy Martin who have privileged the choreographer in the dancer–choreographer relationship in modern dance.[21] Her critique is of the secondary sources. My analysis returns to the primary sources for an investigation into the dancer's point of view.

During the period the term 'choreographer' had come to be accepted as a description of someone responsible for the creation of a ballet. It was, indeed, in the early twentieth century, predominantly a ballet term, although much less used than it is today. Earlier dancing masters and *Maîtres de Ballet* who had created ballets – such as John Weaver and Jean Georges Noverre – and contemporary artists – such as Mikhail Fokine and Leonide Massine[22] – were included in a twentieth-century ballet discourse that began to articulate the way the choreographer had a definite and describable role. British writers in particular – notably Cyril Beaumont and Arnold Haskell[23] – wrote the idea of the choreographer into the history of ballet overtly and explicitly, in marked contrast to later revisionist accounts of modern dance. Thus, when Peter Brinson and Peggy van Praagh wrote their fine account of *The Choreographic Art* in 1963,[24] they were able to draw on a range of sources to describe and analyse the role of the choreographer in ballet. They were quite clear that whereas many choreographers began their career as dancers, it was the few who became choreographers, and it was not imperative that they

DOI: 10.1057/9781137439215.0004

continued to dance. Moreover, they sum up the place of the dancer in ballet unequivocally, opening their chapter on 'The Dancer' with:

> The dancer is the choreographer's human instrument.[25]

Early modern dance artists did not talk of themselves as choreographers. In 1920, Rudolf Laban's first book was about the world of the dancer;[26] Wigman talked about herself and others who made the modern dance primarily as dancers;[27] Martha Graham in her early writings focused on the dancer; Humphrey, although concerned with composition and choreography in the 1930s, wrote about the dancer and 'what a dancer thinks about'.[28] Those dancers and dancer/teachers who attempted to characterise and contextualise their work, such as Elizabeth Selden and Leslie Burrowes, talked of the new modern movement in terms of the 'dancer's quest'[29] and the new 'modernist dancers'.[30] The term dancer was used, even in those discourses that came to challenge the very individuality of the modern dance, be it within the new language of the German Nazi state on the one hand[31] or the Marxist-Leninist ideas of American revolutionary dance on the other.[32] When Virginia Stewart and Merle Armitage compiled a book on *The Modern Dance* for publication in August 1935,[33] they asked seven dance artists to comment on the modern dance in Germany and the United States of America. The artists saw themselves and their fellows at this time as dancers first and foremost.

It is not just the artists who talked of themselves as dancers during this period. Critics too began to craft an account of a history of modern dance as one of the dancers. All the accounts written near to the period – in the 1930s and 1940s – are accounts of dance and dancers. In John Martin's *The Modern Dance* of 1933 and *America Dancing* of 1936, where he endeavours to describe the emerging new form, there is no mention of choreographers; *Introduction to the Dance* of 1939[34] talks of the 'expressional' dance of modern dancers from Duncan to Holm;[35] in *The Dance* of 1946 'expressional dance' has become 'dance as communication'.[36] In all cases he talks of dancers and does not describe them primarily as choreographers. When Martin does begin to refer to the 'choreographer' in modern dance, it is in a very deliberate way; thus, on Humphrey, 'Though it is as a dancer that Humphrey has won her fame…. with her large composition called "New Dance", first presented in 1934, she not only established herself as the first choreographer of her time, but marked the coming of age of the American dance'.[37] Probably the first

DOI: 10.1057/9781137439215.0004

comprehensive historical survey of the new modern dance is Margaret Lloyd's *The Borzoi Book of Modern Dance* of 1949. Although it mentions European modern dance in passing, and as having passed, this is a history of American modern dance. Again, it describes the new form in terms of its dancers. Significantly, like Martin, she makes an exception of Humphrey: 'as a dance artist Doris Humphrey is second to none. As a choreographer she is first of all ... Since her retirement as a dancer she has composed three of her greatest works'.[38] Maynard's later history *American Modern Dancers: The Pioneers* (1965) covers similar ground, and dancers are the focus throughout the book.[39] However, towards the end, she makes the following observation: 'all choreographers are dancers, but in the ballet every great dancer is not necessarily a choreographer. In Modern Dance, almost every major choreographer is also a noted dancer'.[40] This is in marked contrast to the contemporary account of the choreographer in ballet by Brinson and van Praagh, cited earlier.[41] Whilst it has to be acknowledged that the critics of the time, especially John Martin and Edwin Denby, were hugely influential in shaping the new modern dance, the voices of the dancers of the period have, I suggest, been under-represented.

My exposition of *The Dancer's World* is divided into a further four main chapters, a concluding chapter and an epilogue. The chapters are titled from a phrase from a dancer's writing, and the chapter itself takes this writing as a basis for exploring themes suggested by it in the immediate historical period around it. The chapters follow one another chronologically, but there is some overlap because ideas are never demarcated simply by time. Each chapter begins with an abstract that details its content. The chapters themselves have notes that are extensive and fully referenced and that are designed to aid further study and research. The select bibliography is of dancers' writings on modern dance from the period considered: this includes all the dancers' published writings referred to in the text. Not all dancers of the period wrote about their work; some – for example, Charles Weidman and Pearl Primus – wrote very little during the period; some – for example, Uday Shankar – wrote nothing. Although they do not figure large in the bibliography, this does not make their work and contribution to modern dance any less important. My account refers not only to those who wrote, but those who didn't as well. As I said at the beginning, this is not a new history of modern dance, but an account of modern dancers' writings. In this it addresses both familiar and not so familiar figures. There is a sense in which a return to

DOI: 10.1057/9781137439215.0004

dancers' writings allows some practitioners to be recovered, to be given a fresh voice. At the same time, it is necessary to acknowledge how other dancers may have predominated in the historiography of modern dance because they were so widely published, Mary Wigman being the most obvious example.

The focuses of the chapters, and their immediate historical periods, can be summarised as follows:

Chapter 2
The World of the Dancer (Rudolf Laban 1920)
1900–1925

Chapter 3
We (Dancers) Are Standing at the Beginning (Mary Wigman 1926)
1923–1933

Chapter 4
German and American Modern Dance: Constitutional Differences (Hanya Holm 1935)
1933–1936

Chapter 5
A New World for the Dancer (Doris Humphrey 1941)
1935–1945

Chapter 6
Conclusion: A Dancer's World (Martha Graham 1957)

Epilogue
A Historical Sense of a Dancer's World
2015

The majority of the texts referred to are dancers' writings. It goes without saying that these vary considerably in terms of the author, the language they were written in, their geographical provenance and when they were written. None of the dancers wrote with *this* sort of book in mind. They wrote as a way of making known their ideas about dancing. Their writing complemented their dancing and their teaching practice: it was very rarely a substitute for it. In many cases, their writing was thinly disguised self-publicity, but in others it was an attempt to contribute to a developing published discourse about modern dance. The writings mentioned and

DOI: 10.1057/9781137439215.0004

cited are all considered in terms of their time and place. The concluding chapter, A Dancer's World, emphasises the changing nature of the dancer's world that emerges from these writings, and comments on how dancers' writings can help understand the changing ways in which they responded to the world. The Epilogue asks how this may have continuing relevance for dancers today.

Notes

1 A speech given to the Berlin Press Club in 1903.
2 Isadora Duncan, *Der Tanz Der Zukunft* [*The Dance of the Future*] edited by Karl Federn (Leipzig: Eugen Diederichs, 1903).
3 In the United Kingdom there had been a number of suffrage societies that campaigned for change and for the right to vote. These came together in 1897 in the National Union of Women's Suffrage Societies. In 1903, the year that Duncan spoke of the freedom of women, Emmeline Pankhurst founded the more radical Women's Social and Political Union. The ensuing campaigns lasted through the Great War. Many British women over the age of 30 were granted the right to vote in 1918 and the franchise was extended to all over the age of 21 in 1930. In the United States of America the nineteenth amendment to the constitution ratified voting rights in all states for women over 21 on 18 August 1920, a year after Canada.
4 Indeed, many of their writings are well known, thanks to republication in collections such as those of Selma Jeanne Cohen, ed., *Dance as a Theatre Art: Source Readings from 1581 to the Present* (New York: Dodd Mead, 1974, 1977) and Jean Morrison Brown, Naomi Mindlin and Charles Humphrey Woodford, *The Vision of Modern Dance: In the Words of Its Creators*, 2nd ed. (Hightstown, NJ: Princeton Book, 1998).
5 Recent studies by Gay Morris, Rebekah Kowal and Mark Franko have suggested that although American modern dance ideas developed in the 1930s, there were major changes in the post-war period that troubled and changed the very idea of modern dance. See Gay Morris, *A Game for Dancers: Performing Modernism in the Postwar Years, 1945–1960* (Middletown, CT: Wesleyan University Press, 2006); Rebekah J. Kowal, *How to Do Things with Dance: Performing Change in Postwar America* (Middletown, CT: Wesleyan University Press, 2010); Mark Franko, *Martha Graham in Love and War: The Life in the Work* (New York: Oxford University Press, 2012).
6 John Martin, *The Modern Dance* (New York: A.S. Barnes, 1933; repr. New York: Dance Horizons, 1987).

DOI: 10.1057/9781137439215.0004

7 John Ernest Crawford Flitch, *Modern Dancing and Dancers* (London: Grant Richards, 1912).

8 The name on Laban's death certificate dated 2 July 1958 is Rudolf Johann Baptiste Attila Laban. He used many versions of his name during his lifetime. For the purposes of this book I refer to him as he was known in England, Rudolf Laban. The references and the bibliography use his published names, Rudolf von Laban in Germany and Rudolf Laban in England.

9 Rudolf von Laban, *Die Welt des Tänzers* (Stuttgart: Walter Seifert, 1920).

10 Elizabeth Selden, *The Dancer's Quest* (Berkeley: University of California Press, 1935).

11 Olga Maynard, *American Modern Dancers: The Pioneers* (Boston: Little, Brown, 1965).

12 See Maynard, *American Modern Dancers*; Don McDonagh, *The Complete Guide to Modern Dance* (New York: Doubleday, 1976), frontispiece.

13 Martha Bremser and Lorna Sanders, eds, *Fifty Contemporary Choreographers*, 2nd ed. (Abingdon, Oxon: Routledge, 2011).

14 Deborah Jowitt, 'Introduction', In Bremser and Sanders, eds, *Fifty Contemporary Choreographers*, 14, 15.

15 Sally Banes, *Dancing Women: Female Bodies on Stage* (London: Routledge, 1998), 67, 123, 124.

16 Martha Graham, 'The Future of the Dance', *Dance* 6, no. 4, In Sali Ann Kriegsman, ed., *Modern Dance in America – The Bennington Years* (Boston, MA: G.K. Hall, 1981), 288.

17 Graham, 'The Future of the Dance', 288.

18 Sally Banes, *Terpsichore in Sneakers: Post-modern Dance* (Boston: Houghton Mifflin, 1980), 5.

19 See (chronologically):
 Margaret Lloyd, *The Borzoi Book of Modern Dance* (New York: Dance Horizons, 1949); Maynard, *American Modern Dancers*; Don McDonagh, *The Rise and Fall and Rise of Modern Dance* (New York: Dutton, 1970); McDonagh, *The Complete Guide to Modern Dance*; Brown, *The Vision of Modern Dance*; Banes, *Terpsichore in Sneakers*; Sally Banes, 'Introduction to the Wesleyan Paperback Edition', In *Terpsichore in Sneakers: Post-modern Dance*, xiii–xv; Mark Franko, 'Period Plots, Canonical Stages, and Post-metanarrative in American Modern Dance', In Claudia Gitelman and Randy Martin, eds, *The Returns of Alwin Nikolais: Bodies, Boundaries and the Dance Canon* (Middletown, CT: Wesleyan University Press, 2007); Jowitt, 'Introduction', *Fifty Contemporary Choreographers*.

20 Morris, *A Game for Dancers*.

21 Sally Gardner, 'The Dancer, the Choreographer and Modern Dance Scholarship: A Critical Reading', *Dance Research* 25, no. 1 (2007): 35–53.

22 Grigoriev quotes Diaghilev, speaking in 1915 of Massine: 'you see: given the talent, one can make a choreographer in no time'. Serge

DOI: 10.1057/9781137439215.0004

Leonidovich Grigoriev, *The Diaghilev Ballet 1909–1929*, trans. Vera Bowen (Harmondsworth: Penguin, 1960), 119.

23 See, for instance, Arnold Haskell, *Ballet: A Complete Guide to Appreciation, History, Aesthetics, Ballets, Dancers* (Harmondsworth: Penguin, 1938).

24 Peter Brinson and Peggy van Praagh, *The Choreographic Art* (London: A & C Black, 1963).

25 Brinson and van Praagh, *The Choreographic Art*, 173.

26 Originally published in German as Rudolf von Laban, *Die Welt Des Tänzers* (Stuttgart: Walter Seifert, 1920). Stefanie Sachsenmaier and Dick McCaw translate this as *The World of the Dancer*, whilst Susanne Franco uses *The Dancer's World*. See Dick McCaw, ed., *The Laban Sourcebook* (Abingdon. Oxon.: Routledge, 2011); Susanne Franco, 'Rudolf Laban's Dance Film Projects', In Susan Manning and Lucia Ruprecht, eds, *New German Dance Studies* (Urbana: University of Illinois Press, 2012), 63–78.

27 Notably in the following writings from the period 1925–1933: Mary Wigman, 'We Are Standing at the Beginning', trans. Walter Sorell, In Walter Sorell, ed., *The Mary Wigman Book: Her Writings Edited and Translated* (Middletown, CT: Wesleyan University Press, 1975), 81–85 (originally published in German in Stefan [1925], *Tanz in Dieser Zeit* [Dance in Our Time] as Tänzerisches Schaffen der Gegenwart, 5–7); Mary Wigman, 'The Dance and Modern Woman', In *The Mary Wigman Book*, 162–163; Mary Wigman, 'Stage Dance – Stage Dancer', trans. Walter Sorell, In *The Mary Wigman Book*, 107–115 (originally published in *Magdeburger Tageszeitung*, 15 May 1927); Mary Wigman, 'The Dancer', In *The Mary Wigman Book*, 117–121 (originally published in *Tanzgemeinschaft*, 1930); Mary Wigman, 'The Philosophy of Modern Dance', In Selma Jeanne Cohen, ed., *Dance as a Theatre Art* (New York: Harper & Row, 1974), 149–153 (originally published in *Europa*, I, no. 1 (May–July) 1933).

28 Doris Humphrey, 'What a Dancer Thinks About', In Cohen, ed., *The Vision of Modern Dance*, 55–64 (identified by Cohen as unpublished Ms from NYPL Dance Collection).

29 Selden, *The Dancer's Quest*.

30 Leslie Burrowes, 'The Modern Dance Movement in England', *The Dancing Times* (January 1933), 452–453.

31 Mary Wigman, 'The New German Dance', In Virginia Stewart and Merle Armitage, eds, *The Modern Dance* (New York: Privately Published, 1935; repr. Dance Horizons, 1970), 19–24; Mary Wigman, *Deutsche Tanzkunst* (Dresden: Carl Reissner, 1935).

32 Nell Anyon (Nadia Chilkovsky), 'The Tasks of the Revolutionary Dance', In Mark Franko, ed., *Dancing Modernism/Performing Politics* (Bloomington: Indiana University Press, 1995), 113–115 (first published in *New Theatre* September/October 1933).

DOI: 10.1057/9781137439215.0004

33 Stewart and Armitage, *The Modern Dance*: The book published Wigman in English, its translations are attributed to Franzisca Boas.

34 John Martin, *Introduction to the Dance* (New York: Dance Horizons, 1965; first published New York: W.W. Norton, 1939).

35 Martin, *Introduction to the Dance.*

36 John Martin, *The Dance: The Story of the Dance Told in Pictures and Text* (New York: Tudor, 1946), 105–147.

37 Martin, *Introduction to the Dance*, 259–260. *New Dance* was, in fact, premiered in 1935, on 3 August at Bennington.

38 Lloyd, *The Borzoi Book of Modern Dance*, 76. Humphrey stopped dancing on 26 May 1944.

39 Maynard, *American Modern Dancers.*

40 Maynard, *American Modern Dancers*, 173–174.

41 Brinson and van Praagh, *The Choreographic Art.*

DOI: 10.1057/9781137439215.0004

2
The World of the Dancer

Abstract: *This chapter looks at the writings of dancers in the period 1900–1925 to contextualise the start of the period that the book considers, 1920. These artists later became known as modern dancers. Few dancers wrote of their practice at this time, but those who did talked of their dancing and the world of the dancer. They include Maud Allan, Isadora Duncan, Loie Fuller, Margaret H'Doubler, Rudolf Laban, Alexander Sacharoff, Ruth St Denis, Grete Wiesenthal and Mary Wigman.*

Keywords: dancers; modern dancers; writings

Huxley, Michael. *The Dancer's World, 1920–1945: Modern Dancers and Their Practices Reconsidered.* Basingstoke: Palgrave Macmillan, 2015. DOI: 10.1057/9781137439215.0005.

Rudolf Laban began his first book boldly, stating that he was the first of 'today's dancers' to lay out his ideas in book form.[1] He wrote the 1920 *Die Welt des Tänzers* (*The World of the Dancer*) for dancers and stressed the importance of the dancer and of dancing. After all, as he pointed out, he was a dancer himself and his ideas came from his experience. In the preceding two decades a number of dancers who had been trying out new practices had written about their experiences. For instance, Isadora Duncan and Loie Fuller wrote of dance and dancing and of themselves as dancers. This chapter considers what the world of the dancer meant at the time that Laban's book was published. It will show how dancers from a variety of backgrounds articulated their new practices in writing, and what Laban and his contemporaries were trying to develop.

During the first two decades of the twentieth century there were what we now identify as the first indications of a new approach to dance practice. The dancers of the period have become part of the canonical account of modern dance. They have been variously described in retrospect as exponents of 'early modern dance' or as 'forerunners' to modern dance or as 'pioneers'.[2] It is during this period that those who are now regarded as the first modern dancers began to perform, teach and open schools. Some dancers wrote of themselves and their projects in order to articulate their danced experiences, and these took many forms precisely because of the emergent nature of their practices. What is certain is that dancers writing within the context of the emerging modern dance were working primarily in Europe and the United States of America; and these included Americans in Europe.[3] In the years before the outbreak of the Great War in Europe in 1914 many young women practised as solo dancers and some of them opened schools to teach their practice to others.[4] This war had a profound effect on the arts in Europe. David Reynolds, for instance, has shown recently how the 'great war for civilization' had lasting effects on European culture, particularly in literature and the visual arts.[5] It is noticeable that very few writers comment on changes to dance, but many of the arguments that have been applied to the development of modernism in literature and painting might be applied to dance as well. On the one hand, there was clearly a disruption with respect to the emergence of modern dance and modernism in ballet. This affected, for instance, the trajectory of the work of dancers such as Alexander Sacharoff; movement theorists such as Émile Jaques-Dalcroze; artists working with dance such as Wassily Kandinsky; and touring by the recently formed Ballets Russes. Nonetheless, the development of new

DOI: 10.1057/9781137439215.0005

practices continued, not least in neutral Switzerland with the work of Rudolf Laban, Mary Wigman and their fellow dancers. As Hans Brandenburg demonstrates in his surveys of the modern dance of the time, these practices were reinvigorated after the armistice in 1918.[6]

A number of dancers who were later to be known as early exponents of modern dance wrote about their own dancing in the period 1900–1920. Three of them – Maud Allan, Loie Fuller and Grete Wiesenthal – wrote autobiographies: *My Life and Dancing* (1908),[7] *Fifteen Years of a Dancer's Life* (1913),[8] *The Ascent: From the Life of a Dancer* (1919),[9] respectively. They recount key events and people and give glimpses into the danced experience of these women. None of the books attempts an exposition about dance in a wider sense. Allan, who was famous for her solo dance *The Vision of Salomé* (1903), begins her account as follows:

> How I dance, and why, and what is my intention in my dance, no one can say for certain. I, least of all, for as I think and breathe and live, so I dance.[10]

Fuller, writing some years after the triumphs of her performances in Paris,[11] in what could be said to be a typical stage autobiography, has one short (much quoted) section which she refers to as a 'theoretical "essay".'[12] She had been widely acclaimed for her innovative stagings and what we might now call interdisciplinary performance. In this chapter on 'Light and the Dance' she locates her own dancing within a more general context, typical of thinking about expression of the time:

> What is the dance? It is motion. What is motion? The expression of a sensation In the dance, and there ought to be a word better adapted to the thing, the human body should, despite conventional limitations, express all the sensations or emotions that it experience Ignoring conventions, following only my own instinct, I am able to translate the sensations we have all felt without suspecting that they could be expressed.[13]

Both dancers write in a way that is comparable to their contemporary Isadora Duncan. Duncan got her ideas on dancing reported regularly in newspapers and periodicals.[14] Duncan goes much further than her contemporaries in her vision for dance and dancing as a means of liberation for women, and from the ballet at the turn of the century.[15] Her 1903 vision in *The Dance of the Future*[16] is extensive and the following passage indicates its scope.

> The dancer of the future will be one whose body and soul have grown so harmoniously together that the natural language of that soul will have become the movement of the body. The dancer will not belong to a nation but to all

DOI: 10.1057/9781137439215.0005

humanity. She will dance not in the form of nymph, nor fairy, nor coquette, but in the form of woman in her greatest and purest expression. She will realize the mission of woman's body and the holiness of all its parts. She will dance the changing life of nature, showing how each part is transformed into the other. From all parts of her body shall shine radiant intelligence, bringing to the world the message of the thoughts and aspirations of thousands of women. She shall dance the freedom of woman.[17]

There was a search for something new, not yet articulated as modern dance, which talked of the individual, expression, the spiritual and the natural. It placed women at the centre and spoke of a different world where they have the potential to achieve something new and to live life with different expectations both of themselves and of society.

These dancers had been writing at a momentous time for the development of dance. There had been many innovations including contributions from other artists, notably musicians and visual artists[18] as well as dancers. The new dancing was written about by contemporary commentators, notably J.E. Crawford Flitch in England (1912); Ethel Urlin (1912), Caroline and Charles Caffin (1912) and Troy and Margaret Kinney (1914) in the United States of America,[19] who talked of a 'modern' dance with reference to a revival of dancing along natural lines and referring back to classical Greece.[20] At this time this is how dancers, especially Duncan, whose aspiration was for a dance of the future, viewed their practice. Writing in Germany in 1913, Hans Brandenburg[21] struck a different, decidedly contemporary, tone encompassing the work of a range of up and coming artists, primarily those practising in Europe. He wrote of individual dancers – Isadora Duncan, the Wiesenthal sisters, Ruth St Denis, Sent M'Ahesa, Clotilde von Derp, Alexander Sacharoff, Gertrud Leistikow and Ellen Tels – but also included the new Ballets Russes and three newly opened dance schools – notably those of Elizabeth Duncan and Émile Jaques-Dalcroze.[22] Brandenburg's book *Der Moderne Tanz* was a signal work and although he included no writings by dancers themselves, he did associate closely with many of the new dancers both observing their practices and in the case of Laban being in discussion about his first book.[23] Significantly, the second edition of *Der Moderne Tanz*, written just before the outbreak of the Great War, included a new introduction overviewing the work of Anna Pavlova, Rita Aurel, Jutta von Collande, Gertrud Falke, Laura Oesterreich, Elizabeth Mensendieck's *gymnastik*, the Laban School (*Die Labanschule*) and Mary Wigman. Although Brandenburg is still the single authorial voice, he

DOI: 10.1057/9781137439215.0005

captures the practices of the period, especially those in the schools. In this introduction he gives an extended account of Laban's practices and ideas, especially what was known at that time as 'free dance' (*freie tanz*) and 'Dance, Sound, Word' (*Tanz, Ton, Wort*).[24]

Following the Bolshevik revolution in Russia (1917), the end of the Great War in 1918 and the establishment of the Weimar Republic in Germany, there were major developments in the new dance in Europe, the United Kingdom and the United States of America. Dancers wrote of their practice as dancers and as teachers and of the work of their newly founded schools. In many respects, these developments did not signal a strict demarcation between dancing as teaching and as performing. The term 'modern', as we shall see, had yet to achieve currency in dancers' own writings about their performance, although it was extensively used to describe many of the new social dances of the time, as evidenced by the aforementioned Flitch, the Caffins and the Kinneys.[25] There was only one dedicated dance periodical in 1918, *The Dancing Times* of London, and this was not really a vehicle for dancers' writings at this time. Dancers did find outlets for their views including in periodicals such as *The Touchstone* and *Theatre Arts Magazine* in the United States of America, *Die Tat* and *Die Freude* in Germany. Eventually, they began to establish their own publications, starting with *Denishawn Magazine* for the eponymous Californian school in 1924.

The world of the dancer, taken as a description of the period 1920–1925 as found in dancers' books, apart from Laban's, included Margaret H'Doubler's *Manual of Dancing* (1921) *and The Dance and Its Place in Education* (1925), Gertrude Colby on *Natural Rhythms and Dances* (1922) and Margaret Morris's *Margaret Morris Dancing* (1925).[26] There was a negotiation between ideas of the natural harking back to classical Greece as imagined by many dancers and the beginnings of modernity.[27] So, for H'Doubler in 1921, 'dancing is self expression through the medium of bodily movement' using the 'laws of natural movement' so that 'the controlled individual is a free individual'.[28] Dancing is central to a creative approach to life in education and art.

Many early twentieth-century dancers' books published before *The World of the Dancer* were, as we have seen in the cases of Allan, Fuller and Wiesenthal, typically autobiographical.[29] The aforementioned books by Colby, H'Doubler, Morris were largely instructional. Most of the dancers' writings at this time were in single-author books of one kind or another. Very few were published in periodicals. The three main exceptions were

DOI: 10.1057/9781137439215.0005

Duncan, St Denis and Laban. Both Duncan and St Denis had a number of articles published. Duncan restated and developed her ideas for the 'new dance', notably in her first American article of 1917 in *The Touchstone*[30] followed by another in *Theatre Arts Magazine*.[31] In the same year in the same periodical St Denis wrote on 'The Dance as an Art Form'.[32] Laban's first article appeared in 1919 in *Die Tat* (The Deed),[33] this being the first of six articles in the periodical between 1919 and 1922. These articles put forward his ideas on dance as a form of festival and a theatrical form. Thus his first book was part of a new and growing published output, which distinguished him from other dancers. It will be given detailed consideration in the following paragraphs.

Laban's *Die Welt des Tänzers* (The World of the Dancer) was published in 1920 by Walter Seifert of Stuttgart. What made Laban's treatise distinctive, and different to all the other books and articles by dancers, was its scope. Although the ideas in it can be seen to be derivative of Laban's own practice, he embraced a range of others' practices in such a way as to enable him to make universal statements about the place and purpose of the dancer. It can be viewed with hindsight as a deeply flawed and troubling book but, at the time of its publication, it was unique as a statement made by a practising dancer. This is why it merits close examination. There is no published English translation. Stephanie Sachsenmaier and Dick McCaw have translated substantial selected sections for *The Laban Sourcebook* (2011) and these will be referred to. The book was translated in full by S. Goddard in 1966 for Gordon Curl, but this translation has not been published.[34] Even the given English title is open to interpretation. Whereas most favour *The World of the Dancer*, Hodgson, Laban's first biographer, uses *The Dancer's World*.[35]

In *The World of the Dancer* Laban sets out an account which encompasses an enormous range of ideas. The book is 262 pages long with an introduction, five sections and a sort of postscript. I will look specifically at the ideas of the dancer, the dancer's experience and the modern dance. Laban begins his book by stating:

> When I approached my work, to be the first among today's dancers to speak of a world for which the words are missing in our language, I was fully aware of the difficulties of this undertaking.[36]

Laban is making a substantial claim. Goddard translates *den heutigen Tänzerin* as 'the modern dancers'. I am using 'today's dancers' to make the point that in writing of the world of the dancer, Laban does *not* use

DOI: 10.1057/9781137439215.0005

the word *moderne* (modern) in the book, he is talking in a much broader sense. This is interesting because the term *moderne tanz* had been used, as we have seen, by Brandenburg in *Der Moderne Tanz* of 1913. Laban had been associated with Brandenburg, especially during his time at Ascona[37] and was included in the second edition (1917) and the third (1921). Moreover, Brandenburg's book is included in Laban's list of books for further reading and Laban reviewed *Der Moderne Tanz* for *Die Tat* in 1922.[38] McCaw notes that Laban had written to Brandenburg in 1920 about his forthcoming book. Laban says:

> Two essential themes run through my work in general. First to give to dance as an art form and the dancer as an artist their proper value, and second to stress the influence of dance education on the rigid psyche of our time.[39]

Within a context familiar in other dancers' writings – art and education – Laban not only talks of the dancer but, like Duncan, attempts to reinstate the status of the dancer as someone to be taken seriously in both spheres.

In his introduction, Laban makes the uncompromising statement that 'Dance can only be explained by dance'.[40] In order to do this, in writing, Laban employs the idea of *der Gedankenreigen* in both the subtitle and the five sections of his book. He explains:

> The form, with which I clothe my experiences of thousands of dances, discussions with dancers, literature of dance and movement, and furthermore of lessons and studies, is the *round-dance of thoughts* [my emphasis].[41]

Sachsenmaier and McCaw translate *Gedankenreigen* as 'thought round' with the implication that 'round' refers to a danced round. Laban stresses the unity of the bodily-spiritual-mental (*körperlich-seelisch-geistige*) (Sachsenmaier and McCaw use 'physical' rather than 'bodily') throughout the book, thus:

> To order the motives of thought within the meaning of a dance composition and to comprehend the thought as a bodily-spiritual-mental movement, is the basic duty of him who creates a round-dance of thoughts.[42]

He clarifies the basis for his observations when he says that 'the contents [of his study] root exclusively in presentations, explorations, experiences and views of the many dancing and understanding men [or their writings] whom I have met during my profession'.[43] He refers the reader to the book's final section – the postscript, which he titles 'building bricks'.

DOI: 10.1057/9781137439215.0005

Here he clarifies further the idea of the dancing experience and what he has drawn on:

> The five round dances of thoughts of this book have been based upon the thought contents of a natural dancing sequence of exercises. The practising dancers will recognise quite easily that the individual parts performed bodily-dancingly [*körpelich-tänzerisch*], will lead to the aim, which I will call 'Dancing Experience' [*Tänzerisches Ereleben*].[44]

Laban talks of dancers, dance and the dancing experience.[45] However, he doesn't talk as a dancer in the sense of calling on his own dancing and putting it into words. This is an important distinction, which will be developed later in the chapter.

Laban says that his 1920 book was intended as the first of a series and that the books that were to follow would lay out the details of his method: they were published in 1926 and 1928.[46] *The World of the Dancer* was intended as a prefatory exposition on the nature of dance and dancer. It did, along with his subsequent books, have a lasting effect on the teaching of dance in Germany, the United States of America and the United Kingdom. Nothing comparable was published in English at that time. However, it is useful to make some comparison with the other book of the period that had a profound effect on dance education, Margaret H'Doubler's second book of 1925, *The Dance and Its Place in Education*.[47] H'Doubler writes as a dance teacher for other dance teachers so there is none of the grand scope attempted by Laban. Nonetheless, it is a clearly argued case for the teaching of dance as an art in universities.[48] It is also written in a way that evokes the teacher in the classroom. H'Doubler addresses other dance teachers in her introductory chapter with a list of seven questions to reflect on, starting with 'just what do we mean by dance?' and ending with 'what does it contribute to the refinement of the student and the cultivation of his artistic life?'[49] Her argument is built up from here to determine what is needed to teach dance as an art, by which she means 'dancing as an adequate and harmonious means of expressing our emotional life' and which is 'genuinely expressive of the inner man'.[50] In this she is consistent with most of the modern dancers of the period, but differs in her primary concern for her students. It is this that gives the book its significance.

Laban's *World of the Dancer* is a contentious book in many respects. Sachsenmaier introduces the text by noting the difficulties in translating it from the German and the disorganised way in which it had been put together.[51] There is little certainty about the writing and production of

the book: for instance, Valerie Preston-Dunlop says Laban had begun notes for this book either before 1910 or as early as 1912 and completed the script either in 1914 or in 1918 whereas Karen Bradley dates the writing as from 1916.[52] The experiences that Laban is drawing on are those of his performing and teaching and other activities in Munich, Zurich and Ascona. There is a general agreement that the book is far from a systematic study of dancing and more of a collection of notes under various headings. It has been extensively referred to: McCaw gives a thorough account of the work on its own terms; Preston-Dunlop is sympathetic and partisan; Hodgson gives a detailed but largely uncritical account; Bradley's text on Laban mentions it but briefly; Karl Toepfer is scathing in his analysis of the book's disorganisation; Marion Kant locates the book within a wider project with dubious quasi-religious aspirations that laid the foundations for his later reactionary political affiliations.[53] Nevertheless, whatever the perspective, all point to the importance of the book in establishing Laban's reputation as a dancer and a leader of the new dance movement that was developing in Germany.[54]

Laban refers to other dancers as well as drawing on his own experiences. In his final section, *Bausteine* (building blocks), he goes on to mention a number of dancers whom he has worked with, including colleagues Olga Feldt-Bereska (Dussia Bereska), Suzanne Perrottet, Käte Wulff, Maja Lenares (Maja Lederer) and Mary Wigman.[55] He also refers briefly to Vaslav Nijinsky, Alexander Sacharoff and Ernst Mohr.[56] Alexander Sacharoff is an interesting mention because he had written a brief article about his approach to dance, published in one of his programmes in 1910, at a time when both he and Laban were working in Munich.[57] Mary Wigman is the only dancer whom Laban had worked with and who went on to develop her own, extensive writing about dance, and her writing differed fundamentally from his because she wrote as a dancer in a way that captures the sense of her dancing.

Wigman had ceased working with Laban in 1918 and had opened her school in Dresden in 1920 at the age of 34, the same year that she added group dances to the solo repertoire that she had developed since 1914; her dance group debuted three years later. Her first writings were published in periodicals in 1921[58] and in her dance poem/libretto *Die Sieben Tänze Des Lebens - Tanzdichtung.*[59] In three articles she talked about her 'teacher' Laban, dance and her idea for a new 'absolute dance'. Just a year after Laban's book, Wigman, in 'Der Tanz Als Kunstwerk' laid out what Kant calls 'the first coherent definition of her new dance aesthetics: "absolute

DOI: 10.1057/9781137439215.0005

dance"', where she argued against both the moribund ballet and mere gymnastics.[60] Her dance poem/libretto was for one of her first group dances, *The Seven Dances of Life*, which premiered on 14 December 1921 at the Frankfurt Opera House.

Wigman's (1921) dance poem is translated in Sorell's collection of Wigman's writings.[61] It includes stage descriptions, the spoken prologue, description of the seven dances and the spoken poem that accompanies one of them, 'The Dance of the Demon'. It is in the descriptions of the dances that we find, I believe, for the first time a real sense of the dancing itself. The dances are brought to life, especially the 'Dance of Lust' and the 'Dance of Suffering'. They are quoted here at length, not in an attempt to reconstruct the work – Manning and Newhall both give good, but different, accounts of the dance in performance[62] – but to get a sense of the dancer herself dancing.

The Dance of Lust

Who am I? I do not know. I only feel my blood burn in my veins and hear nothing but the beating of my wild pulse. Who is God? I do not know. I only feel how alien forces penetrate and engulf me. I do not want to feel or know anything. I only want to dance. Oh, my limbs dance, dance! – I want to die in the lust of swinging, I want to break to pieces in bending my body.[63]

The Dance of Suffering

Then, in a mood of tranquillity, she steps on the black carpet and makes her limbs speak of sadness reflecting the suffering that is in man. She sinks onto her knees with a feeling of heaviness, as if crushed by the beauty of her mourning. Her nimble feet grope tiredly along the dark veil. The space is filled with such silence that the breathing of the mourning women seems to turn into music.[64]

Wigman's writing here is evocative of a different world to those of Laban and the other contemporaries discussed. There are echoes of the passion of Duncan and Fuller, but couched in different terms. What is being 'expressed' here is of a darker nature than that of St Denis and her dance.[65] And, this is not the convoluted world of the dance that was Laban's; this is the world of the dancer in all its immediacy.

Notes

1 Rudolf von Laban, *Die Welt Des Tänzers: Fünf Gedankenreigen* (Stuttgart: Walter Seifert, 1920).

DOI: 10.1057/9781137439215.0005

2 See Introduction.

3 Many of these will be encountered in the account that follows. At this point it might be worth emphasising that of the dancers mentioned in this chapter Duncan and Fuller were Americans and Allan was Canadian. All three performed extensively in Europe.

4 Many more women tried out new ways of dancing in this period than appear in the canonical accounts. The film record shows a number of named and unnamed young women skirt dancers and imitators of the more famous dancers. Elizabeth Kendall's account is an excellent source here; Karl Toepfer's account of nudity in German dance gives a useful indication of some of the scope of dance practices after 1910 in Germany. See Elizabeth Kendall, *Where She Danced* (New York: Knopf, 1979); Karl Toepfer, *Empire of Ecstasy: Nudity and Movement in German Body Culture, 1910–1935* (Berkeley: University of California Press, 1997).

5 David Reynolds, *The Long Shadow: The Great War and the Twentieth Century* (London: Simon and Schuster, 2013).

6 Hans Brandenburg, *Der Moderne Tanz* (München: Georg Müller, 1913); Hans Brandenburg, *Der Moderne Tanz* (München: Georg Müller, 1917); Hans Brandenburg, *Der Moderne Tanz* (München: Georg Müller, 1921).

7 Maud Allan, *My Life and Dancing* (London: Everett, 1908).

8 Loie Fuller, *Fifteen Years of a Dancer's Life* (Boston: Small, Maynard, 1913).

9 Grete Wiesenthal, *Der Aufstieg: Aus Dem Leben Einer Tänzerin* [*The Ascent: From the Life of a Dancer*] (Berlin: Ernst Rowohlt, 1919).

10 Allan, *My Life and Dancing*, 8.

11 Her most noted performances included those at the Paris World's Fair of 1900. Ann Cooper Albright gives a detailed account of her work. See Ann Cooper Albright, *Traces of Light: Absence and Presence in the Work of Loïe Fuller* (Middletown, CT: Wesleyan University Press, 2007).

12 Fuller, *Dancer's Life*, 62.

13 Fuller, *Dancer's Life*, 70

14 For instance, Isadora Duncan, *The Art of the Dance*, Sheldon Cheney, ed., 2nd ed. (New York: Theatre Arts Books, 1928, 1969) includes identified articles, extracts and quotations from *Frankfurter Zeitung* (1906), *Dionysion* (1915), *Theatre Arts Monthly* (1917); Isadora Duncan, *Isadora Speaks*, Franklin Rosemont, ed. (San Francisco: City Lights Books, 1981) includes *Berlin Morgen Post* (1903), *Current Literature* (1908), *San Francisco Examiner* (1917), *The Touchstone* (1918).

15 Duncan's statement was made some six years before the innovations begun by Diaghilev's Ballets Russes (1909–1929).

16 Isadora Duncan, *The Dance of the Future* [*Der Tanz Der Zukunft*], Karl Federn, ed. (Leipzig: Eugen Diederichs, 1903). Republished as *The Dance* (1909) by the Forest Press. Citations from Duncan, *The Art of the Dance*.

DOI: 10.1057/9781137439215.0005

17 Duncan, *The Dance of the Future*, 62–63.

18 In Europe, in particular, musicians such as Émile Jaques-Dalcroze and visual artists such as Wassily Kandinsky and Oskar Schlemmer wrote about a new approach to dance as practitioners, but not as dancers. The last created a number of works, as a choreographer, at the Bauhaus. See Oskar Schlemmer, 'Man and Art Figure', In Walter Gropius, ed., Arthur Wensinger, trans., *The Theater of the Bauhaus*, 17–32 (Middletown, CT: Wesleyan University Press, 1924, 1961); Michael Huxley and Ramsay Burt, 'Concerning the Spiritual in Early Modern Dance: Émile Jaques-Dalcroze and Wassily Kandinsky Advancing Side by Side', *Journal of Dance, Movement and Spiritualities* 1, no. 2 (2014): 251–269 for a discussion on Jaques-Dalcroze and Wassily Kandinsky; and their own writings in J.W. Harvey, Emile Jaques-Dalcroze, M.E. Sadler and M.T.H. Sadler, *The Eurhythmics of Jaques-Dalcroze*, 1st ed. (London: Constable, 1912) and Wassily Kandinsky, *Concerning the Spiritual in Art*, trans. M.T.H. Sadler (New York: Dover, 1914, 1977) and Wassily Kandinsky, 'On Stage Composition', In *The Blaue Reiter Almanac*, translated edition, Klaus Lankheit, ed. (London: Thames and Hudson, 1974) (originally published 1912).

19 Caroline and Charles H. Caffin, *Dancing and Dancers of Today: The Modern Revival of Dancing as an Art* (New York: Dodd, Mead and Co., 1912); John Ernest Crawford Flitch, *Modern Dancing and Dancers* (London: Grant Richards, 1912); Ethel Urlin, *Dancing, Ancient and Modern* (New York: D. Appleton & Co., 1912); Troy and Margaret West Kinney, *The Dance: Its Place in Art and Life* (New York: Stokes, 1914).

20 For detailed accounts of the American and British experiences see Kendall, *Where She Danced*; Alexander Carter and Rachel Fensham, eds, *Dancing Naturally: Nature, Neo-classicism and Modernity in Early Twentieth Century Dance* (Basingstoke: Palgrave Macmillan, 2011).

21 Hans Brandenburg (1884–1958) became resident in Munich in 1911 at a time when the new modern dance was being experimented with by Alexander Sacharoff, Wassily Kandinsky, Clotilde von Derp, Rudolf Laban and others and when artists such as Isadora Duncan performed in the city. He published a range of non-fiction and fiction works during his career, *Der Moderne Tanz* being his fourth book, and the only one specific to the dance. He wrote in support of a German renewal of dance and theatre. In the 1930s, he aligned himself with the National Socialist state and became a member of one of the Third Reich's theatre organisations. See, especially, Laure Guilbert, *Danser Avec Le IIIe Reich. Les Danseurs Modernes Sous Le Nazism* (Paris: Éditions Complexe, 2000) (2011 André Versaille éditeur).

22 In the first edition of *Der Moderne Tanz* of 1913 Brandenburg devotes whole chapters to the Elizabeth Duncan School and the Bildungsanstalt Jaques-Dalcroze at Hellerau Dresden. In chapters on individual dancers he mentions

DOI: 10.1057/9781137439215.0005

the Denishawn School in California. The third 1921 edition included a whole chapter devoted to a range of schools – Elizabeth Duncan, Jaques-Dalcroze, Rudolf Bode, Bess M. Mensendieck, Gert and Dorothee Fikentscher, Free School Community Wickersdorf, Ellen Tels, the Falkes, Magda Bauer, Rohden-Langgaard – as well as a whole separate chapter on Laban's work, including his schools.

23 Hans Brandenburg met Laban in Munich and was associated with him in various ways. He visited Laban in Ascona and co-devised a performance with him there: *Sieg des Opfers* (1914). They corresponded, not least concerning the publication of *Die Welt des Tänzers* and Laban's return to Germany after World War I. They both contributed to *Die Tat* in the early 1920s, met at the Dancers' Congresses, and Brandenburg contributed to Laban's (1934) book celebrating the Third Reich's view of dance, *Deutsche Tanzfestspiele*. See, especially, Guilbert, *Danser Avec Le IIIe Reich*; Marion Kant in Lilian Karina and Marion Kant, *Hitler's Dancers: German Modern Dance and the Third Reich* [Translated from German] (New York: Berghahn Books, 2003), 153, fn. 56.

24 Brandenburg, *Der Moderne Tanz* (1917), 35–44. Dick McCaw gives translations of a non-dated contemporary writing by Brandenburg on Laban's School and a Laban Course prospectus which mentions Brandenburg: Dick McCaw, ed., *The Laban Sourcebook* (Abingdon, Oxon.: Routledge, 2011), 27–30.

25 Caffins, *Dancing and Dancers of Today*; Flitch, *Modern Dancing and Dancers*; Kinneys, *The Dance.*

26 Margaret Newell H'Doubler, *A Manual of Dancing: Suggestions and Bibliography for the Teacher of Dancing* (Madison, WI: Privately Published, 1921); Gertrude R. Colby, *Natural Rhythms and Dances* (New York: A.S. Barnes, 1922); Margaret Newell H'Doubler, *The Dance and Its Place in Education* (New York: Harcourt, Brace and Company, 1925); Margaret Morris, *Margaret Morris Dancing* (London: Kegan Paul, Trench and Trubner, 1925).

27 See, for instance, various voices, including unpublished ones like Madge Atkinson, in Carter and Fensham, *Dancing Naturally.*

28 H'Doubler, *A Manual of Dancing*, 7, 8, 12.

29 Ted Shawn's book on Ruth St Denis was biographical and particular to his wife. See Ted Shawn, *Ruth St Denis: Pioneer and Prophet, Being a History of Her Cycle of Oriental Dances* (San Francisco: John Howell, 1920).

30 Isadora Duncan. 'The Dance and Its Inspiration: Written in the Form of an Old Greek Dialogue', In Rosemont, ed., *Isadora Speaks*, 41–46 (first published in *The Touchstone* 5, no. 2 October 1917).

31 Isadora Duncan, 'The Dance', *Theatre Arts Magazine* (December 1917): 21–22.

32 Ruth St Denis, 'The Dance as an Art Form', *Theatre Arts Magazine* (February 1917): 75–77.

DOI: 10.1057/9781137439215.0005

33 At this time, the periodical was published by Eugene Diederichs of Jena.
 From 1929, it would become a periodical that espoused Nazi ideas and from
 1933 it became an official party publication.

34 The copy referred to, except when referenced to McCaw and Sachsenmaier,
 is the 1922 printing (1922) whose pagination corresponds with Goddard's
 translation. McCaw's pagination from the 1920 edition is very slightly
 different. I am grateful to Gordon Curl for his kind permission to quote from
 S. Goddard's (1966) translation.

35 John Hodgson, *Mastering Movement: The Life and Work of Rudolf Laban*
 (London: Methuen, 2001), 117.

36 Rudolf von Laban, *Die Welt Des Tänzers: Fünf Gedankenreigen* (Stuttgart:
 Walter Seifert, 1922), 1.

37 See Martin Green, *Mountain of Truth: The Counter-Culture Begins. Ascona,
 1900–1920* (London: University Press of New England, Tufts University, 1986);
 McCaw, *The Laban Sourcebook*.

38 Rudolf von Laban, 'Der Moderne Tanz [The Modern Dance]: Umschau
 [Review] Hans Brandenburg'. *Die Tat* 13, no. 2 (February 1922): 865–867.

39 Brandenburg cited in McCaw, *The Laban Sourcebook*, 9 (Letter from Stuttgart,
 29 April 1920 in JHA, Box 26, Folder 23, Item 1.34).

40 Laban, *Die Welt Des Tänzers*, 9 ('Dance Explains Itself Only in Dance', In
 McCaw, *The Laban Sourcebook*, 14–15).

41 Laban, *Die Welt des Tänzers*, 9.

42 Laban, *Die Welt des Tänzers*, 9.

43 Laban, *Die Welt des Tänzers*, 10.

44 Laban, *Die Welt des Tänzers*, 249–250.

45 Hodgson gives an unpaginated translation that stresses that the book is
 designed to give 'a clear indication of the essence of dance and the dancer'.
 See Hodgson, *Mastering Movement*, 118.

46 Rudolf von Laban, *Gymnastik Und Tanz* (Oldenburg: Gerhard Stalling,
 1926); Rudolf von Laban, *Choreographie* (Jena: Diederichs, 1926); Rudolf von
 Laban, *Schrifttanz* (Wien: Universal-Edition, 1928). *Choreographie* is often
 translated as choreography. However, this is not a book on choreography
 in the sense of a dancer's account of the way they make their dancers. It is a
 book that outlines a system of movement study that Laban was devising and,
 as such, is of similar nature to his later books on notation and effort. McCaw
 places it historically very well when he says that 'the title refers to Feuillet's
 Chorégraphie, ou l'art d'écrire la danse' (Choreography, or the Art of Writing
 Dance) published in Paris in 1700, and Laban gives examples from his script
 in his book. *Choreography* could well be *Die Schrift des Tänzers* (The Dancer's
 Script) which was mentioned in *The World of the Dancer* as its forthcoming
 companion piece. McCaw, *The Laban Sourcebook*, 97.

47 H'Doubler, *The Dance and Its Place in Education*.

DOI: 10.1057/9781137439215.0005

48 H'Doubler established the first US dance degree programme at the
 University of Wisconsin in 1926, where she promoted a progressive view
 of dance education following John Dewey, who had taught her at Teacher's
 College, University of Columbia. See, especially, Janice Ross, *Moving
 Lessons: Margaret H'Doubler and the Beginning of Dance in American Education*
 (Madison, WI: University of Wisconsin Press, 2000).

49 H'Doubler, *The Dance*, 7.

50 H'Doubler, *The Dance*, 8.

51 Sachsenmaier, 'Introduction', In McCaw, ed., *The Laban Sourcebook*, 41–45.

52 Valerie Preston-Dunlop, *Rudolf Laban, an Extraordinary Life* (London: Dance
 Books, 1998), 25, 50–51, 64–65; Karen K. Bradley, *Rudolf Laban* (Abingdon:
 Routledge, 2009), 16.

53 McCaw, *The Laban Sourcebook*, 41–68; Preston-Dunlop, *Rudolf Laban*, 64–66;
 Hodgson, *Mastering Movement*, 116–122; Bradley, *Rudolf Laban*, 16; Toepfer,
 Empire of Ecstasy, 101–102; Marion Kant, 'Laban's Secret Religion', *Discourses in
 Dance* 1, no. 2 (2002): 43–62.

54 Kurt Jooss in an interview said that it was Laban's book that had drawn him
 to dance, and to Laban. See Kurt Jooss and Michael Huxley, 'Interviews'
 (unpublished), Kreuth, Germany (1978).

55 Of the women mentioned, one was his second wife and two were his lovers.

56 Laban, *Die Welt des Tänzers*, 254–257.

57 Alexander Sacharoff, 'Bemerkungen Über Den Tanz', *Programmzettel zum
 Tanz-Abend am 21 Jun 1910 in der Münchener Tanhalle* (1910).

58 In *Die neue Schaubühne*, *Die Tat* and *Deutsche Allgemeine Zeitung*.

59 Mary Wigman, 'Rudolf Von Labans Lehre Vom Tanz', *Die neue Schaubühne*
 3, no. 5/6 (1921): 99–106; Mary Wigman, 'Tanz', *Die Tat* 13, no. 11 (February
 1921): 863–865; Mary Wigman, 'Der Tanz Als Kunstwerk', *Deutsche Allgemeine
 Zeitung*, no. 60 (9 March 1921): 57; Mary Wigman, *Die Sieben Tänze Des
 Lebens – Tanzdichtung* (Jena: Diederichs, 1921).

60 Marion Kant, 'The Moving Body and the Will to Culture', *European Review* 19,
 no. 4 (2011): 579–594, 591.

61 Mary Wigman, *A Dance Poem: The Seven Dances of Life* (1921), In Walter
 Sorell, ed., *The Mary Wigman Book: Her Writings* (Middletown, CT: Wesleyan
 University Press, 1975), 73–80.

62 Manning, *Ecstasy and the Demon*, 97–107; Mary Anne Santos Newhall, *Mary
 Wigman* (Abingdon, Oxon.: Routledge, 2009), 113–126.

63 Wigman, *The Seven Dances of Life*, 76.

64 Wigman, *The Seven Dances of Life*, 77.

65 Ruth St Denis, 'An Essay on the Future of the Dance: Ruth St Denis's
 Prophecy', In Shawn, *Ruth St Denis*, 101–116, 105.

DOI: 10.1057/9781137439215.0005

3

We (Dancers) Are Standing at the Beginning

Abstract: *This chapter considers the consolidation of modern dance as a form as evident in modern dancers' writings. It looks at the period 1923–1933 in Austria, Germany, the United Kingdom and the United States of America. Mary Wigman wrote about her new dance and that of her contemporaries, saying that they are standing at the beginning. The beginnings of this new form, and how dancers saw their world, is analysed by reference to the writings of many dancers. They include: Gertrud Bodenwieser, Leslie Burrowes, Isadora Duncan, Valeska Gert, Martha Graham, Doris Humphrey, Kurt Jooss, Elizabeth Selden and Mary Wigman.*

Keywords: modern dance; recognition of form

Huxley, Michael. *The Dancer's World, 1920–1945: Modern Dancers and Their Practices Reconsidered.* Basingstoke: Palgrave Macmillan, 2015. DOI: 10.1057/9781137439215.0006.

DOI: 10.1057/9781137439215.0006

When Mary Wigman wrote of the experience of the dancer, she referred to her own experience and that of her contemporaries – teachers, dancers and students, and looked to the future. In her chapter for Paul Stefan's 1926 survey of *Tanz in Dieser Zeit* (Dance in Our Time) she talked of 'we dancers'.[1] She went on to say that 'an entire world of dance experiences is spread out before us, and our time is ready for the [new] dance'.[2] It was in this sense that Wigman said that 'we are standing at the beginning'.[3] She sees this as an exciting opportunity for dancers. She was talking from her own experience of the previous period of experiment and including others in her vision for the future of dance. This chapter considers how those dancers who are now becoming known as modern dancers begin to talk of their dancing experience, those whom they teach and those they perform with and the new dance form that they were crafting for themselves. A number of such dancers coalesce around the practices of 'modern dance', however and wherever they describe them. They are as diverse as Gertrud Bodenwieser, Isadora Duncan, Valeska Gert, Doris Humphrey, Elizabeth Selden and Wigman.

During the period 1923–1933, there was a rapid development in the practices of the new modern dance, most especially in Germany, Austria and the United States of America. Dancers who were already established opened, or re-opened, further schools and their pupils followed in their footsteps. Thus, in Europe, Laban opened a number of schools and by 1927 there were Laban schools in no less than 18 German towns and cities as well as Basle, Prague and Zurich. These included schools run by Hertha Feist and Albrecht Knust. His most noted pupil of the earlier period, Mary Wigman, who had opened her Dresden School in 1920 followed with a school in Berlin. In America Martha Graham opened her own school in 1927 followed by Doris Humphrey and Charles Weidman the following year. The dance companies from the earlier period began to tour internationally. Dancers from Germany and Austria visited and later settled in the United Kingdom and the United States of America and young men and women began to visit Germany in particular to undertake courses. This was the period when the first major dancers' organisations were formed, notably in Germany, and dancers discussed their ideas at congresses in Germany and the United States of America, and in print.[4] It was a period of political turmoil in both Europe and the United States of America and the year 1933 marks the coming to power of the NSDAP in Germany and Adolf Hitler's assumption of leadership.[5]

DOI: 10.1057/9781137439215.0006

In the 1920s, dancers began to write extensively in both Europe and the United States of America. Wigman, for instance, was published in 12 different periodicals and in a book between 1920 and 1930 alone. They wrote of their own practice and what was beginning to be termed modern dance. In the period under consideration, dancers' writings made a significant contribution to the way the new modern dance was conceived: they helped to define the discourse. The scope of discussion was wide and included the dance as festival, dance as education, dance on the theatre stage, dance composition, dance theory, dance notation, dance and community and the role of dance for the modern woman.[6] In the early 1920s, they made contributions to a variety of journals to extol the virtues of their practices. These are indeed varied and include those that normally catered for art, music, theatre, on the one hand, and various approaches to body culture, including naturism, on the other. It was in this period that dance began to be represented more in its own publications including dancers' own journals such as the short-lived *Denishawn Magazine* and more mainstream periodicals such as *Der Tanz*.[7]

Wigman's writings continued some of the universal vision of Rudolf Laban, Ruth St Denis and Duncan,[8] but in these there is more of her own direct experience of being a practising dancer and teacher. Wigman acknowledged her teacher Laban throughout the 1920s.[9] However, her writing differs from his in the way she speaks as a dancer and, in doing so, includes other dancers in the way she talks about the new modern dance.[10] Many of these ideas are to be found later that year, 1927, in Wigman's *Dancing Times* article on dance and modern woman.[11] Her performing career was in its 12th year and she had just premiered the second version of *Witch Dance*. She identifies an enthusiasm for the activity of dancing in a wide range of young women who come to it for a variety of reasons, but for whom the modern dance is a valid contemporary form. She describes a cross-section of her contemporaries:

> To many it is an emotional outlet. To some, and mainly to those whose work lies in other directions, it is relaxation and inspiration, a delivery from the monotony of routine. To others again it comes as a solace, and they endeavour to find some consolation in it. And among numerous other reasons there remains the aspect of escape from care or trouble. Among this motley, restless and eager crowd seeking to place their longings through dancing, we sometimes find the really gifted dancer who discovers in this medium her vocation.[12]

DOI: 10.1057/9781137439215.0006

For all of them:

> The solution is in the dance, in the pure delight of movement which is the overflow of abundant vitality and is independent of all but physical appreciation.[13]

In the same year Wigman took the opportunity to write an extensive summary of the state of modern dance in Germany from her point of view. She stresses the importance of modern dance as a dance of its time, which is supplanting the ballet. Much of what she writes about describes the situation in Germany in 1927, but without mentioning individuals or companies. She talks about 'the choreographer' with reference to ballet and to the German theatre system. Here, she stresses the need for the choreographer to have the same level of training as a conductor in the field of music. Later, she refers to herself as 'a dancer and choreographer' and sums up the contemporary situation in concluding that 'our dance is born of our age and its spirit, it has the stamp of our time as no other art form has.'[14] Such statements are consistent with similar claims by contemporary modernist artists in other forms. The following year, Wigman again contributed to *The Dancing Times* and told of how dancers in German were rejecting ballet for the modern dance:

> They feel in their calling the possibilities for expressing their own being and, more than that, an artistic ideal in which they believe and for which they stand. Dancing, for them, is a living language which speaks directly to all mankind without any intellectual detours. The mediator of this language is the human body, the instrument of the dancer.[15]

That is to say the new modern dance allows people, especially women, to find themselves and to identify with wider values embodied by modern dance. *The Dancing Times* had just started to publish articles by European modern dancers, the earliest of these being by the Austrian Gertrud Bodenwieser in 1926. Like Wigman, she stressed the individual educational opportunities afforded by modern dance.[16]

A quarter of a century after *The Dance of the Future*, Isadora Duncan had another vision that was published in *The New York Herald-Tribune* the month after her untimely death in Nice, France and later republished as part of her autobiography, *My Life* (1927):

> I see America dancing, beautiful, strong, with one foot poised on the highest point of the Rockies, her two hands stretched out from the Atlantic to the Pacific, her fine head tossed to the sky, her forehead shining with a crown of a million stars.[17]

DOI: 10.1057/9781137439215.0006

> Let them [American children] come forth with great strides, leaps and bounds, with lifted forehead and far-spread arms, dancing the language of our pioneers, the fortitude of our heroes, the justice, kindness, purity of our women, and through it all the inspired love and tenderness of our mothers. When the American children dance in this way, it will make of them Beautiful Beings worthy of the name of Democracy. That will be America dancing.[18]

This vision is one that rejects the 'inane coquetry' of the European ballet ('inane' in the autobiography, 'servile' in the essay).[19] Sadly, it is one that is also prefaced by and dependent on the exclusion of African dance:

> And this dance will have nothing in it either of the servile coquetry of the ballet or the sensual convulsion of the South African negro. It will be clean.[20]

Duncan could not have been more explicit in the sort of American dance she envisaged.

In 1930, two other American dancers contributed to Oliver Sayler's extensive compilation *Revolt in the Arts*. Elizabeth Duncan wrote of the school that she and her recently deceased sister Isadora had founded and of the practices of Greek dancing that seemed to look to the past. Martha Graham, on the contrary, issued a challenge that looked to the future.[21] Graham, in 'seeking an American Art of the Dance', asked that the American dance distance itself from an unquestioning adherence to European culture. She was writing four years after founding her own dance group but before the new German dance of Wigman and Harald Kreutzberg was seen in performance in the United States of America. She allies herself with the other American dancers of Dance Repertory Theatre[22] mentioning Agna Enters, Doris Humphrey, Helen Tamiris and Charles Weidman. She places herself firmly as a concert dancer who is striving to make dance an art; in terms of a wider context she says:

> It is through the individual that the new must come, the emancipation of the individual, and it is in that state of individualism that the American dance finds itself today.[23]

The idea of the dancer as an individual is an important one and is particular to this period. The place of the individual in American dance will be challenged in the following decade by those who sought a new dance form based on collective action. Graham is clearly writing from her point of view as a practising dancer, but in this article she has little to say about the details of that practice. In contrast, her peer Humphrey began to write in a way that sought to articulate a basis for her practice.

DOI: 10.1057/9781137439215.0006

In 1929, she wrote about technical training for the recently launched *Dance Magazine* and in 1932 she asked the question 'what shall we dance about?' In this brief article she laid down some of the ideas that would, much later, be formed into her book *The Art of Making Dances*.[24] It was here that she first talked about the dancer's experience as a basis for making dance. Significantly, she wrote about what to dance about, *not* what to choreograph.

> There is only one thing to dance about: the meaning of one's personal experience and this experience must be taken in its literal sense as action, and not as intellectual conception.[25]

There is a different emphasis in Wigman's approach to making dance, clearly laid out in English for the American magazine *Modern Music* in 1931, to coincide with her tour.[26] Wigman was asked to write about the relationship of dance and music. Her article 'Composition in Pure Movement' does so, but goes beyond that brief. It is noticeable that she talks of composition and creating dance, not choreography. The following passage gives a clear and sophisticated account of the 'inner' life that motivates her dances:

> Each dance is unique and free, a separate organism whose form is self determined.
>
> Neither is my dancing abstract, in intention at any rate, for its origin is not in the mind. If there is an abstract effect it is incidental. On the other hand my purpose is not to 'interpret' the emotions. Grief, joy, fear, are terms too fixed and static to describe the sources of my work. My dances flow rather from certain states of being, different stages of vitality which release in me a varying play of the emotions, and in themselves dictate the distinguishing atmospheres of the dances.[27]

She goes on to talk about the inspiration for some of her recent dances – *Festlicher Rhythmus* (1929), *Pastorale* (1929)[28] and *Totenmal* (1930). Thus, applying her sense of 'state of being' as described, she says of *Pastorale* that 'out of a sense of deepest peace and quietude I began slowly to move my arms and body'.[29] The music followed the state that inspired the movement.

Two years later, Wigman wrote about group composition in an eponymous chapter for Rudolf Bach's collection *Das Mary Wigman-Werk*. She talks of group dance in terms of '*regie*', usually translated as 'direction'. When the chapter was republished in English in *The Mary Wigman Book*,

DOI: 10.1057/9781137439215.0006

Walter Sorell translated *regie* as 'choreography'. Similarly, 'Der regisseur' became the 'choreographer' (1973: 129–131).[30] Wigman says:

> Whether the dancer moves as a soloist in his own creations, or plays his instrument in the orchestra of moving bodies, he always is, above all, servant to a work of art. This is the only and eternal law under which the dancer lives his entire life. The visual dance image of the one becomes a realization through the co-creation of the many out of a living multiplicity again emerges the oneness of the original conception: this is the essence of group composition in the dance.[31]

> But from the very first moment of the creative process the demands made on a group are different from those made on a soloist. What would have been an unambiguous demand on the one who creates, we face the ambiguous demands of the living material of the many...What distinguishes the orchestration of a dance group from an orchestra of musical instruments is the fact that each dancer is a co-creator and does not read his part from a score. The works breath vibrates in such a mutual act of creativity.[32]

Later, she employs the following analogy:

> A dance creation cannot be made, it must grow, and the choreographer [director] needs the patience of a gardener.[33]

Wigman gives an interesting account of group composition here which suggests an organic process rather than the more didactic one of academic ballet choreography of the time. It seems to be in contrast to the approach used by American artists of the early 1930s and may in part account for some of the perceived differences in approach that are remarked on later by Hanya Holm.[34]

Wigman talks in her 1931 essay about dance composition without categorisation, without being partisan, and with no reference to it being German. Both Graham and Humphrey wrote about the American dancer, rather than the modern dancer. It is in this sense that Humphrey asks that American dancers do not try to dance like 'the Germans' because in doing so he 'turns away from his known experience to the unknown'.[35]

The question of what is meant by 'experience' is crucial. For Humphrey and for Graham at this time it was primarily their lived experience, the former preferring the concrete to the imagined. For Selden, it was an 'inner necessity'. For Wigman, as we have seen, it was about calling on a state of being. Indeed, for many of the German dancers experience was described in terms of their emotional experience or inner life.[36] For instance, Laban, writing on composition, said:

DOI: 10.1057/9781137439215.0006

Like every other artist, the dancer has the desire to communicate an idea arising from his inner life. Only this does not occur in words, in three-dimensional shapes, or in painting, but in a means of expression which is the dancer's own, that is in the movement of one or more human bodies.[37]

Noticeably, like Humphrey, Laban talked here of the dancer, not the choreographer. Other German dancers wrote in a similar vein: Valeska Gert, in an interview in the same journal, talked of the way the modern dancer had given 'visible expression to his innermost feelings' in a way comparable to theatre.[38] She illustrated this by reference to her own dances, especially *Kanaille* (The Dregs).[39] She places her work as part of a modern dance that is making a transition from an old to a new form of theatre and concludes in a way that mirrors Humphrey's contemporaneous idea about the experience of the dancer: 'I believe that any artist can only create in the context of his own period. He is entwined within it'.[40] She talks of her own dancing as follows:

> I am not interested in presenting a particularly artistic arrangement of movements. I only use the most basic and easiest of steps. If one takes the body and its own laws as a starting point, the result will be a dance in which the actions have grown out of each other. However, if one wants to create from the depths of one's spirit and soul, one should not simply develop one movement out of another. Also, I do not believe that by simply devising a skilful sequence of movement one can reveal one's soul.[41]

Gert and Wigman expressed rival views of what the new modern dance should be and Gert criticised Wigman for her conservative, bourgeois approach to the modern dance in one of Germany's new cultural magazines.[42]

Wigman's performances in London (July 1928) and her first tour to the United States of America (1930–1931) caused considerable interest, and a number of British and American dancers and teachers began to travel to Dresden to the Mary Wigman School. Two dancers/teachers trained at the Wigman School in Dresden articulated the modern dance or 'new' dance as a *transatlantic* phenomenon during this period – Elizabeth Selden, writing in Connecticut, United States of America, and Leslie Burrowes, writing in London, England.

Selden was one of the first dancers to articulate the changing nature of the modern dance in the United States of America.[43] She had begun writing about the new dance emerging from Germany in 1929 in an article which outlined the work of Laban, Wigman, Émile Jaques-Dalcroze

DOI: 10.1057/9781137439215.0006

and others in a historical account a year before Wigman's first US tour.[44] Her first book on the new dance was published in 1930 and it is here, in *Elements of the Free Dance*,[45] that she writes as a practitioner trying to make sense of the changing nature of the dance she is working with. Her book is about the 'Free Dance' or the 'New Dance' (Selden's capitalisation). In a helpful glossary she attempts to define 'free dance', 'expressionist dance', 'Greek forms', 'modernistic dance' and 'natural dancing' to name but five. In this book she defines free dance as encompassing all forms that break away from the previous 'fixed forms', beginning with Duncan and including both 'Grecian forms' on the one hand and 'Expressionism' on the other.[46] In her later (1935) book she is less equivocal about the term modern dance: here she equates 'modernistic dance' with 'expressionistic dancing'.[47] In her first section 'The Inner Necessity' she has a chapter on 'The Dancer' and here she attempts to articulate a dancer's inspiration:

> The Dance shares with all art the aim of projecting an inner vision into the world without.[48]

She goes on to try and speak of the difficult task that 'New Dancers' have when creating dance for themselves:

> The moment comes when he is alone with himself. Now he must create. For many there begins a frantic search for the things that *are*. As if *creating* did not mean bringing up from the bottom of the soul the things that *have not yet been*. They go to 'find' what has already been enjoyed. Their own mind does not speak to them. – But the Dance is the silent language of the soul! What will you speak of, Dancers, if you cannot speak for yourselves?[49]

The significance of Selden's writing is considerable, not least in its absence from the canonical dance literature. Whilst it cannot be claimed that she was in any way a major dancer, she was the first modern dancer to have her ideas about the experience of the new modern dance published in book form in English.[50]

The British dancer Leslie Burrowes wrote about her experiences at the Dresden Wigman School.[51] In many ways, Burrowes's practice and writing – both published and unpublished – act as a useful focus for a number of themes that run through this period. She was a young dancer who had originally trained with an English exponent of natural dancing, Margaret Morris, and was teaching at Dartington Hall in Devon, United Kingdom. She was seeking a new, modern approach to dance and travelled to Wigman's Dresden school to find it. In this, she was a pioneer

DOI: 10.1057/9781137439215.0006

of what was to become a growing trend amongst young women of the period.

Numerous British dancers and teachers visited the Dresden Wigman School in the 1930s and Burrowes, exceptionally, left extensive documentation about her time there. Burrowes travelled to Dresden in January 1930 and left in September 1931 after graduating. She returned regularly in 1933, 1934, 1935 and 1937. She first wrote of her experience in January, shortly after her arrival. A letter dated 6 May 1930, over half a year into her course, gives considerable insight into both Wigman's practice and her own and the differences between the two. She begins by saying how the Wigman training lacked 'technique' and this is a theme that runs through her letters. By this she seems to mean that there is not a class with regular repeated and progressive sequences where phrases are learned and corrected. She goes on to explain Wigman's approach and her response as follows:

> I am terribly glad I have my technique and background, for without that I certainly could be nowhere. One learns no technique here, and those who have got on and can dance as they like have mostly had some kind of gymnastic training before. So with this good fundamental basis of being sure of my body, I find that I now have to use it as an invaluable instrument capable, or should be, of what I want to use it for. Mary's first criticism of me was that I was born a dancer. I am an artist, but she felt that what I expressed was not myself, my temperament being out of sympathy or harmony with my dances; and this broke and shattered my movements so that one could not believe in what I was dancing.
>
> I then worked out a new dance, purely from expression and how the feeling moved me, letting form go after; this she said was a great change and was myself. So I saw that at this moment I must work from the inside out. That is the idea here, and very lovely for me at this period to have such a belief in the feeling of an expression, that the body responds.[52]

Burrowes corresponded with Wigman frequently in the ensuing years. This passage gives a fine indication of how Burrowes had to let go of her idea of what it was to be a dancer and find the inner experience that Wigman asked her to draw on. Just over two years later Burrowes wrote an article for *The Dancing Times* where she tried to articulate the new modern dance for a British readership, defending it against English critics. In 'The Modern Dance Movement in England'[53] she talked of Germany *and* the United States of America *and* the United Kingdom, and of the dancers Wigman, Kreutzberg and Graham. Interestingly, she

DOI: 10.1057/9781137439215.0006

defends the new 'modernist' dancers – naming Wigman, Kreutzberg *and* Graham – against accusations that they have no technique. She goes on to explain that whereas the dancer may begin with improvisation as a means of exploring the inner self, they then go on to form this compositionally to strike a 'poise' between 'subconscious "romantic forces" and the demands of conscious "classic" form: this poise is attained not by accident, but by what the Germans call "Vorgang" – that is a development or progression, of both the inner experience and the rhythmic form.'[54] Burrowes went on to develop these ideas in her English performing and teaching, and we will return to them in the following chapters.

Burrowes was published in January 1933, the month that the Nazi party, the NSDAP, took power in Germany. Her teacher, Wigman, was on tour in the United States; Wigman was published in an article in the new American journal *Europa*, where she laid out her 'philosophy of modern dance'.[55] Between 1929 and 1933, Wigman was published in at least 11 journals, from mainstream publications[56] to those aligned with National Socialism, such as *Völkische Kultur*. She wrote about the dancer, the modern dance, dance and the theatre, her compositional methods, about her large-scale 1930 work with Albert Talhoff, *Totenmal* and about the new German dance.[57] Wigman's place in Nazi Germany continues to be debated hotly with reference to her actions, her allegiances, her published and her unpublished writings. She can be read as a particularly pertinent example of how dancers were deeply involved in the political context within which they worked, as can be found in the analyses by Manning and Kant in particular. Kant draws our attention to the considerable correspondence with the Nazi state and the way she accommodated to the new regime and to its inherent racist ideology.[58] Her published writings have been analysed to show political changes during this period. As we shall see in the following chapter her writings in English about the new German dance in the mid-1930s were at odds with what she espoused in Germany. Susan Manning suggests that Wigman's ideas can be read as developing in a way that will become sympathetic to National Socialism. She identifies Wigman's article 'Der Tanzer und das Theater' as showing evidence of reactionary ideas that are to be found in National Socialism, notably the importance of the *Volk* in preference to that of the individual.[59] Her predominant publicly expressed concern was for dancers and what she continued to refer to as the modern dance. In 1930, she wrote a piece of personal rhapsodic prose titled 'The Dancer' for the Wigman community journal *Tanzgemeinschaft*.[60] It describes her experience of

DOI: 10.1057/9781137439215.0006

dancing as a solo artist, evoking *Monotonie I* and *II* (*Drehmonotonie*) of 1926 in particular. The writing is in five parts – The Feet, The Turning, The Leap, The Circle, The Space – and speaks of dancing as a heightened state. It is intensely personal. Walter Sorell's (1975) translation stresses the rhapsody of a dancer suffused with the success of the moment, and suggests that some of the writing was first published in 1920.[61] Sabine Huschka's more recent translation deliberately acknowledges the historical moment and errs on the side of a reading that places this writing in a lineage leading up to Wigman's embrace of National Socialism.[62] Wigman, in Sorell's translation, describes 'Turning' as follows:

> In the center of the stage the dancer turns with steps small and rapid, spinning around herself. Increasingly rapid grow the steps, higher and higher stretch the tips of the toes, greater and greater grows the tension of the body. Now she spins incredibly fast around herself. Suddenly something mysterious occurs: she rises from the ground, remains as if still in the air, as if floating in quiet suspense.

In Huschka's translation,

> She turns in the middle of the room with small, rapid steps, round and round herself. The steps become faster, she is stretched further over tiptoe, her body becomes tenser. Racing now she turns around her own center. Suddenly, a strange thing happens; she rises above the ground, stands still in the air, hovers calmly.[63]

When Wigman looked beyond herself, as she did in her 'Philosophy of Modern Dance', published in English in the United States of America in 1933,[64] she still stressed the inner experience of the dancer as the key to modern dance performance:

> The primary concern of the creative dancer should be that his audience not think of the dance objectively, or look at it from an aloof and intellectual point of view, – in other words, separate itself from the very life of the dancer's experiences; the audience should allow the dance to affect it emotionally and without reserve.[65]

For her, the modern dance was 'the expression of youth and of today, and it is as positive in its expression as all the other modern arts.'[66] This echoes her earlier 1927 ideas of the dance and the modern woman. The modern dance differed from ballet, which could no longer deal with great inner emotions and the subjects of today.

DOI: 10.1057/9781137439215.0006

The new modern dancers all distanced themselves from ballet in one way or another, whether they were attempting to establish a modern American dance or modern dance in Germany. For Duncan, 'The real American type can never be a ballet dancer'[67] and for Graham the new American art of dance required dancers to 'shun the imperialism of the ballet'.[68] Notwithstanding the political turn that Wigman took, made explicit after her return from the United States in 1933, her antipathy to ballet at this time was written in terms of the form and the dancer. She reflected on the last two decades as follows:

> The ballet had reached such a state of perfection that it could be developed no further. Its forms had become so refined, so sublimated to the idea of purity, that the artistic content was too often lost or obscured. The great 'ballet dancer' was no longer a representative of a great inner emotion, (like the musician or poet) but had become defined as a great virtuoso.[69]

Kurt Jooss gave his views on 'the dance of the future' at the time of Ballets Jooss's first London season at the Savoy Theatre in 1933, where they showed *The Green Table* in England for the first time. He went along with the sort of criticism of ballet typified by Wigman, and indeed Graham, but distinguished himself from other modern dancers of the period by rejecting the formlessness of much German modern dance:

> My objections to the two present forms of the dance are that the Classical Ballet ignores the emotions and remains simply a play with outward forms, while the so-called Central European Dance has practically no outward form and only considers the emotions.[70]

His interview focused on the new training that a dancer would need, drawing on the example of his own school, which was in the process of going into exile at Dartington Hall. He talked approvingly of what ballet might be able to contribute, although the reality differed somewhat.[71]

Jooss's view on how he worked with his dancers is most revealing. During the 1930s he danced much less because of an injury sustained in 1927, but he had continued to create roles for himself, not least as Death in *The Green Table* (1932). In this interview he reveals a process of making dances that continued through his exile in England,[72] and which he reiterated 14 years later in an interview with Fernau Hall, again in *The Dancing Times*.[73] Interestingly, Jooss, speaking at the start of his period of exile from Nazism, anticipated some of the ideas on composition, group work and democracy that Humphrey was later to articulate as part of her response to the political situation in 1936.[74] He had already distanced

DOI: 10.1057/9781137439215.0006

himself geographically and intellectually from the new German regime, from the dancers who chose to work with it and from their writings. The dancer's world at the end of this period was quite different from that of 1920. There was less of a universal optimistic vision of modern dance than there had been when Wigman talked about a new beginning. In some dancers' practices and writings there was acquiescence to reactionary and authoritarian ideas. However, there were also new approaches that emerged from the cultural ferment of the early 1930s, and these bore fruit in both the United States of America and the United Kingdom, in different ways. This shift of emphasis will be considered in the next chapter.

Notes

1 Mary Wigman, 'Tänzerisches Schaffen Der Gegenwart', In Paul Stefan, ed., *Tanz in Dieser Zeit*, 5–7 (Wien: Universal-Edition, 1926), translated by Walter Sorell as Mary Wigman, 'We Are Standing at the Beginning', In Walter Sorell, ed. and trans., *The Mary Wigman Book: Her Writings Edited and Translated*, 81–85 (Middletown, CT: Wesleyan University Press, 1926, 1975). Sorell took his title from the opening of her third paragraph – 'Wir stehen am Anfang' (1926, 5). A possible translation for Wigman's chapter would be 'Dance Creations of the Present'.

2 Wigman, 'We Are Standing at the Beginning', 82. Sorell added the 'new' to the translation.

3 Wigman, 'We Are Standing at the Beginning', 81.

4 This and the following period tend to be the most widely discussed. A great deal of the literature considers the situation in Germany in relation to the rise of Nazism, followed by those that relate the development of dance in the United States of America. A few accounts detail modern dance as a transatlantic phenomenon and there are very few that consider the modern dance in the United Kingdom. Much of the literature is focused on individual artists and often, especially in the case of Manning, these give a detailed picture of the broader context too. See Jack Anderson, *Art without Boundaries: The World of Modern Dance* (London: Dance Books, 1997); Ramsay Burt, *Alien Bodies: Representations of Modernity, 'Race', and Nation in Early Modern Dance* (London, New York: Routledge, 1998); Carter and Fensham, *Dancing Naturally*; Lynn Garafola, ed., *Of, by, and for the People: Dancing on the Left in the 1930s* (Madison, WI: Society of Dance History Scholars at A-R Editions, 1994); Ellen Graff, *Stepping Left: Dance and Politics in New York City, 1928–1942* (Durham: Duke University Press,

1997); Guilbert, *Danser Avec Le IIIe*; Lilian Karina and Marion Kant, *Hitler's Dancers: German Modern Dance and the Third Reich* [Translated from German] (New York: Berghahn Books, 2003); Susan Manning, *Modern Dance, Negro Dance: Race in Motion* (Minneapolis: University of Minnesota Press, 2004); Susan Manning, *Ecstasy and the Demon: The Dances of Mary Wigman*, new ed. (Minneapolis: University of Minnesota Press, 2006); Susan Manning and Lucia Ruprecht, eds, *New German Dance Studies* (Urbana: University of Illinois Press, 2012); Hedwig Müller, *Mary Wigman: Leben Und Werk Der Grossen Tänzerin* (Berlin: Quadriga, 1986); Larraine Nicholas, *Dancing in Utopia: Dartington Hall and Its Dancers* (Alton: Dance Books, 2007); Valerie Preston-Dunlop, *Rudolf Laban, an Extraordinary Life* (London: Dance Books, 1998); Dee Reynolds, *Rhythmic Subjects: Uses of Energy in the Dances of Mary Wigman, Martha Graham and Merce Cunningham* (Alton: Dance Books, 2007); Janice Ross, *Moving Lessons: Margaret H'Doubler and the Beginning of Dance in American Education* (Madison, WI: University of Wisconsin Press, 2000); Patricia Stöckemann. *Etwas Ganz Neues Muß Nun Entstehen: Kurt Jooss Und Das Tanztheater* (München: K. Kieser, 2001); Karl Toepfer, *Empire of Ecstasy: Nudity and Movement in German Body Culture, 1910–1935* (Berkeley: University of California Press, 1997).

5 The NSDAP (Nationalsozialistische Deutsche Arbeitpartei – National-Socialist German Workers Party) gained the most seats in the German Reichstag in the elections of November 1932 with 33% of the popular vote. Adolf Hitler was appointed Reich chancellor on 30 January 1933 and this post and that of president were merged and confirmed by referendum on 19 August 1934, making Hitler *Führer* of Germany and de facto supreme leader of the Third Reich. There is a vast literature on the politics of this period and on the Third Reich in particular. There is an excellent brief overview, with key documents, at http://germanhistorydocs.ghi-c.org/chapter. cfm?subsection_id=93. For books that put the situation in a broader global context, I favour Niall Ferguson, *The War of the World* (Harmondsworth: Penguin, 2007), which contains a substantial bibliography and David Reynolds, *The Long Shadow: The Great War and the Twentieth Century* (London: Simon & Schuster, 2013).

6 See select bibliography of dancers' writings for examples.

7 See select bibliography of dancers' writings.

8 Her American contemporaries Isadora Duncan and Ruth St Denis erred on the side of hyperbole when writing about the dancer and the future. St Denis, writing in 1924, talks of the dancer as 'one who expresses in bodily gesture the joy and power of his being', but writes of the dancers' world in a way similar to Wigman when she says that 'we dancers today are struggling and sacrificing so that at some precious hour in the future we may live!'. See Ruth St Denis, 'The Dance as Life Experience', In Jean Morrison Brown, ed.,

DOI: 10.1057/9781137439215.0006

The Vision of Modern Dance, 22–25 (London: Dance Books 1924), 22 (first published in *Denishawn Magazine* 1, no. 1 (1924): 1–3).

9 From her 1921 article to her 1929 celebration of his work on the occasion of his birthday: Mary Wigman, 'Rudolf Von Labans Lehre Vom Tanz', *Die neue Schaubühne* 3, no. 5/6 (1921): 99–106; Mary Wigman, 'Rudolf Von Laban Zum Geburtstag', *Schrifttanz* 2, no. 4 (1929): 65–66.

10 Mary Wigman, 'Stage Dance – Stage Dancer', In Walter Sorell, ed. and trans., *The Mary Wigman Book: Her Writings Edited and Translated*, 107–115 (Middletown, CT: Wesleyan University Press, 1927, 1975), 112 (originally published in 'Das Deutsche Kulturtheater', *Magdeburg Tageszeitung* 15 May 1927).

11 Mary Wigman, 'The Dance and Modern Woman', *The Dancing Times* (November 1927), 162–163.

12 Wigman, 'The Dance and Modern Woman', 163.

13 Wigman, 'The Dance and Modern Woman', 163.

14 Wigman, 'Stage Dance – Stage Dancer', 115.

15 Mary Wigman, 'The Central European School of Dance (2)', *The Dancing Times* (December 1928), 324.

16 Gertrud Bodenwieser, 'Dancing as a Factor in Education', *The Dancing Times* (November 1926), 169, 71. Bodenwieser, an Austrian dancer, performed in London and Manchester England in 1929 and a number of her pupils taught in the United Kingdom. She went on to establish modern dance in Australia. For details of her career see Shona Dunlop MacTavish, *An Ecstasy of Purpose, the Life and Art of Gertrud Bodenwieser* (Dunedin, New Zealand: Shona Dunlop MacTavish, Les Humphrey and Associates, 1987); Bettina and Charles Vernon-Warren, eds, *Gertrud Bodenwieser and Vienna's Contribution to Ausdruckstanz* (Amsterdam: Harwood Academic, 1999).

17 Isadora Duncan, 'I See America Dancing', In Sheldon Cheney, ed., *The Art of the Dance by Isadora Duncan* (New York: Theatre Arts Books, 1928, 1969) (from the original Ms Cheney, 145) (first published in the New York *Herald-Tribune*, 2 October 1927).

18 Duncan, 'I See America Dancing', 50.

19 Isadora Duncan, *My Life*, 11th ed. (London: Victor Gollancz Ltd, 1928, 1936), 359; Duncan, 'I See America Dancing', 49.

20 Duncan, 'I See America Dancing', 49.

21 Elizabeth Duncan, 'Nature, Teacher of the Dance', In Oliver M. Sayler, ed., *Revolt in the Arts*, 245–248 (New York: Brentano's, 1930); Martha Graham, 'Seeking an American Art of the Dance', In Sayler, *Revolt in the Arts*, 249–255.

22 Formed 1929–1930 season by Helen Tamiris.

23 Graham, 'Seeking an American Art of the Dance', 253.

24 Doris Humphrey, 'Interpretor or Creator?', In Selma Jeanne Cohen, ed., *Doris Humphrey: An Artist First*, 250–252 (Middletown, CT: Wesleyan

DOI: 10.1057/9781137439215.0006

University Press, 1929, 1972) (first published in *Dance Magazine*, January 1929); Doris Humphrey, 'What Shall We Dance About?', In Cohen, *Doris Humphrey*, 252–254 (first published in *Trend: A Quarterly of the Seven Arts*, June–July–August 1932); Doris Humphrey, *The Art of Making Dances* (New York: Grove, 1959).

25 Humphrey, 'What Shall We Dance About?', 252.

26 There was considerable discussion in the US dance press at this time, including *The Dance Magazine* survey of 13 dancers' views on 'the German dance' following Wigman's first US tour. See Louise Brown et al., 'What Dancers Think about the German Dance', *The Dance Magazine of Stage and Screen* 16, no. 1 (May 1931): 14–15, 63, 64.

27 Mary Wigman, 'Composition in Pure Movement', *Modern Music* 8, no. 2 (January/February 1931): 20–22, 20.

28 These first two dances were part of the seven-part *Shifting Landscape* cycle. For detailed discussions of *Pastorale* see Manning, *Ecstasy and the Demon*, 140–146; Reynolds, *Rhythmic Subjects*, 83–89.

29 Wigman, 'Composition in Pure Movement', 22.

30 Mary Wigman, 'Group Dance/Choreography', In Walter Sorrel, ed. and trans., *The Mary Wigman Book: Her Writings Edited and Translated*, 129–131 (Middletown, CT: Wesleyan University Press, 1927, 1975); (originally published as 'Gruppentanz/Regie', In Rudolf Bach, ed., *Das Mary Wigman Werk* (Dresden: Carl Reissner, 1933), 45–47).

31 Wigman, 'Group Dance', 129.

32 Wigman, 'Group Dance', 130.

33 Wigman, 'Group Dance', 131.

34 See Chapter 4.

35 Humphrey, 'What Shall We Dance About?', 253.

36 Whilst this basis for making dance is less common in the twenty-first century it was a predominant way of thinking in the 1930s and consistent with ways of thinking about other art forms. See, especially, R.G. Collingwood's contemporary account of artists and art making: R.G. Collingwood, *The Principles of Art* (Oxford: Clarendon Press, 1938; repr. 1958).

37 Rudolf von Laban, 'Dance Composition and Written Dance', In Valerie Preston-Dunlop and Susanne Lahusen, eds, *Schrifttanz a View of German Dance in the Weimar Republic*, 38–39 (London: Dance Books, 1990) (originally published in *Schrifttanz* 1, no. 2 (October 1928): 19–20).

38 Valeska Gert, 'Dancing (from a Talk Given at Radio Leipzig)', In Preston-Dunlop and Lahusen, eds, *Schrifttanz* (originally published *Schrifttanz* 4, no. 1 (June 1931)).

39 Gert, 'Dancing', 14.

40 Gert, 'Dancing', 16.

DOI: 10.1057/9781137439215.0006

41 Gert, 'Dancing', 14.

42 Valeska Gert, 'Mary Wigman und Valeska Gert', *Der Querschnitt* 6, no. 5 (1926): 361–362.

43 Elizabeth Selden was a European dancer who had trained with Laban, Wigman and others; she taught for five years at the Bennett School, Millbrook, New York City, and then lectured and performed at Berkeley, California. She wrote two books on the modern dance. After World War II she returned to Germany on the staff of the Education Branch of the US military government in Germany, as part of the denazification programme. She maintained contact with Wigman and is mentioned in one of Wigman's letters to Holm of 1958: Claudia Gitelman, ed., *Liebe Hanya: Mary Wigman's Letters to Hanya Holm* (Madison, WI: University of Wisconsin Press, 2003), 153. An account of her writings interpreted as a 'dance theory' is given in Judith B. Alter, *Dance-Based Dance Theory: From Borrowed Models to Dance-based Experience* (New York: Peter Lang, 1991).

44 Elizabeth Selden, 'The New German Credo', In *The Dancer's Quest*, 25–32 (Berkeley: University of California Press, 1935) (first published in the *New York Evening Post*, January 1929).

45 Selden, *Elements of the Free Dance.*

46 Selden, *Elements of the Free Dance*, 154.

47 Selden, *Elements of the Free Dance*, 157.

48 Selden, *Elements of the Free Dance*, 6.

49 Selden, *Elements of the Free Dance*, 12–13.

50 And by a major reputable US publisher: A.S. Barnes of New York.

51 Larraine Nicholas recounts Burrowes's career and her visits to the Wigman School as described in her letters to Dorothy Elmhirst of Dartington Hall: Larraine Nicholas, 'Leslie Burrowes: A Young Dancer in Dresden and London, 1930–34', *Dance Research* 28, no. 2 (2010): 153–178. My references are to the original documents held in the NRCD, University of Surrey. Burrowes trained with Margaret Morris at her London school in 1924. She was employed to teach dance at Dartington Hall in 1928. In 1930, Elmhirst paid for Burrowes to visit Germany, and she spent some time at the Wigman School in Dresden, and wrote to Elmhirst of her experiences there.

52 Leslie Burrowes, 'Typed Transcript of Letter to Dorothy Elmhirst', dated 6 May 1930, NRCD LB/E/1/1.

53 Leslie Burrowes, 'The Modern Dance Movement in England', *The Dancing Times* (January 1933), 452–453.

54 Burrowes, 'The Modern Dance Movement', 453.

55 Mary Wigman, 'The Philosophy of Modern Dance', In Selma Jeanne Cohen, ed., *Dance as a Theatre Art*, 149–153 (New York: Harper & Row, 1933, 1974) (originally published in *Europa* 1, no. 1 (May–July)).

DOI: 10.1057/9781137439215.0006

56 *Der Tanz, Die Musik, Theatre Arts, Modern Music* and *Tanzgemeinschaft.*

57 Mary Wigman, 'Das "Land Ohne Tanz"', *Tanzgemeinschaft* 1, no. 2 (April 1929): 12–13.
Mary Wigman, 'Der Neue Künstlerische Tanz Und Das Theater', *Tanzgemeinschaft* 1, no. 1 (1929): 1–9.
Mary Wigman, 'Rudolf Von Laban Zum Geburtstag', *Schrifttanz* 2, no. 4 (1929): 65–66.
Mary Wigman, 'Der Tanzer Und Das Theater', *Blätter des Hessischen Landestheater* 7 (1929/1930): 49–58.
Mary Wigman, 'Der Tänzer', *Tanzgemeinschaft: Vierteljahrschrift für tänzerisches Kultur* 2, no. 2 (1930): 1–2.
Mary Wigman, 'Wie Ich Zu Albert Talhoffs Totenmal Stehe', *Der Tanz* 3, no. 6 (June 1930): 3–4.
Mary Wigman, 'Composition in Pure Movement', *Modern Music* 8, no. 2 (January/February 1931): 20–22.
Mary Wigman, 'The Mood of the Modern Dance', *Theatre Magazine* 52, no. 6 (January 1931): 45, 62.
Mary Wigman, 'The World and the Theatre: Wigman Writes of Dancers', *Theatre Arts* 15, no. 12 (December 1931): 966–968.
Mary Wigman, 'Mein Erster Erfolg', *Die schöne Frau* 7, no. 9 (1931/1932): 1–2.
Mary Wigman, 'Wer Kann Tanzen, Wer Darf Tanzen?', *Der Tanz* 5, no. 11 (1932): 3–4.
Mary Wigmann (*sic*), 'How I Arrange My Ballets and Dances. A Symposium. vii. A Record of an Interview with *The Dance Journal*', *The Dance Journal* 4, no. 3 (1932): 671–673.
Mary Wigman, 'Das Tanzerlebnis', *Die Musik* 11 (1933): 801–802.
Mary Wigman, 'Der Tänzer Und Das Theater', *Völkische Kultur, Dresden* (June 1933): 26–32.
Mary Wigman, In Rudolf Bach, ed., *Das Mary Wigman Werk* (Dresden: Carl Reissner, 1933).

58 Marion Kant in Lilian Karina and Marion Kant, *Hitler's Dancers: German Modern Dance and the Third Reich* [Translated from German] (New York: Berghahn Books, 2003).

59 See Manning, *Ecstasy and the Demon*, 146–147; Mary Wigman, 'Der Tanzer Und Das Theater', *Blätter des Hessischen Landestheater* 7 (1929/1930): 49–58.

60 First published as Mary Wigman, 'Der Tänzer', *Tanzgemeinschaft: Vierteljahrschrift für tänzerisches Kultur* 2, no. 2 (1930): 1–2. The section on Turning discussed here begins:

> In der Mitte des Raumes dreht sie sich mit Schritten, die klein, schnell sind, um sich selbst. Schneller werden die Schritte, höher die Streckung auf den Spitzen, stärker die Spannung des Körpers. Rasend im Schwung dreht sie sich um den eigenen Mittelpunkt. Plötzlich geschieht das Selt-same: sie hebt sich über den Boden, steht still in der Luft, ruhige Schwebe. Wohl weiß sie, daß sie weiter dreht, aber sie fühlt die Bewegung nicht mehr. Gehoben, ganz leicht, schwebt sie, die große Seligkeit tragend.

61 Mary Wigman, 'The Dancer', In Walter Sorell, ed. and trans., *The Mary Wigman Book: Her Writings*, 117–121 (Middletown, CT: Wesleyan University Press, 1975), 118.

DOI: 10.1057/9781137439215.0006

62 Sabine Huschka, 'Bausch, Wigman and the Aesthetic of "Being Moved"',
 In Manning and Ruprecht, eds, *New German Dance Studies*, 182–199, 194.
 Huschka includes just the section on Turning here as part of her analysis.

63 Wigman, trans. Huschka 2012, 194; cf. Wigman, trans. Sorell 1975, 118.

64 Her essay was published in the first issue of *Europa*, a new journal that set out
 to review European culture, edited by William Kozlenko and Samuel Putnam
 and including essays by the likes of Clive Bell.

65 Wigman, 'The Philosophy of Modern Dance', 152.

66 Wigman, 'The Philosophy of Modern Dance', 153.

67 Duncan, 'I See America Dancing', 49.

68 Graham, 'Seeking an American Art of the Dance', 252.

69 Wigman, 'The Philosophy of Modern Dance', 52.

70 Kurt Jooss, 'The Dance of the Future: In an Interview with Derra De Moroda',
 The Dancing Times (1933), 453–455, 453. Interestingly, this is published in the
 same year that John Martin was drawing a distinction between the modern
 dance and ballet (1933). Jooss uses the term 'Central European Dance' which
 was in common use during the late 1920s and early 1930s, especially in *The
 Dancing Times* to describe the new modern dance in Europe.

71 A Jooss Leeder School of Dance Prospectus (c. 1936) (author's copy)
 makes brief reference to ballet as part of the curriculum as follows: 'Dance
 Technique …. Training in such values of Classical Ballet as are of general
 importance is included' (n.p.). Anne Hutchinson-Guest, who was a student
 from 1936 to 1938, recalls that during her time there was very little ballet
 taught: 'Sad to say, "ballet" was a dirty word at the Jooss-Leeder School. It
 was scorned, frowned upon, derided …. Before I came, one ballet class a
 week was on the schedule, but unfortunately that had been dropped. During
 my years only once was a ballet class given'. Ann Hutchinson Guest, 'The
 Jooss-Leeder School at Dartington Hall', *Dance Chronicle* 29, no. 2 (2006):
 161–194, 176.

72 See Michael Huxley, 'Kurt Jooss in Exile in England', *Discourses in Dance* 5,
 no. 1 (2012): 39–58.

73 Fernau Hall, 'An Interview with Jooss', *The Dancing Times*, November (1945),
 55–57.

74 Most evident in *New Dance* (1936) and her writing about its composition
 in both its extant forms: Doris Humphrey, 'New Dance', In Selma Jeanne
 Cohen, ed., *Doris Humphrey: An Artist First*, 238–244 (Middletown, CT:
 Wesleyan University Press, c. 1936, 1972); Doris Humphrey, 'New Dance', In
 Sali Ann Kriegsman, ed., *Modern Dance in America: The Bennington Years*,
 284–286 (New York: Harper Row, c. 1936, 1981).

DOI: 10.1057/9781137439215.0006

4

German and American Modern Dance: Constitutional Differences

Abstract: *This chapter looks at modern dancers' writings in the turbulent period 1933–1936. It examines therein the differences between modern dance in Germany and the United States of America at this time. These are constitutional in both the institutional and bodily senses. The dancing of this time, and how dancers wrote about it, marks a growing gulf between the dance of the new German Nazi state and that of democratic America. Dancers' writings examined include those of Leslie Burrowes, Jane Dudley, Blanche Evan, Martha Graham, Hanya Holm, Doris Humphrey, Harald Kreutzberg, Rudolf Laban, Gret Palucca, Elizabeth Selden and Mary Wigman.*

Keywords: dancers' differences; democratic United States of America; modern dance; Nazi Germany

Huxley, Michael. *The Dancer's World, 1920–1945: Modern Dancers and Their Practices Reconsidered*. Basingstoke: Palgrave Macmillan, 2015. DOI: 10.1057/9781137439215.0007.

DOI: 10.1057/9781137439215.0007

In 1935, Hanya Holm wrote of the constitutional differences[1] between the German modern dance and the American modern dance. She did so in a unique book, *The Modern Dance*, a compilation by Virginia Stewart and Merle Armitage, which included contributions from dancers on both sides of the Atlantic. Holm's account of modern dance in terms of its German and American forms is possibly the most important piece of dancer's writing of the time.[2] It is Holm who, as a practising dancer and teacher, chooses to compare the German and American modern dance, because 'they exemplify *two constitutionally different* [my emphasis] responses to identical forces active in the world today'.[3] She talks of what it is like to be a European in the United States of America and the differences that she sees in European and American culture. She suggests that the two forms have a common historical heritage and that differences have developed between the two forms of modern dance and she locates these in the experience of the dancer. This chapter examines the emerging differences between the dancer's world of Europe and the United States of America from the dancer's perspective.

The idea of the dancer in modern dance underwent profound changes in the brief period 1933–1936.[4] These changes were different in Germany, the United States of America and the United Kingdom. It was particularly marked in the work and writing of Mary Wigman, Hanya Holm, Jane Dudley, Doris Humphrey and Leslie Burrowes, respectively. In many ways they expressed directly the situation of the time. However, it was also during this period that there was the greatest intercontinental exchange that led to a transnational modern dance discourse. This discourse inevitably saw dancers taking sides, both artistically and politically. The period was also marked by genuine attempts to give dancers a voice in the shaping of a literature and pedagogy of the new form. 1934 saw the first Bennington School of the Dance, where dancers from the United States and Germany – notably Graham, Humphrey, Charles Weidman and Holm – taught and performed. That same year saw Uday Shankar and Margaret Barr teaching at Dartington Hall in Devon – a utopian nexus for British, American, German and Indian versions of modern dance – and the opening of the Jooss-Leeder School there.[5] In Germany, the year saw the inauguration of the German Dance Festival under the auspices of Josef Goebbels's Ministry of Culture, where only German dancers of proven Aryan origin performed.[6] In the United States of America modern dancers became involved increasingly in the politics of the left, notably the Workers Dance League and the New Dance

DOI: 10.1057/9781137439215.0007

Group.[7] Humphrey showed her tribute to freedom and democracy, *New Dance*, at the second Bennington Summer School of Dance in 1935. A year later, 1936 saw the XI Olympiad, in Berlin, where Wigman, Harald Kreutzberg and hundreds of other dancers contributed to *Olympic Youth*, the opening ceremony, an apotheosis of the Third Reich's *Deutscher Tanz*. Ballets Jooss, now based in the United Kingdom, toured *The Green Table* (1932), a dance of the time with its prescient warnings, across the United States of America. In retrospect, the contrasts are stark.

In Germany from 1933 onwards the dancer's world became increasingly and inexorably part of the new National Socialist state.[8] Dancers' writings became constrained by and contributed to the state's idea of what dance should be, becoming part of the definition of the newly termed German Dance, *Deutscher Tanz*. This transition has been admirably elucidated by Marion Kant and Laure Guilbert and, in terms of Wigman, by Hedwig Müller and Susan Manning.[9] Wigman, Rudolf Laban and others had their ideas about dance published in state-approved and/or state-sponsored publications and in NSDAP (Nazi) publications. Thus, their ideas of *Deutscher Tanz* or *Deutsche Tanzkunst* are to be found in the *Reichskulturkammer*'s publication for the 1934 *Deutsche Tanzfestspiele*,[10] in the programme for the planned 1936 Olympic Cultural Festival performance of *Vom Tauwind und der neuen Freude – Wir Tanzen*,[11] in *Der Tanz* (after its editor Josef Lewitan had been deposed) and in *Singchor und Tanz*. In this period Laban writes as an ideologue. In his introduction about the 'German' dance in the book published for the 1934 German Dance Festival he says:

> We want to convey the source of joy and exaltation, which we feel to be in our art, to the German people. We want to place our means of expression and the language of our enthusiasm and vigour at the service of the great tasks, which our people accomplish, and to whom our leader [*Führer*] points the way with indisputable clarity.[12]

Laban's published writings demonstrate acquiescence to the new status quo. In this he had much in common with some other artists and intellectuals, not least in their unwillingness to publically repent of their errors and make amends once the regime had been defeated in 1945. It was in this context that Wigman's book *Deutsche Tanzkunst* set out her views of German Dance in Germany. Susan Manning discusses the tension between the Reich's view of German dance and Wigman's. Manning makes the point that, despite earlier relating dance to the

DOI: 10.1057/9781137439215.0007

German people, it is in the book's first essay that Wigman shifts her point of view from one that related dance to 'universal human experiences' to one that linked 'Germanness to the *Volk*':[13]

> We German artists today are more aware of the fate of the Volk than ever before. And for all of us this time is a trial of strength, a measuring of oneself against standards that are greater than the individual is able to fathom. The call of the blood, which has involved us all, goes deep and engages the essential.[14]

Deutsche Tanzkunst is explicit about the need for a new German art of dance, with the emphasis on German. When Wigman's essay 'The New German Dance' was published in *The Modern Dance* in 1935 in the United States of America her ideas of the new German dance were not given quite this emphasis, as I show in the following paragraphs. The many American and British dancers who visited Wigman's school in the period after 1933 might have been aware of the change in emphasis in the curriculum, but made no direct mention of it.[15] Wigman's idea of dance as presented on tour and in print belied the changed dancer's world that she was subscribing to.[16]

Two seminal books on the modern dance as a transatlantic form were published in 1935: the compilation co-edited by Virginia Stewart and a single-author collection of essays by Elizabeth Selden. Both women were American advocates of the new German modern dance. Both had studied at the Dresden Wigman School. Selden taught and performed first in New York and then in San Francisco. Stewart became a representative of the Dresden Wigman School in the United States of America and a key organiser of American dancers' visits to the Wigman School.[17] Their books are illuminating, but the context of their publication is a matter of controversy.

Selden, as we have seen, had been writing about the new dance form, as a dancer/teacher, since the late 1920s. *The Dancer's Quest* of 1935 gathered her writings and presented a view of the changes that were taking place as the free dance of Isadora Duncan and natural dancing began to develop into a new American dance at a time when the new German dance was becoming influential in the United States of America.[18] She makes a point of the transatlantic scope of her book:

> I have drawn on the work of European and American dancers to illustrate the use of some principles of dance composition and to show the underlying oneness. In that sense I was hoping that this book might form a bridge for the

DOI: 10.1057/9781137439215.0007

dancers of two continents. As a native of Europe and a citizen of America I have always felt the pulse beat of the dance on both sides a unity.[19]

Selden wrote about the dancers she was familiar with, as teachers or performers. Her book, published in California in 1935,[20] makes no reference to the situation in Germany, although it is current in mentioning the Bennington Summer Schools. It does provide a fascinating single-author account of the similarities and differences between the technical and compositional aspects of German and American modern dance. John Martin, reviewing the book in 1936,[21] suggested that it was dated in content and view, especially as it tried to pin down modern dance as a system comparable to ballet.[22] Nonetheless, some salient points are to be found, not least in Selden's answer to her own question 'in the welter of different approaches to the dance, have we found a style of our own, which might be called the American Dance?'[23] She answers herself by saying that the fact that 'we' are asking such questions suggests that the new dance is sufficiently mature to begin to define itself as an American form. Selden, writing as a practitioner, makes the point that German and American modern dance at this time, as espoused by its dancers, had much in common. Because much of Selden's account draws on the work of other dancers, there is less sense of her own dancing, even though she devotes some space to compositional and technical matters. She closes her book with a concluding statement on 'the quest of perfection' that shows a real dancer's understanding:

> The extremely labile balance between the seen and the visualized, the felt and the hoped-for, composes the taunting quality of art. By its infinite promise we know it as divine; by its partial fulfillment it is so humanly ours
>
> The modern dance…. has perfectly translated the divine restlessness, the constant movement, of the human soul, on its way to the larger horizons. And by that token, the modern dance is probably nearer than any other dance form has been since Greek times, to that perfection 'which must forever shed despair into a dancer's heart': the eternally unfinished dance of a future in which man becomes all that man can be.[24]

Her vision for dance as an art is of its time: her idea of the transient and changeable nature of art, especially in the sense that an art work is never finished, is remarkably close to R.G. Collingwood's in his 1938 *The Principles of Art*.[25]

In *The Modern Dance*, the book's compiler and its designer, Stewart and Armitage, respectively, collated the first 'printed symposium' by the

DOI: 10.1057/9781137439215.0007

leaders of the German and American modern dance, as John Martin acknowledged.[26] The volume included three dancers from Germany – Gret Palucca, Wigman and Kreutzberg – and five from the United States of America – Martha Graham, Charles Weidman and Humphrey,[27] Holm and Stewart herself.[28] Holm had been resident in New York for four years. August 1935, when the volume was published, had seen the beginning of a debate in American dance periodicals about the new regime in Germany and dancers' places within it, most especially Wigman's.[29] There was open criticism of Stewart's apologist stance in the American dance press.[30] The German dancers' contributions to *The Modern Dance* need to be read as part of their promotion of their practices to what was becoming an increasingly hostile American audience. Wigman's chapter, 'The New German Dance',[31] warrants comparison with her first chapter in *Deutsche Tanzkunst* (Die Deutsche Tanz), because some of it is remarkably similar once translated from the German. Most noticeably, part of a paragraph on the origins of the new German dance appears almost word for word in both books.[32] In her German chapter Wigman is at pains to articulate what is German, the Germanness, in the new German dance and this becomes the leitmotif of her account.[33] Her exposition has an altogether darker tone. She talks of how this form of dance 'gave shape to the ancient Faustian desire for fulfillment in a final unity encompassing the whole of life, that is what makes it essentially German'.[34] German dance is a German art form. In answer to the question what is German, she says:

> the unmistakable trademarks of true German art are not and never have been contained solely within the matter and the subject of the creative artwork. They take shape on the irrational plane [*irrationalen Ebene*] into which personal experience must enter and be re-forged so that it may find its way back to the people [*Menschen*] in its essential, meaningful form, the above-personal [*überpersönlicher*] statement.[35]

Although Wigman's (1935) chapter has German in its title, the references to German and Germany and the new German dance are fewer by name and largely descriptive.[36] The marked exception is when she says:

> That which marks this new dance, revealing its intrinsic expression and differentiating it from other dance forms is that it reaches back to the fundament of existence as the source of all aesthetic creation and form, like any true German art.[37]

In *The Modern Dance* Palucca, Kreutzberg and Wigman herself related their work to their country in a more benign way than in Wigman's

DOI: 10.1057/9781137439215.0007

German espousal of German dance. Wigman, writing about 'the New German dance', said:

> In speaking of the new German dance, whose exponent I am considered in America, I do not wish to treat the theme from the point of view of my own dances and their influence. I wish, instead, to speak of the dance itself as I perceive and experience it; as I must, indeed, represent it, since I can dance in no other way.[38]

Palucca, writing about 'my dance', 'in Germany', said:

> My dancing seems to arouse similar feelings in people and to give them something for which they have felt a need. It is for this reason that I belive [*sic*] that the absolute dance, free from any abstract idea is the only dance for me.[39]

Kreutzberg, in a far-ranging account that tries to locate modern dance as distinctive, yet in need of some of the technical rigour found in ballet, says:

> The modern dance is a definite stylistic phenomenon, analogous to the appearance of expressionism in painting. It has as its aim the loosening of certain technical laws in favor of more salient and atmospheric communication.[40]

Wigman acknowledged the modern dance in the United States of America as an equal, whereas Graham was combative in the way she distanced herself and American dance from the older European forms, perhaps unsurprisingly as many Europeans regarded American culture as, at best, derivative. Graham wrote for the 'American dancer', saying that 'nothing is more revealing than movement. What you are finds expression in what you do. The dance reveals the spirit of the country in which it takes root'.[41] These two main protagonists stress the need for a sound technique, as do Palucca and Kreutzberg, and this is echoed in Love's interpretation of Humphrey and Weidman.[42] At the same time, looking beyond the idea that modern dance expresses the dancer's country there is a subtle but profound difference in emphasis. Wigman herself points to the crux of this 1935 moment when she says, in a concluding paragraph that talks of both German and American dance, 'though the forms may differ, and the conceptions even oppose each other, one common link unites the new American and the new German dance'.[43] This link is to do with experience:

> The shape of the individual's inner experience which is carried by the elements of existence and which has passed through his total being will also have the unique, magnetic power of transmission which makes it possible to

DOI: 10.1057/9781137439215.0007

draw other persons, the participating spectators, into the magic circle of the creation.[44]

The individual's experience is, for her, a quasi-mystical one that is imbued with a spirit of the irrational.

> Like a flash, perhaps only for an instant, he is caught and galvanized by the wave of life's great current which extinguishes him in his single existence and endows him, through this experience, with the gift of participation in the All. This is the moment of grace in which man becomes a vessel ready to absorb the energies flowing into him. This is the ecstatic state which substitutes the plane of mere knowing for that of experiencing.[45]

However, for Graham, the experience being dealt with is of a different, more progressive order:

> We look to the dance to impart the sensation of living in an affirmation of life, to energize the spectator into keener awareness of the vigor, the mystery, the humor, the variety, and the wonder of life.[46]

Again, the contrast, read with a fuller knowledge of the period than was possible at the time, and of a reading of *Deutsche Tanzkunst*, is stark. Wigman was writing shortly after premiering her group's *Frauentänze* (Women's Dance) cycle of 1934, drawing on her experience of life in the new Germany to present a new image of the German woman dancer that fitted more closely with that of the Third Reich. Graham had just premiered *Frontier* in April 1935, with its open, expansive vision of an American pioneer woman. The dancers, along fundamentally different lines, were redefining the dancer's world.

Of all the dancers contributing to *The Modern Dance*, it is Graham who marks a turn in approach to the idea of the dancer most vividly. Having begun by addressing the American dancer, she goes on to spell out a precise idea of how the new American dance is to be created:

> The dancer faces also the duties of a choreographer. Sometimes the union is a perfect one. Sometimes it is not.... Why shall we not be able to turn for subject matter to an American choreographer in whose material the dancer shall have something significant to dance, of his own time, of his own understanding.[47]

It is this new choreographer, born in America, who, trained as a dancer, will have something significant to say about America. It is important to note Graham's use of the term 'choreographer' here, as it marks a significant shift in emphasis for the modern dance.

DOI: 10.1057/9781137439215.0007

Hanya Holm, with great insight, wrote her essay 'The German Dance in the American Scene' for *The Modern Dance* a mere year before she had to discard the name of Wigman from her New York School because of the debates around Wigman's alignment with Nazi Germany. Holm's first concert programme in the United States of America was to follow just over a year later. Her chapter is clearly about her own experience as a German in the United States of America. However, it is also a sophisticated consideration of the differences between the American and German dancer's experience. The following discussion is concerned with constitutional differences as set out in Holm's essay. Holm has chosen her description remarkably well, as 'constitution' can refer to both a person's condition and to their relationship to the state and its principles. It is therefore an excellent way of opening up discussion about the political without using the word politics. Holm says that 'emotionally the German dance is basically subjective and the American dance objective in their characteristic manifestations'.[48] She illustrates this by first talking of the American dancer whose tendency is 'to observe, portray and comment on her surroundings with an insight lighted mainly by intellectual comprehension and analysis' whereas the 'German dancer on the other hand starts with the actual emotional experience itself and its effect upon the individual'.[49] She exemplifies these differences further by talking about how German dancers and American dancers approach space, where the former are credited with a more profound understanding of its use.[50] She credits Wigman as the source (in her early work) for German dance's contribution to an understanding of space. It is worth re-emphasising that here Holm is talking of the dancer's experience, not the choreographer's. She does talk about how the *dancer* makes (composes) her dance and, again, makes crucial distinctions between German and American dancers. She is worth quoting at length:

> Superb and precise as is the technical virtuosity of even the less than great American dancers, their approach and interest are usually directed towards bodily accomplishment for its own sake. Even though a given dance may be composed to convey an emotional theme the mechanics used in its externalization are separately developed. A gesture and movement vocabulary are first prepared and only subsequently employed in various combinations for various ends. This can be done with finished and brilliant results, but it is an approach radically different from that of the German dancer. For us each composition evolves through its own emotional demands, not only its special gestures, but more important still, its particular tension and even its distinctive technique.[51]

DOI: 10.1057/9781137439215.0007

These substantive differences continued to have an effect in the following decades.[52]

Holm was remarkably open and even handed in the way she described the difference between her practices and those of comparable US dancers. However, others were not beyond criticising her. We have already seen that the British dancer Leslie Burrowes, as evidenced in her letters, had found Wigman's training to be quite different to any she had encountered, not least in its focus on improvisation, rather than the acquisition of a set technical vocabulary through repetition and correction in class. A young American dancer, Blanche Evan, wrote of her experience at the New York Mary Wigman School under Hanya Holm in 1934 and published her thoughts in an article in 1936. The article, as Manning has pointed out,[53] is not just about improvisation and technique. Nonetheless, it gives an idea of the danced experience of the classes, here taught by Louise Kloepper:

> We have two classes daily, one in improvisation and one in so-called technique. So-called because even the technical classes are built on improvisation.[54]

When talking of Holm's own teaching, she says:

> Hanya's explanation was very refreshing for those professionals in the class who had mastered the technique before coming to the Wigman School. But for the majority it was futile and dangerous … If only the school would *teach* fundamental technique, as a base, its stress on quality would be really fruitful.[55]

This is precisely what Holm was talking about when she identified the differences between the American dancer's approach that prioritised a general technique and the German approach that built technique from improvisation for specific purposes. Interestingly, Burrowes, writing in the United Kingdom, but drawing on her continuing experience at the Dresden Wigman School, makes very similar points to Holm, in an article published in 1936 (within a year of Holm's, and some six years after her first written observations). She tries to explain for a British teacher audience how technique works within modern dance:

> To be of value to-day, and to be capable of 'giving' whatever our work, we must be expressive and be able to bring out expression in those we help or work with. We cannot do this by a rigid technique, theory or form, but nevertheless technique must exist, a technique which is not an end in itself, but a means to an end. The technique in Modern Dance is a means towards an end; it demands a self discipline from within, rather an enforced one from without.[56]

DOI: 10.1057/9781137439215.0007

This liberal idea of technique, and dance, is at odds with the imperatives of the new German constitution of the Third Reich in Germany, and also with some of the political practices of the American left.

The dancer's world, as set out in Armitage and Stewart's *The Modern Dance*, had been contested by those who wished dancers to follow a Marxist-Leninist line.[57] Critics and dancers writing in *New Theatre* and *New Dance*, in particular, took issue with the 'bourgeois' and 'commercial' nature of modern dance and, in 1935, with the political stance attributed to Wigman.[58] Published writings by dancers of the left in this period give an insight into a competing vision for the United States of America in the 1930s. A number of dancers associated with the New Dance Group and with the Workers Dance League wrote about the dance of the time. Some became quite extensively published, but there are very few writings about their own practice. Edna Ocko, for instance, wrote extensively about the dance of the period from a communist point of view in a range of periodicals of the left. She had trained with Holm and began writing while a practicing dancer and as one of the founders of the New Dance Group. She continued as a writer, critic and editor after she had stopped performing. Most of her writing, although informed by her own practice, is about other people's practice. Most of it is written in the rhetoric of the left. She took issue with many of those who were to become well known – notably Graham, Humphrey and Weidman – criticising them for not dealing with real everyday issues of importance to workers and to the workers' struggle. She praised the subject matter of dances performed by members of the Workers Dance League in a 1935 review titled 'World of the Dance' for the *Daily Worker* including praise for *Work and Play*, which showed the 'joy of workers in Socialist countries'.[59] Another co-founder of the New Dance Group, Nadia Chilkovsky, wrote in a similar vein. She criticised the 'modern bourgeois dance' because its dances did not deal with everyday issues.[60] Dances had become degenerated by commercial interests, but 'dancers must look to the future, to the eventual destruction of capitalism, to the building of a new society for their source of inspiration'.[61] These dancers presented a vision of a very different dancer's world.

A third dancer from the New Dance Group, Jane Dudley, who had trained and danced with Hanya Holm, was one of the few to actually articulate her own (revolutionary) practice. In 'The Mass Dance', written in 1934 for *New Theatre*, she described in detail 'an outline of procedure and specific directions for the formation and teaching of a class in

DOI: 10.1057/9781137439215.0007

mass dancing'.[62] The importance of appropriate themes – such as 'class struggle, anti-war issue, Negro rights, class war prisoners, Fascism' – is stressed.[63] Finally, a scenario for a dance, *Strike*, where pickets call on workers to down tools and the militia intervenes, is outlined in detail.[64] Her description of how lay choric dance can be used as a means to promote a political message needs to be considered in light of similar exhortations for the benefits of mass dancing being made for different purposes on the other side of the Atlantic.[65] She says:

> Large groups of lay dancers, even at times the most superficially trained people can, by careful direction, set simple but clear patterns of group movement into a form that presents our revolutionary ideas movingly and meaningfully. The dancer learns to move communally, to express with others a simple class-conscious idea. In this way, large numbers of people can be mobilized not only to dance but to observe, and through the discussion of the theme and the problems of movement brought forward by the leader and dancers, clarity of ideology can be given.[66]

Dudley gives a fine insight into the thinking in this sort of dance making. She was, however, one of the very few to do so. Much of the dancers' writings from this point of view were criticisms of others. Thus, for instance, Ocko, writing of a Humphrey-Weidman performance in January 1935, is scathing in her criticism: 'If *Credo* states the dance belief of Doris Humphrey, then one sympathizes with the innocuity and meagerness of her faith, that she has naught else to cling to save a precious technique (also on the wane), and an emasculated and detached allegiance to formal design'.[67]

The dancer's world sees a fundamental shift in 1935/1936. In Germany, Mary Wigman's *Deutsche Tanzkunst* consolidated her idea of the German dancer, whereby technical and compositional advances in dance were subjugated to political ones. In the United States of America the differing worldviews of dancers competed and contributed to a changing idea of the modern dance. Stewart and Armitage's book, and the promise of its title *The Modern Dance*, was timely as it was not just the first but also the last such German/American 'symposium'. It also unintentionally marked the fracture between the German modern dance and its American counterpart. Whilst Wigman, Laban and their contemporaries all talked of German dance, the Americans and British were now unequivocal in their acknowledgement of the term modern dance, even when they were referring to the work of their German colleagues. The once-prolific Wigman wrote very little after her 1935 book on the German dance art. German

DOI: 10.1057/9781137439215.0007

dancers who stayed in Germany ceased to contribute significantly to the international discourse that helped form the modern dance after 1936.[68] There is a sense that during the early 1930s the focus shifted and that dancers of various political persuasions were concerned directly with competing views of what the dancer's world should be like: a reactionary German one, an international socialist one or a progressive American one. The last of these will be considered in the next chapter.

Notes

1 Hanya Holm, 'The German Dance in the American Scene', In Virginia Stewart and Merle Armitage, eds, *The Modern Dance*, 79–86 (New York: Dance Horizons, 1935; repr. Dance Horizons, 1970), 79.

2 John Martin, in his foreword to the Dance Horizons reprint 35 years after its publication, said that it was a book that seemed good when it was new (but) has proved to be immeasurably more valuable now that it is old (1970, foreword). Its value lies in its evocation of the experience of the time through dancers' points of view.

3 Holm, 'The German Dance in the American Scene', 79.

4 Year 1933 marks a turning point and, because it is a time when previous practices and new practices overlap, writings from this year appear in both this and the previous chapter. The political context of dance in this period, in particular in Germany and the United States of America, though not in the United Kingdom, has been extensively scrutinised by Marion Kant, Laure Guilbert, Susan Manning, Hedwig Müller, Ellen Graff, Stacey Prickett and Mark Franko. I don't intend to repeat their diverse arguments here, except where they impinge directly on an understanding of the dancer's point of view.

5 See, in particular, Larraine Nicholas, *Dancing in Utopia: Dartington Hall and Its Dancers* (Alton: Dance Books, 2007).

6 Susan Manning, *Ecstasy and the Demon: The Dances of Mary Wigman*, new ed. (Minneapolis: University of Minnesota Press, 2006), 173; Lilian Karina and Marion Kant, *Hitler's Dancers: German Modern Dance and the Third Reich* (New York: Berghahn Books, 2003), 104–108.

7 See, especially, Lynn Garafola, ed., *Of, by, and for the People: Dancing on the Left in the 1930s* (Madison, WI: Society of Dance History Scholars at A-R Editions, 1994); Ellen Graff, *Stepping Left: Dance and Politics in New York City, 1928–1942* (Durham: Duke University Press, 1997).

8 Karina and Kant give a chronology of events and include a letter from the Wigman School Dresden dated 11 July 1933 which itemises the party and government organisations that the school is now associated with:

DOI: 10.1057/9781137439215.0007

National-Socialist Teachers' Federation and its sections including the Reich Association of German Turn, Sport and Gymnastic Teachers and the Professional Association for Gymnastic and Dance; and the Fighting League for German Culture. See Karina and Kant, *Hitler's Dancers*, 195, 317–330.

9 The first such examination was made by Horst Koegler, 'In the Shadow of the Swastika: Dance in Germany 1917–1936' (*Dance Perspectives*, no. 57 (1974)). See, particularly, Karina and Kant, *Hitler's Dancers*; Laure Guilbert, *Danser Avec Le IIIe Reich. Les Danseurs Modernes Sous Le Nazism* (Paris: Éditions Complexe, 2000); 2011 André Versaille éditeur; Marion Kant, 'Practical Imperative: German Dance, Dancers, and Nazi Politics', In Naomi M. Jackson and Toni Shapiro-Phim, ed., *Dance, Human Rights, and Social Justice*, 5–19 (Lanham, MD: Scarecrow Press, 2008); Manning, *Ecstasy and the Demon*; Müller, *Mary Wigman: Leben Und Werk Der Grossen Tänzerin* (Berlin: Quadriga, 1986); Hedwig Müller, 'Mary Wigman and the Third Reich', *Ballett International* 9, no. 11 (1986): 18–23. Hedwig Müller, 'Wigman and National Socialism', *Ballet Review* 15, no. 1 (Spring 1987): 65–73.

10 Die Deutsche Tanzbühne, *Deutsche Tanzfestspiele 1934* (Dresden: Carl Reissner, 1934).

11 'Wir Tanzen' (Berlin: Reichsbund für Gemeinschaftstanz in der Reichstheaterkammer, 1936). The circumstances of its cancellation are well documented in Karina and Kant, *Hitler's Dancers*, 118–121.

12 Rudolf von Laban, 'Die Deutsche Tanzbühne', In *Deutsche Tanzfestspiele 1934*, 3–7.

13 *Volk* translates as 'people' or 'folk' but the term had much further reaching connotations in the 1930s, being appropriated by the Nazis and used explicitly as a term to denote a German people who were 'pure' in their lineage. See Wilfried Van Der Will, '"*Volkskultur*" and Alternative Culture', In Eva Kolinsky and Wilfried Van Der Will, eds, *The Cambridge Companion to Modern German Culture* (Cambridge: Cambridge University Press, 1998); Karina and Kant, *Hitler's Dancers*; Manning, *Ecstasy and the Demon*.

14 Translation of Wigman, *Deutsche Tankunst*, 11–12, in Manning, *Ecstasy and the Demon*, 192.

15 There is no mention of the changes in the many letters and diaries by Leslie Burrowes in the NRCD archive collection.

16 The Dresden Wigman School brochures included a number in English. See Heide Lazarus, *Die Akte Wigman: Ein Dokumentation Der Mary Wigman Schule Dresden (1920–1942) Edition Tanzdokumente Digital 3* (Hildeshelm: Georg Olms Verlag, 2007).

17 Merle Armitage (1893–1975) was a designer, publisher and entrepreneur who worked closely with Graham and who, two years later, published a small volume dedicated to her.

DOI: 10.1057/9781137439215.0007

18 It is noteworthy because, in many ways, it complements Martin's *The Modern Dance*, except that it is written by an American dancer/teacher with roots in Europe. Selden attempted to characterise the new modern dance, writing as a practitioner, but also writing of her contemporaries as practitioners – Wigman, Humphrey, Graham, Benjamin Zemach, Maja Lex and Margaret Gage. Gage was an American Duncan dancer who also trained at the Dresden Wigman School and with Selden at the Bennett School where she subsequently taught. Gitelman emphasises the key role that she played financially, supporting first the New York School and Holm and then Wigman herself. See Claudia Gitelman, ed., *Liebe Hanya: Mary Wigman's Letters to Hanya Holm* (Madison, WI: University of Wisconsin Press, 2003), 26.

19 Elizabeth Selden, *The Dancer's Quest* (Berkeley: University of California Press, 1935), xiii.

20 Her preface is dated May 1935.

21 John Martin, 'Miss Selden's Study of the Modern Dance', *The New York Times Book Review* (12 January 1936).

22 Martin had argued that modern dance was not a system but a point of view in *The Modern Dance* (1933).

23 Selden, *The Dancer's Quest*, 176.

24 Selden, *The Dancer's Quest*, 187.

25 R.G. Collingwood. *The Principles of Art* (Oxford: Clarendon Press, 1938). Judith Alter has given an interesting comparison of Selden with Collingwood and others, although their writing cannot be said to be of the same order. See Judith B. Alter, *Dance-based Dance Theory: From Borrowed Models to Dance-based Experience* (New York: Peter Lang, 1991).

26 Martin, 1969, in the foreword to the *Dance Horizons* reprint (1970).

27 Humphrey and Weidman's contributions were written for and with them by Paul Love. Franziska Boas (daughter of Franz Boas, dancer and percussionist with Holm) was credited for translations. The whole volume was edited by Ramiel McGehee.

28 There were also contextual essays by Stewart, by Hanns Hastings, Paul Love and Merle Armitage. See Stewart and Armitage, *The Modern Dance*.

29 See Ellen Graff, *Stepping Left: Dance and Politics in New York City, 1928–1942* (Durham: Duke University Press, 1997) and Manning, *Ecstasy and the Demon*.

30 There was an open criticism of Stewart in print. See Edna Ocko, 'Letters: Anti-fascism', *Dance Observer* 2, no. 8 (1935): 93, 95. Susan Manning gives a detailed account of the controversy. See Manning, *Ecstasy and the Demon*, 275–277.

31 Mary Wigman, 'The New German Dance', In Stewart and Armitage, eds, *The Modern Dance*, 19.

32 They are given below: first, an English translation from *Deutsche Tanzkunst*, second; a comparable paragraph from *The Modern Dance*:

DOI: 10.1057/9781137439215.0007

The new German dance [Der neue deutsche Tanz] is not the result of a preconceived program....The tragic, the heroic – up to now buried beneath shallow playfulness – won through and gave dance its new, its German face [Deutsches Gesicht]. (Wigman, *Deutsche Tanzkunst*, 15)

When seen in this light, it is clear that the new German dance is not the outcome of a preconceived program.... The tragic, the heroic, until then crowded out by too much playfulness, forced its way through and gave the dance new vision. (Wigman, 'The New German Dance', 20)

33 Wigman uses German 14 times (including a parenthetical translation into English and French), Germany 7 times, Germans once and Germanness once in a chapter of comparable length to the American one.

34 Wigman, 'Deutsche Tanzkunst', 15–16.

35 Wigman, 'Deutsche Tanzkunst', 12.

36 Wigman uses German five times and Germany twice, but also refers to America twice and American twice.

37 Wigman, 'The New German Dance', 23.

38 Wigman, 'The New German Dance', 19.

39 Gret Palucca, 'My Dance', In Stewart and Armitage, eds, *The Modern Dance*, 25–27, 27.

40 Harald Kreutzberg. 'The Modern Dance', In Stewart and Armitage, eds, *The Modern Dance*, 29–34, 31.

41 Graham, 'The American Dance', 53.

42 Doris Humphrey and Paul Love, 'The Dance of Doris Humphrey', In Stewart and Armitage, eds, *The Modern Dance*, 59–71; Charles Weidman and Paul Love, 'The Work of Charles Weidman', In Stewart and Armitage, eds, *The Modern Dance*, 71–78.

43 Wigman, 'The New German Dance', 23.

44 Wigman, 'The New German Dance', 23.

45 Wigman, 'The New German Dance', 22.

46 Graham, 'The American Dance', 57.

47 Graham, 'The American Dance', 57.

48 Holm, 'The German Dance in the American Scene', 83.

49 Holm, 'The German Dance in the American Scene', 83.

50 Holm, 'The German Dance in the American Scene', 85.

51 Holm, 'The German Dance in the American Scene', 85.

52 Holm, reflecting on this period some 40 years later, continued to have concerns about dancers whose technical accomplishments had nothing to underpin them. Jane Dudley, who was a student and dancer with Holm from 1931 to 1935, touches on the sort of comparisons that Holm herself made: 'Looking back at it, I think I was not as well trained at the Wigman School as I would have been by Martha Graham, but the range of movement and the idea of moving from quality, which is the way Hanya taught, rather than from set technical sequences, was an important experience for me as a young dancer'. See Jane Dudley, 'The Early Life of an American Modern

DOI: 10.1057/9781137439215.0007

Dancer', *Dance Research* 10, no. 1 (1992): 3–20, 10. Dudley suggests that whilst the classes at Holm's School could be 'exhilarating, joyous and inspiring, developing fluidity and fullness of movement, with grace and harmony in the body' they did not give her the technical proficiency that she was later to find with Graham. See Dudley, 'The Early Life', 13. Tresa Randall, in her essay on Holm's American *Tanzgemeinschaft*, draws attention to how Holm's dancers compelled her to change her practice to give greater emphasis to technique but how Holm did so whilst maintaining a sense of community of purpose. See Tresa Randall, 'Hanya Holm and an American Tanzgemeinschaft', In Susan Manning and Lucia Ruprecht, eds, *New German Dance Studies*, 79–98 (Urbana: University of Illinois Press, 2012), 94.

53 Manning, *Ecstasy and the Demon*, 272–281. Manning writes in detail about the reception of Wigman's and Holm's work in this period and locates *New Theatre* at the centre of the political criticism of the former's stance; she suggests that Blanche's article can be read as a criticism of Wigman's political affiliations as well as of her approach to technique.

54 Blanche Evan, 'From a Dancer's Notebook', *New Theatre* 3, no. 3 (March 1936): 16–17, 28–29, 17.

55 Evan, 'From a Dancer's Notebook', 28.

56 Leslie Burrowes, 'Modern Dance', *The Ling Association Leaflet* (July 1936): 331–332, 331 (NRCD: LB/E/3/7).

57 The relationships between dancers and organised political groupings and parties is a complex one. Stacey Prickett locates many of the dancers' 'ideological' positions as being allied not just to the US Communist Party but specifically to the Soviet Union (under the leadership of General Secretary Joseph Stalin) of the time: Stacey Prickett, ' "The People": Issues of Identity within Revolutionary Dance', In Garafola, ed., *Of, by, and for the People*, 14–22.

58 The role of the left in dance in the United States of America has been extensively written about by Prickett, Franko and Graff. Graff identifies Armitage's naïve reporting of Wigman's German activities between 1934 and 1936 and the ensuing debates in *New Theatre* and *Dance Observer*. See Graff, *Stepping Left*.

59 Edna Ocko, 'World of the Dance: Outstanding Program by Dance League', In Lynn Garafola, ed., *Of, by, and for the People: Dancing on the Left in the 1930s* (Ocko selected by Stacey Prickett), 79–80 (Madison, WI: Society of Dance History Scholars at A-R Editions, 1994) (originally published in *Daily Worker*, 20 February 1935, 5 under the pseudonym Elizabeth Skrip), 80. In 1935, the main socialist country was the USSR, a country which had just suffered the first, 1933–1934, mass famine as a result of Stalin's first Five Year Plan.

60 Nadia Chilkovsky (writing under the pseudonym Nell Anyon), 'The Tasks of the Revolutionary Dance', In Mark Franko, ed., *Dancing Modernism/*

DOI: 10.1057/9781137439215.0007

Performing Politics, 113–115 (Bloomington: Indiana University Press, 1933, 1995) (first published in *New Theatre* September/October 1933), 113.

61 Chilkovsky, 'The Tasks of the Revolutionary Dance', 114.

62 Jane Dudley, 'The Mass Dance', In Franko, ed., *Dancing Modernism/Performing Politics*, 119–122 (originally published in *New Theatre* December 1934), 119.

63 Dudley, 'The Mass Dance', 119.

64 Dudley, 'The Mass Dance', 121.

65 See the exceptional view of Martin Gleisner, in particular. The orthodox view, under Nazism, is well illustrated in 'Wir Tanzen'. See Martin Gleisner, *Tanz Für Alle: Von Der Gymnastik Zum Gemeinschaftstanz* (Leipzig: Hesse und Becker 1928); Reichsbund für Gemeinschaftstanz in der Reichstheaterkammer, 'Wir Tanzen' (Berlin: Reichsbund für Gemeinschaftstanz in der Reichstheaterkammer, 1936). Laban's view, from 1936, in English, can be found in Rudolf Laban, 'Extract from an Address Held by Mr. Laban on a Meeting for Community-Dance in 1936', *Laban Art of Movement Guild Magazine* no. 43 (November 1936, 1974): 6–11.

66 Dudley, 'The Mass Dance', 119.

67 Edna Ocko, 'Humphrey-Weidman', In Lynn Garafola, ed., *Of, by, and for the People: Dancing on the Left in the 1930s* (Ocko selected by Stacey Prickett), 78 (Madison, WI: Society of Dance History Scholars at A-R Editions, 1994) (first published in *New Theatre* 2, no. 2 (February 1935): 28 under the pseudonym Elizabeth Skrip), 78.

68 For instance, Wigman published just a couple of articles in the next two decades before the publication of her reminiscences in German in 1963 in Mary Wigman, *Die Sprache Des Tanzes* (Stuttgart: Ernst Battenberg, 1963).

DOI: 10.1057/9781137439215.0007

5
A New World for the Dancer

Abstract: *The modern dance of the period 1935–1945 was marked by a burgeoning of a progressive dance from the United States of America. It was a modern dance of the new world, one that Doris Humphrey in particular wrote of. The chapter examines the writings of modern dancers – both American and European – who helped create this new world for the dancer. It also considers how the modern dance of Germany found new expression in the dancing and writing of dancers and teachers in the United Kingdom. Dancers' writings discussed in this chapter include those of Gertrud Bodenwieser, Leslie Burrowes, Katherine Dunham, Martha Graham, Margaret H'Doubler, Hanya Holm, Doris Humphrey, Diana Jordan, Ted Shawn and Louise Soelberg.*

Keywords: dance education; progressive American modern dance

Huxley, Michael. *The Dancer's World, 1920–1945: Modern Dancers and Their Practices Reconsidered.* Basingstoke: Palgrave Macmillan, 2015. DOI: 10.1057/9781137439215.0008.

DOI: 10.1057/9781137439215.0008

In 1939, Doris Humphrey made a forthright 'declaration' of her American values in an essay that was later published on her 'approach to the modern dance':

> My dance is an art concerned with human values.
>
> This new dance of action comes inevitably from the people who had to subdue a continent, to make a thousand paths through forest and plain, to conquer the mountains, and eventually to raise up towers of steel and glass. The American dance is born of this new world, new life, and new vigor.[1]

This narrative about America is, at first sight, similar to that of Isadora Duncan's 'I See America Dancing' of a decade earlier. It is also there in Ted Shawn's vision for American Dance of 1926, which he restated in the conclusion to *Dance We Must* of 1946 where he talked of

> The vastness of our plains, the majesty of our mountains, the fertility of our soil.... we must in all our activities be a torch to the world and in the dance most of all.[2]

It is a view that persists through this period, finding its culmination in the performances of both Humphrey and Martha Graham and those of Hanya Holm and José Limón. Humphrey's statement encapsulates ideas that she had been developing in her writings and her group dances since the mid-1930s. This chapter considers the 'new world', in its broadest sense, out of which dancers created a new set of values for the modern dance. In doing so, it pays attention to the different trajectories of modern dance in dancers' writings from 1935 through to the years of World War II.

This was a difficult period for the new modern dance as the hostilities in Europe from 1938 onwards led inexorably into World War II of 1939–1945. Whereas German dancers' writings, noticeably those of the once prolific Wigman, are eclipsed by events, those of American modern dancers gain in their vigour. In 1938, in the United States of America the groundbreaking summer schools at the liberal Bennington College[3] were in their fifth year and these continued through until the year after the United States of America joined the war, 1942. It was here that Graham, Humphrey, Weidman, Holm, Limón and many others showed much of their new work, and especially their group dances, for the first time. In Germany, by contrast, the Nazi states' dance organisation, *Reichsinstitut für Bühnentanz*, ran ideologically controlled master workshops in German Dance, and these ran through the war years

DOI: 10.1057/9781137439215.0008

until 1945. Rudolf Laban left Germany in 1937 and Mary Wigman gave her final solo concert in 1942. In England, the new modern dance was promulgated by English exponents of Wigman and Laban's practices and the first UK-based American modern dancers. Kurt Jooss's Ballets Jooss toured his anti-war 'dance-drama' *The Green Table* throughout the United Kingdom and the Americas. During the war years, starting in 1941, there was a growing interest in the educational application of modern dance and Laban re-emerged as an authority.

In *The Modern Dance* (1935), the 'symposium' discussed in the last chapter, there were essays by both Humphrey and Weidman written by Paul Love, but quoting the dancers directly and indirectly at length. Love encapsulated the fundamentals of Humphrey's practice memorably:

> Miss Humphrey has called movement the arc between two deaths. Thus, movement is essentially unbalance, and the degree of unbalance conditions the intensity of the movement.... There is no Being (which would be a permanent stoppage at either of the poles) but only a continual Becoming between these two poles of immobility.[4]

Humphrey is quoted directly about the art of making dances or, as Love puts it, the 'content of the dance':

> In choosing a theme for a dance, theoretically I claim the world, at least the Western World, as possible material.... I said that the world is ours theoretically. Practically, it is not. In the first place, some themes, however stirring to the imagination they may be, are static in their essence and do not permit of a movement treatment.[5]

Again, although Humphrey is clearly talking about choreography, she does not speak of herself as, or have Love describe her as, a choreographer. The emphasis is on the theme, or what the dancer dances about. This is consistent with her earlier writings of the late 1920s and early 1930s.

The ideas that she was developing at this time are the ones that were realised in *New Dance* (1935). Humphrey wrote about her thinking for this work at the time.[6] These writings mark a transition from solo dance to group dances that are more capable of dealing with the themes of the contemporary situation. She describes the dance in some detail in relation to the rest of the trilogy – *Theatre Piece* and *With My Red Fires*. She speaks of herself as a dancer and addresses herself to other modern dancers. In the following passage she talks about how it expressed the

DOI: 10.1057/9781137439215.0008

liberal, progressive, democratic ideals that made it such a profound and timely dance:

> In almost the entire dance world I had seen nothing but negation. Anyone could tell you what was wrong but no one seemed to say what was right. It was with this mental conflict that I approached *New Dance* first, determined to open up to the best of my ability the world as it could be and should be: a modern brotherhood of man.[7]

She says that 'the individual has a place within that group'.[8] Hers is a bold new approach to reconciling the individual and the group because 'too many people seem content to achieve a mass-movement and then stop. I wished to insist that there is also an individual life within that group life'.[9] Humphrey goes on to describe the way she works in some detail and to give a vision for this new approach, which 'broadens the field of the modern dance, gives it a new life and a new potency'.[10] In *New Dance*,

> solo dances flow out of the group and back into it again without break and the most important part *is* the group. Except for an occasional brilliant individual, the day of the solo dance is over. It is only through the large use of groups of men and women that the modern dance can completely do what it has always said it would do. It has not done it before mainly because a new technique and new forms had to be evolved.[11]

New Dance premiered at Bennington on 3 August 1935. The Bennington Summer Schools provided opportunities for dancers to show their work, to teach and to talk with each other in a higher education setting. In the early summer schools from 1934 to 1937 a number of dancers, notably Graham, Holm, Humphrey and Weidman, led lecture discussions and gave lecture demonstrations. Many modern dancers who taught there had begun to articulate their practice in writing at this time. Graham was quoted extensively in American newspapers.[12] The archives show that Holm, Humphrey and Weidman all wrote during this period for lecture demonstrations and, in the case of Humphrey, for potential publication.[13] A section from a manuscript for a book provisionally titled 'What a Dancer Thinks About' lays out Humphrey's thinking about making dances, with an emphasis on dance and the dancer, rather than the choreographer, although she does use the word.

This is a period when other dancers began to appear in print. Helen Tamiris wrote about dance groups in 1936 and José Limón was interviewed for *Dance Observer* in 1937.[14] It was during this period that Katherine Dunham conducted her anthropological researches and

DOI: 10.1057/9781137439215.0008

developed her performance practice; she captured the latter in an article that acknowledged the former.[15] With the exception of Hanya Holm, German modern dancers and American exponents of their approaches had little to say in US publications after 1935. Ted Shawn, who was now leading his all-male dance company, chose to distance himself from his contemporaries. He admonished them:

> A group of American dancers have taken to themselves this word 'modern' to describe their personal style of dancing. This personal style has been greatly influenced by the personal style of Mary Wigman and other Germans of her school, although this American group are at great pains to disclaim any such influence. In both German and American groups, we find so great a similarity, however, that they can, for all practical purposes, be discussed as one. Both are born of revolt against what they considered limitations – not realizing that two utterly different concepts of the dance may be complementary, rather than deadly enemies.[16]

The international discourse did continue in some quarters. The exiled German dancer Kurt Jooss gained considerable attention thanks to his company's international tours. The following brief statement, which encapsulates his vision well, comes from a programme from Ballet Jooss's 1938 US tour, one that brought his prescient *The Green Table* (1932) to new audiences:

> We believe in the Dance as an independent art of the Theatre, an art which cannot be expressed in words, but whose language is movement built up of forms and penetrated by the emotions.
>
> We aim therefore at discovering a choreography deriving equally from the contributions of modern art and from the technique of the classic Ballet.[17]

In Australia another – Austrian – exile, Gertrud Bodenwieser, gave extensive tours of her Viennese version of modern dance. A programme statement gives her ideas of the 'Aims of the Modern Dance':

> Every work of art is the expression, through a form, of an adventure of the soul every epoch has its own form of artistic expression, showing so the inner feeling of the soul of the people of that age.…The idea of the new dance is that it has taken up relationship to the great stream of modern life…a world full of problems and fight, and also of great ideas and developments.[18]

During the late 1930s, there was a continuing comment on the modern dance in *The Dancing Times*. In 1938, there was a surge of interest in anticipation of possible tours by two prominent American exponents.

DOI: 10.1057/9781137439215.0008

When articles by Graham and Humphrey appeared in *The Dancing Times* in December 1938 under the banner 'This Modern Dance: Two Important American View-Points' their views gave a hint of the different thinking of modern dancers in the months leading up to the start of World War II.[19] However, unlike a decade earlier, when a flurry of articles had accompanied Wigman's first performances in England, there was to be no opportunity for London audiences to see Humphrey dancing; and Graham's debut had to wait a further 16 years.

Humphrey talks in general of American dance, and of her and Weidman's particular approach.

> The modern American dance.... is something so uniquely of the American spirit, expressed in terms so contemporary and characteristic of the time and place, that it must be seen before it becomes tangible enough to discuss in the same breath with more familiar forms.... It is dance for to-day, understandable in to-day's language.[20]

Graham, in her article, which was an essay previously published in America, talks of the 'modern dance, as we know it today' and the work of the dancer–choreographer (the first use of the term). She speaks in a way that typifies the approach that she will use for the next two decades.

> To understand dance for what it is, it is necessary we know from whence it comes and where it goes. It comes from the depths of man's nature, the unconscious, where memory dwells. As such it inhabits the dancer. It goes into the experience of man, the spectator, awakening similar memory.[21]

Graham is writing (in the 1937 original) at a time when her dance for Spain at the time of its Civil War, *Immediate Tragedy*, premiered at Bennington.[22] In August of the year that this was published in *The Dancing Times*, 1938, Graham premiered *American Document* at Bennington.[23] The 'libretto' for *American Document* was published in full in *Theatre Arts* in 1942.[24] This nine-page written score for the dance outlines its five episodes and its spoken narrative. In some structural respects there is a similarity to Wigman's dance poem of 1921, but what the librettos have to say, both metaphorically and literally, is worlds apart. *American Document* is a dense work, as is the libretto and much has been written about it.[25] What stands out, in the context of this chapter, are the questions that are asked (and answered) in each episode:

> An American – What is an American?
>
> America – what is America?

DOI: 10.1057/9781137439215.0008

> An American – What is an American?
>
> The United States of America – what is it?[26]

Finally, in answer to the proclamations 'America! Name me the word that is "courage"… "justice"… "power"… "freedom"… "faith".

> Here is that word – Democracy![27]

So this is the proclamation that was made on 6 August 1938 at the Vermont State Armory. Graham's work spoke for itself, as dance, and spoke, literally, to the Bennington audience, and beyond.

The dancers' contributions to the later Bennington Summer Schools were predominantly in the studio and the theatre. An opening did arise elsewhere for words about the new modern dance to be given a public voice, one that led to a publication that ably demonstrated the breadth of thinking of the time. In 1939, a seminar series was organised at Boston University by its director of physical education, Frederick Rand Rogers, working with, amongst others, local dancer Mary Starks.[28] The 15 seminar series brought together 20 dancers, educators and 'theorists' including Graham, Humphrey, Holm, Shawn, Martin and Walter Terry, for lectures and demonstrations.[29] Rogers published the lectures in a June 1941 book, thereby capturing the moment in a way that harks back to Armitage and Stewart's book of six years earlier. The dancers' talks are designed for a series on the educational benefits of dancing but Graham, Humphrey and Holm write of their work in a way that speaks of the modern dancer at this moment.

All three dancers speak of themselves and of their practice as dancers. Humphrey repeats some of the ideas from her 1938 *Dancing Times* article in an open declaration that highlights and develops the idea of a dancer being historically and geographically located.

> I believe that the dancer belongs to his time and place and that he can only express that which passes through or close to his experience. The one indispensable quality in a work of art is a consistent point of view related to the times.[30]

In the earlier *Dancing Times* article she had talked of how, for Weidman and herself, 'the dancer must belong to his time and place and that he can only express that which passes through or close to his experience' before continuing with a statement about the 'new dance of action', 'the American dance', 'born of this new world' that then reappeared in 'My Approach to the Modern Dance'.[31]

DOI: 10.1057/9781137439215.0008

She goes on to develop a conceptually coherent 'approach to the modern dance' that sets out the basis for both a technical training and introduction to composition for the young modern dancer. The technical training stresses her idea of fall and recovery, a development of Love/Humphrey's (1935) account, and she introduces design studies and choreography.[32] Although she talks of her modern dance as American, she does so as part of her thinking that dance as art is composed from direct experience. She does still maintain that modern dance is essentially technically different from 'the dehumanization' of ballet[33] and that it is the one that can deal with contemporary life.

Graham, speaking shortly after showing *American Document* (1938) at Bennington, is, as ever, forthright. She begins her 'certain basic principles' by saying 'I am a dancer' and talks of her aim to 'dance significantly.'[34] It is here, in what became a well-known statement of principle, that she lays out her 'primer for action' and the basis of her technique.[35] Significantly, she introduces her ideas on technique because the approach taken by an individual dancer is no longer the best basis for a group, although technique is a means to an end, not an end in itself.[36] Holm contributed an 'essay' focused on one of her key principles: 'the attainment of conscious, controlled movement' in relation to gravity.[37] All three dancers write about the technical and educational basis of their practice.[38] The changed dancer's world that they describe comes into sharp relief when compared with some of the other writings in the same volume. Ruth St Denis's piece on dance as spiritual expression harks back to a past era inflected through her particular American Christian spirituality.[39] Juana de Laban writes about Laban's 'principles and methods' and the use of movement choirs as if nothing had changed in Germany since 1933.[40]

Clearly, the educational context for these lectures and the subsequent book gave a certain consistency of style and approach, although some of the other contributors wrote in a markedly different way. Nonetheless, it is striking that there are substantial similarities in tone, content and vision of Graham, Humphrey and Holm's contributions. Most particularly, all three place a great emphasis explicitly on 'technique' and discipline. The tone is very different from the comparable essays of 1935; it is more confident, definite and convincing. The following passages have been selected to show how the three dancers – they still refer to themselves as dancers – talk of their art. Martha Graham says:

> The instrument of the dance is the human body; the medium is movement....
> It has not been my aim to evolve or discover a new method of dance training,

DOI: 10.1057/9781137439215.0008

but rather to dance significantly....Training, technique, is important; but it is always in the artist's mind only the means to an end. Its importance is that it frees the body to become its ultimate self.[41]

For Doris Humphrey:

my entire technique consists of the development of the process of falling away from and returning to equilibrium [italics in original]. This is far more than a mere business of 'keeping your balance', which is a muscular and structural problem. Falling and recovery is the very stuff of movement, the constant flux which is going on in every living body, in all its tiniest parts, all the time.[42]

To dance well, technical mastery of the body is the first prerequisite. And since my dance grows out of natural bodily movement, training for it must involve natural movements.[43]

Hanya Holm, it will be remembered, had been criticised in the early 1930s for her lack of 'technique'. Here she is unequivocal about the rigour of her practice:

In order to arrive at the essential fundamentals of conscious, controlled movement, I start with sheer, physical hard work. To exercise the body until it becomes a known entity. Through the discomfort of strain, the attention of the student is called to the point where work is needed. Then, through continued practice, the body becomes so sensitively aroused that the parts have come to have a local knowledge, muscular sense, and react kinesthetically... The value lies, not in reproducing movements, or sequences of movements, but rather in achieving a body that is alert and controlled. One cannot practice balance, poise, assurance, ease. The instrument must be mastered so that one has balance, poise, assurance, and ease.[44]

There is a marked difference between these statements by practising dancers who had developed their performance and training at Bennington and the definitive statement on her approach to dance made by Margaret H'Doubler, of the University of Wisconsin, at the same time. H'Doubler had given a lecture demonstration at the first Bennington Summer School and visited in 1938, but was not involved to any greater extent than that. Neither was she part of Roger's Boston University seminar series. Her practice, and her writing, had been developing within the higher education context of the dance degree course at University of Wisconsin, a very different setting for the dancer.

H'Doubler's third book, *Dance: A Creative Art Experience*, was published in 1940. Its title is important, as it does not constrain itself to education. Indeed C.H. McCloy in the editor's introduction to the first edition

DOI: 10.1057/9781137439215.0008

points out that H'Doubler was concerned with the 'basic fundamentals of *all* dance' and her aim was to 'integrate *all* forms into their proper places as seen in the perspective of a complete and unified philosophy of that art.[45] Interestingly, the second largest chapter (of nine) is devoted to 'Technique and Expression'. Here the idea of technique is in contrast to those of Graham, Holm and Humphrey, but the idea that technique is there to serve a means to expressing an inner life is remarkably similar.

> Any work of art begins with a purpose and grows through technique. In dance, as in every art, it is essential to train the mind to use some tool as an instrument with which to mould a medium into an art form.
>
> In dance the body is employed as the instrument, and movement as the medium. Consequently, a dancer has two goals to keep in view. First he must train the mind to use the body... Second, he must train the body to be responsive to the expressive mind.[46]

It is notable that here, and throughout, the book is addressed to the dancer. H'Doubler's principles are for dance and those who dance; and this is open to all. The educational side is introduced because schools (and universities) are the places where dance can be introduced to people. Her book is

> A discussion of the basic aspects and enduring qualities of dance, which are within the reach of everyone. Its main purpose is to set forth a theory and a philosophy that will help us to see dance scientifically as well as artistically.[47]

It is important to stress the universality of H'Doubler's vision. Ross points out the divide that opened up – in the United States of America – between 'professional' modern dance training and the dance education developing in American colleges and universities: 'for H'Doubler, sustaining this separation between dance as an educational enterprise, as she practiced it, and dance as a performing art, as emphasized in the professional New York studios, was fundamental'.[48] Interestingly, like many others of the period, she did visit the Mary Wigman Dresden School in 1937.[49]

Throughout *Dance: A Creative Art Experience* the emphasis is on the experience, on the process of learning to dance and to create, rather than the product, the artwork.[50] For H'Doubler:

> Of all the art forms, dance is the most generally available, since everyone finds the instrument needed for his purpose in his own body.... In observing and evaluating the life patterns that surround him, he [the student] has a chance to

DOI: 10.1057/9781137439215.0008

become more understanding, more sympathetically respectful of the inner life of others, and so to enter through the gate of his own experience into a universal understanding. At the same time he enriches his own emotional life.[51]

In her extensive annotated bibliography H'Doubler includes a recently published English book, Diana Jordan's *The Dance as Education*.[52] Jordan, a teacher, had been working with Leslie Burrowes and with the American dancer Louise Soelberg and in the late 1930s they had founded a Dance Centre in London.[53] The early exponents of European-derived modern dance in Britain had sought to establish in professional practice as much as in educational practice. However, in a way that echoed the American experience, a divide was to open up between professional dance training and the development of what came to be known as modern (educational) dance in formal British education. However, this did not happen until after World War II. During the late 1930s, both at Dartington Hall where the Jooss-Leeder School was based, and in London, especially around the practices of the Dance Centre, there was a parallel development of modern dance as both a concert dance practice and as an educational practice.

Jordan, as the title of her book indicates, was explicitly concerned with dance as education. Her small book of 84 pages was the first dance book to be published by Oxford University Press – a most significant achievement. Jordan makes it clear that she is writing from her own experience and that she is proposing the benefits of *modern* dance in education. There is a substantive difference between this and what eventually became known as 'modern educational dance' after the publication of Laban's book of that name, although Laban's practice, flourished in the mid-1940s, was developed with and was supported by Jordan and others.[54] She says:

> Modern dance is a form of self-expression which is sane and healthy, because it requires hard work, and a certain amount of drudgery in acquiring technical skill, if the individual is to get any satisfaction out of it, and some people may find in modern dance their only, or their best means of self-expression.

> The chief value of modern dance is to introduce a dramatic element into dance, and make it not only an act of the body, but a combination of mind and body. Modern dance is an interpretation of every scene and emotion of life.[55]

Like Humphrey she stresses the benefits of working together that modern dance brings: 'one learns to work in one large pattern, and not only in individual movements'.[56] She concludes that modern dance 'teaches one all sides of dancing' and 'spontaneity is the great characteristic of modern dance'.[57]

DOI: 10.1057/9781137439215.0008

Jordan's book was published in the year that Laban arrived in Britain. Soelberg's pamphlet appeared four years later at a time when British schoolteachers were taking a renewed interest in modern dance, and when Laban himself began teaching again.[58] Soelberg wishes to relate modern dance to 'progressive educative principles':

> For the dance is a means of man's expression like all other arts, and in them it is the same living fire, 'movement' which is manifested. But it is clear that DANCING itself is the primary manifestation of this re-creating force, and this can be fully conveyed to us through modern and creative dance teaching.[59]

Jordan's book remains a significant work, which bears some comparison with H'Doubler's. H'Doubler concludes her 1940 book by answering the question 'why dance?':

> The dancer who has understood the process of composition should be able to carry over his knowledge into a technique of artistic living. In creating a style of life, one is ever searching for ways to become more sensitive to the many stimuli that constantly bombard mankind, seeking how best to evaluate and select experiences and meanings, and trying to organize these innumerable and conflicting elements into coherent patterns of behavior that reveal a life well integrated and adjusted to its environment, which, when all is said, is any one man's greatest art achievement. The contribution dance can make to such living is its primary value to an individual life and to society.[60]

H'Doubler is interesting because she is not place-specific in her writings. Her writing, by reaching for universality, has as much to say about freedom and democracy as her compatriots in the professional dance sector. She eschews the term 'modern dance' but makes it clear in her survey that she looks to a new dance that is American, a dance expressive of its people.[61] In this sense, the American perspective characterises her book as much as the educational one. Like Humphrey and Graham, she is an advocate of the 'new world'. That world was to change beyond recognition following the United States of America's entry into World War II in 1942.

Notes

1 Doris Humphrey, 'My Approach to the Modern Dance', In Frederick Rand Rogers, ed., *Dance: A Basic Educational Technique*, 188–192 (New York: Macmillan, 1941), 188.

DOI: 10.1057/9781137439215.0008

2 Shawn cites his earlier book *The American Ballet* (1926). See Ted Shawn, *Dance We Must* (London: Dobson, 1946), 93–94.

3 For the definitive account, see Sali Ann Kriegsman, *Modern Dance in America – The Bennington Years* (Boston, MA: G.K. Hall, 1981).

4 Doris Humphrey and Paul Love, 'The Dance of Doris Humphrey', In Virginia Stewart and Merle Armitage, eds, *The Modern Dance*, 59–70 (New York: Privately Published, 1935; repr. Dance Horizons, 1970), 62. John Martin, in the foreword to the Dance Horizons edition of 1970, called Love's statement for Humphrey 'quite the best statement anywhere to be found of a specific approach to creative practice that delves all the way down to the roots of universality as no other theory has done in this country since Isadora, and in Europe since Wigman'.

5 Humphrey, 'The Dance of Doris Humphrey', 69.

6 The writing 'New Dance' has been republished in two slightly different versions, both dating the original manuscript to 1936: Doris Humphrey, 'New Dance', In Selma Jeanne Cohen, ed., *Doris Humphrey: An Artist First*, 238–241 (Middletown, CT: Wesleyan University Press, 1972); 'New Dance', In Kriegsman, ed., *The Bennington Years*, 284–286.

7 Humphrey, 'New Dance', Kriegsman, 284.

8 Humphrey, 'New Dance', Kriegsman, 284.

9 Humphrey, 'New Dance', Cohen, 240.

10 Humphrey, 'New Dance', Cohen, 241.

11 Humphrey, 'New Dance', Cohen, 241.

12 See, for instance, the extensive extracts from 27 sources cited in Merle Armitage, ed., *Martha Graham* (Los Angeles, CA: Armitage, 1937. Reprint and republished by Dance Horizons, New York, 1966).

13 The Jerome Robbins Dance Research Collection at the New York Public Library for the Performing Arts holds substantial material including notes, book drafts, correspondence relating to Humphrey, H'Doubler and Holm. Recently, Tresa Randall has used material on Holm to draw attention to the development of her written ideas in the period 1931–1934. See Tresa Randall, 'Hanya Holm and an American *Tanzgemeinschaft*', In Susan Manning and Lucia Ruprecht, eds, *New German Dance Studies*, 79–98 (Urbana: University of Illinois Press, 2012).

14 Helen Tamiris, 'Dance Groups', *Dance Observer* (May 1936): 49, 56; Naomi Lubell, 'José Limón: Interview', *Dance Observer* (August–September, 1937), 78.

15 Katherine Dunham, 'Thesis Turned Broadway', In Veve A. Clarke and Sarah E. Johnson, eds, *Kaiso: Writings by and about Katherine Dunham*, 214–216 (Madison, WI: University of Wisconsin Press, 1941, 2005) (first published in *California Arts and Architecture*, August 1941).

16 Ted Shawn, 'The "Modern" Dance', In *Fundamentals of a Dance Education*, 25–27 (Girard, Kansas: Haldeman-Julius, 1937), 25–26.

17 Kurt Jooss, '[Untitled Statement]', In *Ballet Jooss Dance Theatre US Tour Programme*, 3 (New York: Nicolas Publishing, 1938).

18 Gertrud Bodenwieser, 'Aims of the Modern Dance', The Viennese Ballet Australian Tour 1940 Programme, In Bettina Vernon-Warren and Charles Vernon-Warren, eds, *Gertrud Bodenwieser and Vienna's Contribution to Ausdruckstanz*, 51–56 (Amsterdam: Harwood Academic, 1999).

19 The *Dancing Times* had reported extensively on the dance emerging from Germany in the 1930s, although, unlike its US counterparts such as *Dance Observer*, there was little direct comment on the political situation. There had been sporadic mention of the modern dance from the United States of America, including in the regular New York Letter. There was considerable interest generated in 1938 by an article by F.L. Orme titled 'The Modern Dance in America: Are We Overlooking It?' in an issue where the New York Letter mentioned Graham, Humphrey and Weidman. Margaret Einert, inspired by Orme's article, went to that year's Bennington Summer School and wrote an extensive piece on it, followed by acknowledgement from the Sitter Out who, in turn, cited John Martin. See F.L. Orme, 'The Modern Dance in America: Are We Overlooking It?', *The Dancing Times* (February 1938), 644–647; Margaret Einert, 'Bennington...July...1938: Focal Point of the American Modern Dance', *The Dancing Times* (September 1938), 645–648; The Sitter Out, 'This Modern Dance and Other Notes', *The Dancing Times* (November 1938), 135–137. Einert gave a guest lecture that year at Bennington on 'Dance in England'.

20 Doris Humphrey, 'This Modern Dance; Two Important American View-Points', *The Dancing Times* (December 1938), 272–274, 274.

21 Martha Graham, 'This Modern Dance; Two Important American View-Points', *The Dancing Times* (December 1938), 270–272, 270. See original in Martha Graham, 'Graham 1937', In Merle Armitage, ed., *Martha Graham*, 83–88 (Los Angeles, CA: Armitage, 1937. Reprint and republished by Dance Horizons, New York, 1966). There is no acknowledgement of the original 1937 source in the 1938 article. The 1937 essay was written especially for Armitage's book.

22 30 July 1937 Vermont State Armory.

23 6 August 1938 Vermont State Armory.

24 Martha Graham, 'Dance Libretto: American Document', *Theatre Arts* 26, no. 9 (1942): 565–574.

25 See, especially, most recently, Mark Franko, *Martha Graham in Love and War: The Life in the Work* (New York: Oxford University Press, 2012).

26 Graham, 'American Document', 567, 569, 571, respectively.

27 Graham, 'American Document', 574.

28 Mary Starks, a Boston American dancer and teacher, had trained at the Dresden Wigman School.

DOI: 10.1057/9781137439215.0008

29 'B. U. Program Stresses Dance; Experts in Series Will Lecture and
 Demonstrate Its Values in Physical Education', *The New York Times*, 29
 January 1939; Joy Weber, *The Evolution of Aesthetic and Expressive Dance in
 Boston* (Amherst: Cambria Press, 2009), 169–178.

30 Humphrey, 'My Approach to the Modern Dance', 188.

31 Humphrey, 'This Modern Dance', 272: compare with Humphrey, 'My
 Approach to the Modern Dance', 188.

32 Humphrey, 'My Approach to the Modern Dance', 188. There is an editorial
 footnote (192) that mentions the book that Humphrey was working on; her
 full account of choreography as the art of making dances would have to wait
 a further two decades for posthumous publication in Doris Humphrey, *The
 Art of Making Dances* (New York: Rinehart, 1959).

33 Humphrey, 'My Approach to the Modern Dance', 188.

34 Graham, 'A Modern Dancer's Primer for Action', In *Dance: A Basic
 Educational* Technique, 178–187. It is notable that Graham's autobiography,
 published half a century later, begins with 'I am a dancer' too: Martha
 Graham, *Blood Memory* (New York: Doubleday, 1991).

35 Graham, 'A Modern Dancer's Primer for Action', 184–187.

36 Graham, 'A Modern Dancer's Primer for Action', 178–179.

37 Hanya Holm, 'The Attainment of Conscious, Controlled Movement', In Rand
 Rogers, ed., *Dance: A Basic Educational Technique*, 298, 299.

38 There is an interesting consonance between some of the writings of 1939/1941
 collected by Rogers and the publication of other books on dance and
 education in the late 1930s: Ted Shawn's *Fundamentals of a Dance Education* of
 1937, Diana Jordan's *The Dance as Education* of 1938 and Margaret H'Doubler's
 Dance a Creative Art Experience of 1940 all promulgate the idea of the benefits
 of an education through modern dance as art: Ted Shawn, *Fundamentals of
 a Dance Education*, 25–27 (Girard, Kansas: Haldeman-Julius, 1937); Diana
 Jordan, *The Dance as Education* (London: Oxford University Press, 1938);
 Margaret H'Doubler, *Dance: A Creative Art Experience* (Wisconsin: University
 of Wisconsin Press, 1957) (first published by New York: F.S. Crofts, 1940).

39 Ruth St Denis, 'Dance as Spiritual Expression', In *Dance: A Basic Educational
 Technique*, 110, 109.

40 Juana de Laban, 'Basic Laban Principles and Methods', In *Dance: A Basic
 Educational Technique*, 202.

41 Graham, 'A Modern Dancer's Primer for Action', 178–179.

42 Humphrey, 'My Approach to the Modern Dance', 189.

43 Humphrey, 'My Approach to the Modern Dance', 191.

44 Holm, 'The Attainment of Conscious, Controlled Movement', 299.

45 C.H. McCloy, Editor's Introduction, In Margaret H'Doubler, *Dance: A
 Creative Art Experience* (New York: F.S. Crofts, 1940), vii, viii. The second
 (1957) and later (1998) editions do not include the original Editor's

DOI: 10.1057/9781137439215.0008

Introduction nor the extensive 27-page Bibliography/Annotated Reading List.

46 H'Doubler, *Dance: A Creative Art Experience*, 70.

47 H'Doubler, *Dance: A Creative Art Experience*, xi, xii.

48 Janice Ross, *Moving Lessons: Margaret H'Doubler and the Beginning of Dance in American Education* (Madison, WI: University of Wisconsin Press, 2000), 166.

49 Ross says that the 'one professional modern dance artist whom H'Doubler regarded highly' was Wigman. She has H'Doubler and then several 'alumnae of her dance program' visiting Wigman's School 'just prior to the outbreak of World War II': Ross, *Moving Lessons*, 164. Ross points out that a number of the drawings by H'Doubler's husband, Wayne Claxton, are of Kreutzberg and that Kreutzberg visited H'Doubler and Claxton on a number of occasions. See Ross, *Moving Lessons*, 164. In a Marcia Lloyd interview with Elizabeth (Betty) Hayes Wilson et al., there is mention of the visit to the Wigman School and this is given as 1937. See Appendix 2, Margaret H'Doubler's Personal Data Sheet, Thomas K. Hagood and Marcia L. Lloyd, 'Chapter Three: The Middle Years, 1932–1942: Interviews with Elizabeth R. Hayes Part Two', In John M. Wilson, Thomas K. Hagood and Mary A. Brennan, eds, *Margaret H'Doubler: The Legacy of America's Dance Education Pioneer*, 70–93.

50 Ross makes substantial comparisons, not always favourably, with John Dewey's *Art as Experience* of 1934. It is also worth noting that much of H'Doubler's thinking, not least about the social benefits of art, are reminiscent of Collingwood's *The Principles of Art* of 1938.

51 H'Doubler, *Dance: A Creative Art Experience*, 164–165.

52 Diana Jordan, *The Dance as Education* (London: Oxford University Press, 1938).

53 Leslie Burrowes and Louise Soelberg established the Dance Centre in London on 3 October 1938. They were joined in 1939 by the educationalist Diana Jordan and others and proceeded to run classes, performances and talks on modern dance with some success in the early 1940s.

54 Rudolf Laban, *Modern Educational Dance* (London: Macdonald & Evans, 1948). This was the second of Laban's English publications. It relied heavily on, and acknowledged, the contributions of Lisa Ullmann and Veronica Tyndale Biscoe. In many respects, it echoes some of Jordan's concern for the modern dance in education, but also encompasses both Laban's earlier ideas about the art of movement and his then current interest in movement study in industry.

55 Jordan, *The Dance as Education*, 79.

56 Jordan, *The Dance as Education*, 79.

57 Jordan, *The Dance as Education*, 80.

58 Louise Soelberg, 'Modern Dance: What Is It?' (TRT Publication, 1942). The copy held by the NRCD University of Surrey has a handwritten inscription

DOI: 10.1057/9781137439215.0008

by Soelberg: 'To Mr Laban – with deep appreciation for your invaluable assistance. Louise – March 1942' (NRCD: LB/E/91).

59 Soelberg, 'Modern Dance', 2, 8.

60 H'Doubler, *Dance: A Creative Art Experience*, 167–168.

61 H'Doubler, *Dance: A Creative Art Experience*, 34.

DOI: 10.1057/9781137439215.0008

6
Conclusion: A Dancer's World

Abstract: *This chapter concludes that modern dancers of the period 1920–1945 wrote about their practices mainly in terms of their dancing. In this sense it was a dancer's world. Modern dancers did begin to refer to themselves as choreographers too and this began to mark changes in their practice. In the ensuing decade, the 1950s, some new dancers, such as Merce Cunningham, began writing of their dancing. The practice extolled by Martha Graham in her film A Dancer's World and in Doris Humphrey's The Art of Making Dances marked a distinction between up and coming practices and those of the pre-war period too. Dancers' writings include those of Merce Cunningham, Martha Graham, Doris Humphrey and Pearl Primus.*

Keywords: choreography; dancer's world; dancing; modern dance

Huxley, Michael. *The Dancer's World, 1920–1945: Modern Dancers and Their Practices Reconsidered*. Basingstoke: Palgrave Macmillan, 2015. DOI: 10.1057/9781137439215.0009.

I began this book by making the historical point that the modern danc-ers of the 1920s and 1930s spoke of themselves, almost exclusively, as dancers. That is also how contemporary critics and historians spoke of them. The dancer's world was precisely that, the world of the dancer. And yet, as I also indicated, that world has come to be redefined as part of the choreographer's world. There can be no doubt that the modern dance of this period changed markedly in its nature. In rethinking the idea of the dancer's world from the point of view of the dancer, I have endeavoured to allow the changes in this world to be revealed. When dancers' writings, which talk about the dancers themselves and their contemporaries almost exclusively as dancers, are considered together, the instances where they think of themselves as 'choreographers' stand out. I will return to these instance in this conclusion.

Modern dancers thought of themselves as part of a bigger picture – of modern dance. Most of their writings addressed what they were doing in relation to their peers and often they named other dancers' practices in trying to work out what they were doing. To a large extent there was a transatlantic discourse about the ideas that helped form the modern dance. There was a striving to develop and promote dance practices, with a focus on the activity of dancing itself. This led to a concern for what dance might express of the dancer's self, or what they might dance about. Modern dancers wrote of their work as solo performers, and about how they made work for their dance groups. Most of them had a concern for a wider dissemination of their practice in education practices involving their fellow dancers as professionals and the wider public too.

In the Introduction I said that dancers contributed to the discourse about modern dance. They helped define its scope. Merle Armitage and Virginia Stewart's collection of 1935, *The Modern Dance*,[1] helped make the new transatlantic discussion about the form visible, from a dancer's point of view. From a dancer's perspective, 'modern dance' became a term of common currency from the late 1920s, most especially in Germany and the United Kingdom. From 1935 onwards, it became the commonly used term to describe practices that, whatever their differences, were suffi-ciently similar to warrant some agreement. By the 1940s, it was a term used by most American and British dancers, as well as the critics, to mark out a territory whereas in Germany it had been eclipsed.[2]

American, British and German dancers' writings were inflected by their experience and this, to a large extent, echoed the dances they performed. Many of them, notably Doris Humphrey and Hanya Holm,

DOI: 10.1057/9781137439215.0009

recognised the importance of the milieu in which they worked. Some dancers wrote of themselves as American or German dancers who were creating a modern dance that could express the particularity of that experience where the resulting dance was recognisably American or German. Some were quite outspoken in this, notably Isadora Duncan in her later writing, Martha Graham and Mary Wigman. At the same time, there was a recognition and acknowledgement by many modern dancers that modern dance was wider, more international, in many of its commonalities. Some, such as Hanya Holm and Elizabeth Selden, sought a rapprochement between the technical bases of American and German dance. Whilst there might be different emphases, there was an almost universal concern to make a new dance form that was relevant to its time and to the young people of that time, and that meant an almost wholesale rejection of the technique and aesthetics of ballet.

The sense of modern dance encapsulating the dancer's experience and the idea of dance being relevant for its time gives a focus for the great changes that happened during the early 1930s. Certain German dancers wrote of a changed idea of dance that perfectly captured their embrace of a new idea of what the world might be like: Rudolf Laban and Mary Wigman, in particular, rewrote their earlier ideas of the whole man expressing himself universally in terms of a new, fascist vision of Germany. This new idea of German Dance entered the transatlantic modern dance discourse in a way that must have been, at the time, disarmingly similar to the advocacy of a need for an American Dance. However, the underlying thinking was profoundly different. A drying up of new ideas and new writings in Germany highlighted the retrogressive nature of this thinking. What was said was concerned with justifications of dance as being German, in the Third Reich's sense. This is in marked contrast to Wigman's earlier idea of dance for the modern woman. At the same time, dancers working in the United States of America and the United Kingdom did continue to develop their ideas about dancing and how modern dance can, as dance, be relevant in its time. Graham, Humphrey and Holm, in particular, but not exclusively, developed their ideas at this time in ways that changed the idea of what modern dance was and of how it could achieve something significant. They, along with other dancers, including Kurt Jooss and Jane Dudley, developed ideas about the need for modern dance to expand a technical basis and an extended notion of composition that enabled them to make works on a

DOI: 10.1057/9781137439215.0009

larger scale that sprang from modern dance and spoke to the needs of the time.

It was in this situation that modern dancers began to talk of themselves as choreographers. They did so, it seems, neither to separate themselves from their fellow dancers, nor to emulate the choreographers of the ballet. The turn from dancer to choreographer was a very subtle one that took place during the 1930s as dancers gathered at the Bennington Summer Schools of Dance and at Dartington Hall. The change was driven by the imperative for dance to deal with great issues. 1935 was the year when the transatlantic modern dance discourse saw the writings on the new German dance, revised for an American audience, presented alongside its more progressive contemporaries. It was also the year when modern dancers working in America began to articulate fully the changing nature of the new modern dance that was emerging. It was the year when Graham asked for the American choreographer to make a modern dance for the United States of America. It was the year that Humphrey and Weidman premiered *New Dance*, with its hopeful vision for the future at a time of great turmoil. This new idea of the modern dance, and what it could achieve, is the one captured by the critics in the same year when they wrote of Humphrey as a great choreographer. The writings coming out of the United States of America in the next few years reinforced this new idea of modern dance.

In introducing this topic in Chapter 1, I noted that Margaret Lloyd, like Martin, makes an exception of Humphrey when talking of her as a 'choreographer' following her retirement from dancing'.[3] Olga Maynard in 1965 talks of how in modern dance, in contrast to ballet, 'almost every major choreographer is also a noted dancer'.[4] Humphrey, herself, added to this sense of redefining modern dance in terms of choreography and choreographers: 1959 saw the posthumous publication of *The Art of Making Dances*.[5] Her book had been over 20 years in gestation and although written in the final months of her life drew on ideas that she had developed and which had appeared in written form in the 1930s and 1940s. In it she makes a clear and coherent case for the *choreographer* as the one who will perfect the art of making dances. This was Humphrey's first major published statement for 18 years and reflects changes in her practice and that of her contemporaries. She acknowledges these changes and locates their beginnings in the introduction to her book. In an historical survey of dance she asks, 'why did choreographic theory

DOI: 10.1057/9781137439215.0009

suddenly emerge in the nineteen thirties?'[6] She locates the answer in the political upheavals of this period and goes on to say:

> In the United States and in Germany, dancers asked themselves some serious questions 'What am I dancing about?' 'Is it worthy in the light of the kind of person I am and the kind of world I live in?' 'But, if not, what other kind of dance shall there be, and how should it be organised?'

The crucial point that she makes is that it was the need to respond to the climate of the 1930s that led dancers to make work in a different way. We have seen in examples in Chapters 3–5 in particular that dancers' practices changed in the 1930s and that the term 'choreographer' began to enter the dance lexicon. Thus, John Martin began to refer to Humphrey as a choreographer in 1934;[7] Martha Graham talked of the dancer being also a choreographer in 1935[8] and in 1937 used the term 'dancer-choreographer'.[9] In the same year Humphrey in her short article on 'what a dancer thinks about' ends up talking about the 'choreographer'.[10] There do seem to be differences in ideas of how dance is made, and where, that also contribute to the development of the usage of the term choreographer. There is an opening for a further major study to establish exactly how the modern dancer changed into the choreographer in the United States of America after 1934. At this point it is perhaps pertinent to note that the annual Bennington Summer Schools began in 1934 and that the Federal Dance Project was initiated by dancers and provided funding for modern dance and a range of other forms from 1936 to 1939.

It was at the Bennington Summer Schools that many modern dancers – but notably Graham, Humphrey, Holm, Limón and Weidman – taught and premiered new works. The first Summer School of 1934 included study of the techniques of Graham, Humphrey, Holm and Weidman and dance composition was taught by Martha Hill. The 1935 School inaugurated a separate but conjoint Workshop Programme, this first one being led for technique and choreography by Martha Graham and resulting in the premiere of *Panorama*. Subsequent Schools (1936–1938) continued this pattern with Graham, Holm, Humphrey and Weidman and this is where a number of the major works referred to earlier in Chapter 5 were premiered.[11] This was followed by a further fellowship scheme in 1937–1938 which subsidised the emergent group work of Anna Sokolow, José Limón, Esther Junger, Louise Kloepper, Eleanor King and Marian van Tuyl. John Martin, who had been a major contributor to the Bennington Summer Schools, commented on both the work that had

DOI: 10.1057/9781137439215.0009

emerged from Bennington and the financial climate that obtained in the 1930s and early 1940s. Writing in 1943, after the United States of America had entered World War II, he reinforced the idea of American dancers creating a 'new world':

> Through unbelievable effort and personal heroism these results have at last been, if not materialized as richly as adequate financing would make possible, at least admirably realized both in principle and in detail. In Doris Humphrey's great *New Dance* trilogy, in Martha Graham's *Letter to the World*, in Hanya Holm's *Trend*, a new world of dance has been opened.
>
> But as yet this mightily potential art has not been allowed to enter the promised land of financial security, where alone its values can be realized in material shape.[12]

Thus, whilst the ways modern dance addressed the world had changed significantly, the financial situation needed to allow it to flourish had lagged behind.

I have made the point that the modern dance of the period 1920–1945 differed from the modern dance that followed World War II. Indeed, recent studies by Gay Morris, Rebekah Kowal and Mark Franko[13] have suggested that whilst American modern dance ideas developed in the 1930s, there were major changes in the post-war period that troubled and changed the very idea of modern dance. It is interesting to consider how modern dancers wrote of themselves in the later period as a way of highlighting this difference and in order to emphasise the particularity of the dancer's world of the 1920s and 1930s.

A decade after Frederick Rogers's compilation of dancers' writings, Walter Sorell published his compilation of 1951, *The Dance Has Many Faces*.[14] It is clear that this is a personal selection of commissioned writings from both ballet and modern dance, although Sorell does not dwell on such a distinction. Thus it cannot be taken to be representative, but, nevertheless, it includes a number of dancers who had begun their careers in the earlier period, as well as some notable newcomers. Martha Graham did not write; Ruth St Denis and Doris Humphrey did; Hanya Holm wrote about Mary Wigman's practice; José Limón, Helen Tamiris and Charles Weidman contributed. Rudolf Laban wrote about his new educational work in England in a way reminiscent of *The World of the Dancer*, but as if nothing significant had happened in the world in the intervening years.[15] Two new figures made significant contributions. Pearl Primus wrote about African dance, ending with a plea:

DOI: 10.1057/9781137439215.0009

The spirit which was responsible for the dynamic dance and the exciting forms of yesterday is merely underground... [*sic*] Sometime it will spring forth in a seemingly new form. This time, let us hope, the world will open its arms to welcome it and place it without reservation where it belongs with the greatest.[16]

Another dancer to have a profound effect on dance in the coming decades was Merce Cunningham. In 1951, he had spent six years dancing with the Martha Graham Company and over a decade making his own work including at the Bennington Summer Schools; he premiered *Sixteen Dances for Soloist and Company of Three* in 1951. His first major essay 'The Function of a Technique for Dance' is most interesting as it is addressed to the dancer and would not have been out of place alongside Graham's, Humphrey's and Holm's contributions to Frederick Rogers's 1941 compilation (as discussed in the previous chapter).[17] He writes that 'the technical equipment of a dancer is only a means, a way, to the spirit' and:

The final and wished-for transparency of the body as an instrument and as a channel to the source of energy becomes possible under the discipline the dancer sets for himself – the rigid limitations he works within, in order to arrive at freedom.[18]

In many ways the year 1951 marked a turning point for the modern dance, and we are fortunate to have this essay which, as well as restating much that was said in the previous decade, is a bellwether for the changes to come. *Sixteen Dances for Soloist and Company of Three* was the first of Cunningham's works to utilise chance procedures. His essay does not talk about chance procedures as such, but it can be read, with hindsight, in those terms, and, as such, marks a real break with the past: 'An art process is not essentially a natural process; it is an invented one. It can take actions of organization from the way nature functions, but essentially man invents the process'.[19]

In terms of dancers' writings Cunningham's essay could be said to mark both the end of the modern dance period and the beginning of a new era. Writings after 1951 are of a different order and a different time.

I will end with a consideration of the historical perspective given by two examples of later statements by modern dancers who had developed their practice in the period before World War II. They have been chosen because in many ways they draw attention to two of the central concerns of this book – the modern dancers' experiences and the ways in which they made their dances. Both statements – a film and a book – appeared

DOI: 10.1057/9781137439215.0009

at a time when the practices of modern dance were being questioned, leading to the new practices that emerged in the 1960s. Nonetheless, both in their own ways continued to have a lasting effect and were taken to be paradigmatic statements about modern dance despite the fact that they were products of the post-war period rather than the 1920–1945 period discussed in this book.

In 1957, Martha Graham and her Company featured in a film titled *A Dancer's World.*[20] It is a well known and often referred to document of the modern dance of the post-war era. Graham introduces the film. In her script she talks of the dancer. It is still the dancer who is central: she does not talk of the choreographer's world. Much of what she says harks back to her 1941 statement, where she had pronounced 'I am a dancer'.[21] However, this is a refined, even rarefied dancer's world, one that is self-selective for the individual who takes on a rigorous technical self-discipline: it is a world of the studio and the theatre. It is one where the dancer needs 'ten years' of study so that the 'house of the body can hold its divine tenant, the spirit'.[22]

In 1959, as mentioned earlier in this chapter, Doris Humphrey's *The Art of Making Dances* was published. She attributes the development of modern dance in the years since the 1930s to dancers in both the United States of America and Germany who responded to the violent upheavals of the period through dance. She also acknowledges the growth of dance courses in the education system and the growing need for compositions for students. She addresses the rest of the book to 'the choreographer'.[23] Indeed, she goes so far as to have one chapter titled 'Choreographers Are Special People'.[24] However, as we have seen, when she identifies the 1930s as the crucible for changes in modern dance she says:

> In the United States and in Germany, dancers asked themselves some serious questions. 'What am I dancing about?' 'Is it worthy in the light of the kind of person I am and the kind of world I live in?' 'But, if not, what other kind of dance shall there be, and how should it be organised?'[25]

She then goes on to talk about what happened in the following years as follows:

> The dancers in the United States took fully ten years to think about these problems, to detach themselves from the patterns of life and work which enmeshed them, and set themselves to evolve a dance of their own. I was one of the dancers who was fortunate enough to be in at the beginning of these stirring times.[26]

DOI: 10.1057/9781137439215.0009

Even though Humphrey is writing in 1958 in a book that is clearly addressed to aspiring choreographers, where choreographers are now described as 'special people', when she talks historically of the 1930s she refers to herself and to her fellow Americans as *dancers*. It seems to me that this is an excellent historical point to end on.

Notes

1 Virginia Stewart and Merle Armitage, eds, *The Modern Dance* (New York: Dance Horizons, 1970 (first published 1935, New York: E. Weyhe).

2 The usage of the term by dancers can be traced chronologically through their writings. The following chronological list highlights writings where usage by dancers of the term 'modern dance' is employed as a description of their practice in the period. In some examples 'modern dance' appears in the title, in others it is to be found in the body of the writing.

Mary Wigman, 'The Central European School of Dance (2)', *The Dancing Times* (December 1928), 324.

Elizabeth Selden, *Elements of the Free Dance* (New York: A.S. Barnes, 1930), 157 (glossary: 'modernistic').

Valeska Gert, 'Dancing', In Valerie Preston-Dunlop and Susanne Lahusen, eds, *Schrifttanz a View of German Dance in the Weimar Republic* (London: Dance Books, 1990) (first published as 'Tanzen', *Schrifttanz* 4, no. 1 (June 1931): 5–7) ('Welchen Platz hat der moderne Tanz in der Kunstgeschichte der Zeit', p. 5 in the original).

Ruth St Denis (Motion Picture) *Moments from Famous Dancers*, Dir. Philip Baribault, Paramount Pictures (1932/1933). ('What is called the modern or classical dance was begun by two American pioneers – the late Isadora Duncan and myself'.)

Leslie Burrowes, 'The Modern Dance Movement in England', *The Dancing Times* (January 1933), 452–453, 452.

Mary Wigman, 'The Philosophy of Modern Dance', In Selma Jeanne Cohen, ed., *Dance as a Theatre Art*, 149–453 (New York: Harper & Row, 1974) (first published in *Europa* 1, no. 1 (May–July 1933)).

Elizabeth Selden, *The Dancer's Quest* (Berkeley: University of California Press, 1935).

Martha Graham, 'The American Dance', In Merle Armitage and Virginia Stewart, eds, *The Modern Dance* (New York: Dance Horizons, 1970), 53–58 (first published, New York: E. Weyhe, 1935).

Hanya Holm, 'The German Dance in the American Scene', In Armitage and Stewart, eds, *The Modern Dance*, 79–86.

Harald Kreutzberg, 'The Modern Dance', In Armitage and Stewart, eds, *The Modern Dance*, 29–34.

Gret Palucca, 'My Dance', In Armitage and Stewart, eds, *The Modern Dance*, 25–27.

Mary Wigman, 'The New German Dance', In Armitage and Stewart, eds, *The Modern Dance*, 19–24.

Leslie Burrowes, 'Modern Dance', *The Ling Association Leaflet* (July 1936), 331–332. NRCD: LB/E/3/7.

Martha Graham, 'Graham 1937', In Merle Armitage, ed., *Martha Graham*, 83–88 (Los Angeles, CA: Armitage, 1937; repr. New York: Dance Horizons, 1966).

DOI: 10.1057/9781137439215.0009

Ted Shawn, 'The "Modern" Dance', In *Fundamentals of a Dance Education*, 25–27 (Girard, Kansas: Haldeman-Julius, 1937).
Martha Graham, 'This Modern Dance: Two Important American View-Points', *The Dancing Times* (December 1938), 270–272.
Doris Humphrey, 'This Modern Dance: Two Important American View-Points', *The Dancing Times* (December 1938), 272–274.
Martha Graham, 'A Modern Dancer's Primer for Action', In Frederick Rand Rogers, ed., *Dance: A Basic Educational Technique*, 178–187 (New York: Macmillan, 1941).
Doris Humphrey. 'My Approach to the Modern Dance', In Rogers, ed., *Dance: A Basic Educational Technique*, 188–192.
Louise Soelberg, 'Modern Dance: What Is It?' (TRT Publication, 1942). NRCD: LB/E/91.

3 Lloyd, *The Borzoi Book of Modern Dance*, 76. Humphrey stopped dancing on 26 May 1944.

4 Maynard, *American Modern* Dancers, 173–174.

5 Doris Humphrey, *The Art of Making Dances* (New York: Rinehart, 1959).

6 Humphrey, *The Art of Making Dances*, 18.

7 Martin, *Introduction to the Dance*, 259–260. *New Dance* was, in fact, premiered in 1935, on 3 August at Bennington.

8 Graham, 'The American Dance', 57.

9 Martha Graham, 'This Modern Dance; Two Important American View-Points', *The Dancing Times* (December 1938), 270–272, 270. See the original in Martha Graham, 'Graham 1937', In Merle Armitage, ed., *Martha Graham*, 83–88 (Los Angeles, CA: Armitage, 1937. Reprint, republished by Dance Horizons, New York, 1966). There is no acknowledgement of the original 1937 source in the 1938 article. The 1937 essay was written especially for Armitage's book.

10 Doris Humphrey, 'What a Dancer Thinks About', 1937, In Cohen, ed., *The Vision of Modern Dance*, 55–64 (identified by Cohen as unpublished Ms. from NYPL Dance Collection).

11 See Sali Ann Kriegsman, *Modern Dance in America: The Bennington Years* (New York: Harper Row, 1981). Group works resulting directly from the workshop/professional programme were, chronologically, *Panorama* (Graham, 1935); *With My Red Fires* (Humphrey, 1936); *Quest* (Weidman, 1936); *Trend* (Holm, 1937); *American Document* (Graham, 1938); *Dance Sonata* (Holm, 1938); *Passacaglia* (Humphrey, 1938); *Opus 51* (Weidman, 1938).

12 John Martin, 'The Dance Completes a Cycle', In Sali Ann Kriegsman, ed., *Modern Dance in America: The Bennington Years* (New York: Harper Row, 1939), 288–290 (first published 1943 in *American Scholar* 12, no. 2 (Spring 1943): 205–215).

13 Gay Morris, *A Game for Dancers: Performing Modernism in the Postwar Years, 1945–1960* (Middletown, CT: Wesleyan University Press, 2006); Rebekah J. Kowal, *How to Do Things with Dance: Performing Change in Postwar America* (Middletown, CT: Wesleyan University Press, 2010); Mark Franko, *Martha*

DOI: 10.1057/9781137439215.0009

Graham in Love and War: The Life in the Work (New York: Oxford University Press, 2012).

14 Walter Sorell, ed., *The Dance Has Many Faces* (New York: World Publishing Company, 1951). This edition differs in content from the subsequent editions.

15 The notes on contributors give a negationist account of the 1930s and Laban's complicity with the State: 'The freedom thus bestowed on them [Laban centres for movement for the "common people"] amidst the wickedness of Nazidom [*sic*], and Laban, with some of his pupils, sought sanctuary in England'. See Sorell, *The Dance Has Many Faces*, 279.

16 Pearl Primus, 'Out of Africa', In Sorell, ed., *The Dance Has Many Faces*, 255–258.

17 Rogers, *Dance: A Basic Educational Technique*.

18 Merce Cunningham, 'The Function of a Technique for Dance', In Sorell, ed., *The Dance Has Many Faces*, 250–255, 251.

19 Cunningham, 'The Function of a Technique for Dance', 251.

20 Peter Glushanok, '*A Dancer's World [Martha Graham]*' (Pittsburgh: WQED-TV, 1957).

21 Graham, 'A Modern Dancer's Primer for Action', In *Dance: A Basic Educational* Technique, 178–187.

22 Martha Graham, 'A Dancer's World', *Dance Observer* 25, no. 1 (January 1958): 5.

23 Humphrey, *The Art of Making Dances*.

24 Humphrey, *The Art of Making Dances*, 20–25.

25 Humphrey, *The Art of Making Dances*, 18.

26 Humphrey, *The Art of Making Dances*, 18.

DOI: 10.1057/9781137439215.0009

Epilogue: A Historical Sense of a Dancer's World

Abstract: *This chapter revisits the idea of history and how it is relevant to an understanding of the dancer's world of the twenty-first century. A recent example of a critic's and a dancer's writing is considered to give substance to the sense of the historical in the present. Readers are encouraged to revisit the modern dance of the period 1920–1945 to consider again how modern dancers wrote of the practice of dancing.*

Keywords: dance artists; dance students; dance teachers; new media; young dancers

Huxley, Michael. *The Dancer's World, 1920–1945: Modern Dancers and Their Practices Reconsidered.* Basingstoke: Palgrave Macmillan, 2015. DOI: 10.1057/9781137439215.0010.

DOI: 10.1057/9781137439215.0010

In my preface I said that this book's central thesis was that an examination of dancers' writings can contribute a new, additional perspective to the history of modern dance and that my account places dancers at the centre of their own narrative and shows how they have contributed to history in its widest sense. This has been, unashamedly, a historical account. I concur wholeheartedly with Mark Franko's conclusion in his recent monograph on Martha Graham that 'the history of dance is not "dance history", but in fact, *history*'.[1] Why, then, is history important for today's dancers?[2]

I acknowledged R.G. Collingwood as a historian who had recently inspired me to look afresh at dance, and modern dance in particular. In his autobiography of 1939, Collingwood said:

> We study history in order to see more clearly into the situation in which we are called upon to act. Hence the plane on which, ultimately, all problems arise is the plane of 'real' life: that to which they are referred for their solution is history.[3]

What then does this historical account of modern dancers writings and practices have to say to the contemporary situation?

When the dancers who are featured in this book wrote for the newly established periodicals of the early part of the twentieth century they did so to try and articulate what the dancer's world was for them at that time. They wrote for themselves and for dancers and others within a relatively small sphere of influence. In many cases it is only later that those writings became more generally known, contributing to the canon of modern dance. They wrote to promote their new forms of practice and to help define their world. They established a practice of modern dance writing, a precedent that has helped those who have followed. Although some wrote for others within their sphere of influence[4] and many acknowledged other modern dancers, few worked together as dance writers.[5]

Their public writings pose a number of questions. Can writing help develop and articulate my practice as a dancer? How might I promote my ephemeral dance practice through the inscribed word? Does writing help develop a community of practice for dancers? How can writing contribute to an understanding of the world as it is for the dancer? How can dancing articulate my experience? A consideration of these questions for the dancers of the past can help open up possibilities for the practitioner of the present. I believe strongly that, by engaging in a historical approach to dance, past ideas about practice can reveal their contemporary relevance.

DOI: 10.1057/9781137439215.0010

The twenty-first century poses different problems for the dancer. It is a changed world to that of the period described in this book. Dance practice has changed. So has writing. So has dance writing.[6] The written word has become ubiquitous, but the new ways in which it is read – such as in emails, texts, tweets, blogs and posts – offer different possibilities to those of a century ago, not least in terms of the speed of response and the way ideas are then disseminated.[7]

So what do the writings of modern dancers in books, magazines, journals and newspapers of the early twentieth century have to say to dancers today who are more likely to be found voicing their thoughts through Facebook, Twitter, Tumblr and on-line blogs? I will take one recent example of one dancer's contribution to contemporary discourse about the nature of dance and its making to highlight the continuing need for historical perspective. The example does indeed talk of problems on the plane of real life. It is raised within the discourse enabled by the new world of digital media. Finally, it begs consideration because it talks of dancers and choreographers and a name evocative of modern dance – Martha Graham.[8]

In 2010, the respected British dance critic Judith Mackrell posted an item on her *Guardian Culture* on-line critic's notebook blog. In her post 'There is no sense of family in dance now'[9] she bemoaned the lack of a sense of 'family' in contemporary dance, compared with ballet, because dancers 'want to experiment with as wide a range of choreographers and styles as possible'. It is in the nature of such posts that a response is encouraged. Theo Clinkard, a dancer, choreographer and teacher, responded fully.[10] Mackrell's short post touched on a number of issues – working conditions, a quest for experimentation and the relationship between dancer and choreographer. All these were addressed fully by Clinkard in his three-part response from the point of view of an artist with substantial experience of working with many other dancers and choreographers as a dancer, choreographer, teacher and designer. He spoke passionately about his dancer's world.

A real life problem raised by the original post is to do with ideas of the (contemporary) dancer and the choreographer. In bemoaning the lack of family, of permanence, in contemporary dance, Mackrell invokes the past:

> It's no accident that the pioneering choreographers of the last century – Martha Graham, Merce Cunningham et al – worked with a core of dedicated

DOI: 10.1057/9781137439215.0010

performers. Dancers are a choreographer's instrument: it's tough when they don't stay in one place.[11]

Clinkard, in his thoughtful response, takes issue with the term 'instrument' and, speaking from his own experience, says:

> Most dances are now made in an entirely different collaborative and far more democratic way. The archaic term 'instrument' is simply inapplicable, dancers are articulate collaborators and artists in their own right.[12]

He points out that he has many years' experience responding creatively to others and that

> It is very different from the widely held view that steps are still created by the choreographer and taught to dancers.[13]

He acknowledges that 'the Cunningham and Graham company dancers were working in a radically different dance climate'. However, what he really objects to, throughout, is the idea that dancers are 'instruments'. He ends by saying:

> Contemporary dancers are brilliant, loyal, creative articulate artists and god knows they have it hard without being referred to as undedicated instruments that just learn styles.[14]

In many ways, a number of the issues under discussion here seem at first sight to call on the past, not least in the appeal to authorities like Graham. Collingwood, in his 1939 autobiography, wrote with admirable clarity about how history, in looking at the past, can help us understand the present:

> If the function of history was to inform people about the past, where the past was understood as a dead past, it could do very little towards helping them to act; but if its function was to inform them about the present, in so far as the past, its ostensible subject-matter, was incapsulated in the present and constituted a part of it not at once obvious to the untrained eye, then history stood in the closest possible relation to practical life.[15]

So let us look at what is being said in the Mackrell/Clinkard exchange in terms of how the past is encapsulated in the present by reference to what has been explored in *A Dancer's World*.

First, the idea of the dancer as the choreographer's instrument just does not occur in the modern dancers' written account of modern dance before 1945. Dancers referred to themselves and their fellows as dancers and it is evident that they did so to give themselves agency. They distanced

themselves from ballet because it did not give them the freedom and scope to deal with the big issues of the time. The differences between the modern dance and the ballet in the 1920s and 1930s in particular are encapsulated in the implicit and explicit differences between contemporary dance and ballet in the 2010 discussion. Mackrell's phrase is almost identical to Peter Brinson and Peggy van Praagh's description of the dancer in their account of *The Choreographic Art* in ballet, as cited in the Introduction:

> The dancer is the choreographer's human instrument.[16]

The use of the terms dancer and choreographer in this way does not do justice to the wealth of twenty-first-century contemporary dance practices including Clinkard's. The irony is that many of the very features of these practices – collaboration, democratic ways of working, artists in their own right – were being explored and negotiated in the 1930s in modern dance, as we have seen. Indeed, some of the most significant works of modern dance are tributes to these alternative (to ballet) ways of working, and the dancer's world of the period, as found in modern dancer's writings, is further evidence of progressive ideas about what dance might do. This is why the elision between ideas of 'pioneering' and 'choreographers', citing Martha Graham and Merce Cunningham with their 'core of dedicated performers' and 'dancers' as a 'choreographer's instrument', borrowed from the ballet of half a century ago, is so striking. Graham made a number of statements in the period that distanced her work from the ballet. Maybe Graham should be allowed to speak for herself. When talking of 'interpretive dancing' and 'the traditional ballet', she said, in 1935:

> But they are not for us. What they have sought to express, we no longer create. We deny their influence over us, and embark upon our own art-form.[17]

Later, in 1941, she reflected:

> As a result of twentieth-century thinking, a new or more related movement language was inevitable. If that made necessary a complete departure from the dance form known as ballet, the classical dance, it did not mean that ballet training itself was wrong. It was simply found not to be complete enough, not adequate to the time, with its change of thinking and physical attitude.[18]

This was written at a time when she was working with her tightly knit group of dancers. The way she worked with them after World War II did indeed change. However, at the time that she was pioneering the modern

DOI: 10.1057/9781137439215.0010

dance, not least at Bennington, she had a quite clear view that was not derived from ballet. Indeed, she saw herself in opposition to the ballet. That fact is one that resonates down the years and gives substance to ideas that contemporary dance of the twenty-first century is not predicated on the idea that dancers are a choreographer's instrument.

Throughout my account I have insisted on seeing the dancers of the period as they saw themselves, as dancers, and have shown that the term embraced a range of practices, including composition and choreography, but that this did not make them 'choreographers' as such. This term was certainly used in ballet, but was largely eschewed by modern dancers, taking on significance only as they developed their practices into the post-war period. Indeed, I began my account with a consideration of the seemingly ubiquitous use of the term and how it had been inaccurately applied to the modern dance of the 1920s and 1930s. It is more than a matter of vocabulary. It is of historical significance and resonates in discussions about today's practice.

History is important. I hope that dancers writing today will find encouragement from those of an earlier period and that they too may find inspiration to develop their own writings and practices in new directions.

Notes

1 Mark Franko, *Martha Graham in Love and War: The Life in the Work* (New York: Oxford University Press, 2012), 177.
2 Dancers today talk of themselves as dancers, dance artists, artists, improvisers, performers, teachers and indeed as choreographers. In this final short chapter my use of the term dancer as a descriptor for the current century embraces all of these.
3 R.G. Collingwood, David Boucher and Teresa Smith, *R. G. Collingwood: An Autobiography and Other Writings: With Essays on Collingwood's Life and Work* (Oxford: Oxford University Press, 2013), 114.
4 For instance, Ruth St Denis and Ted Shawn's *Denishawn Magazine* (1924–1925) and Mary Wigman's *Die Tanzgemeinschaft* (1929–1930). The *Laban Art of Movement Guild News Sheet*, published to promote the work of Laban and his followers in England in 1948 – currently *Movement, Dance and Drama* – could lay claim to be the longest running dance-practitioner-based periodical.
5 The journal *Schrifttanz* (Written Dance) (1928–1931) was published to promote discussion of, and through, dance notation. It became a vehicle

DOI: 10.1057/9781137439215.0010

for a broader discussion of dancers' writing. However, although it featured dancers' writings more significantly than any other dance journal of the period, it was edited by a publisher, Alfred Schlee of Universal Edition, not a dancer.

6 Although modern dancers wrote for the newly founded early dance magazines these were not established and managed by dancers. This changed in the 1970s with the establishment of magazines to give platforms to dancers, for dancers, by dancers. *Contact Quarterly* had its first issue in the winter of 1976 in California, as a development of *Contact Newsletter* of 1975, and *New Dance* appeared in London, with its first issue in early 1977. *New Dance* flourished for 44 issues and 11 years as a magazine 'by, for and about today's dancers'. *Contact Quarterly* is still published as 'a vehicle for moving ideas'. The latter has embraced the digitisation of writing with an on-line journal and a website. Others followed them, notably *Movement Research* in 1990, which now makes a substantial on-line contribution to artists' discussions. *New Dance* has recently been digitised by De Montfort University. 'Movement Research'. Accessed 3 October 2014, http://www.movementresearch.org. 'Contact Quarterly'. Accessed 3 October 2014, http://www.contactquarterly.com.

7 The media available have changed for dancers and writers. Both have benefited from the digitisation of the moving image and the word. There are now many outlets for the documentation of practitioners' work – anyone can set up a website, Facebook page or blog, and many do. Not only that, but these writings can be readily collected, connected and shared, as, for instance, with dance bloggers. 'Dancebloggers'. Accessed 3 October 2014, http://www.dancebloggers.com. Social media open up opportunities for dissemination and promotion with a scope undreamed of a 100 years ago. Some artists now include substantial video archives of their work on their websites but far fewer include their writings. There are some excellent live discussion forums that have been archived, notably by Siobhan Davies Dance. 'Siobhan Davies Dance'. Accessed 3 October 2014, http://www.siobhandavies.com. A number of dancers, choreographers and teachers have used academic research to develop their writing and practice and to contribute to peer-reviewed journals. Recently, there have been initiatives where practitioners have collaborated to develop their own writings about dance largely outside an academic context. Two of the most notable recent examples are *BellyFlop* (est. 2008) in London and *thINKingDance* (est. 2011) in Philadelphia, PA. There is, then, a growing interest in practitioners writing about themselves and others. These writings develop the discourse in a way that complements but is different from the many live discussions that have taken place in recent years.

DOI: 10.1057/9781137439215.0010

8 I am grateful to Gwen Nelson for alerting me to the on-line discussion presented here.

9 Judith Mackrell, 'There is no sense of family in dance now', *Ballet Critic's Notebook* (blog), *The Guardian Culture*, 26 May 2010, http://www.theguardian. com/culture/2010/may/26/critics-notebook-judith-mackrell.

10 Theo Clinkard, comments parts 1, 2, 3 on Mackrell, 'There is no sense of family in dance now'.

11 Mackrell, 'There is no sense of family in dance now'.

12 Clinkard, comments part 1 on Mackrell.

13 Clinkard, comments part 1 on Mackrell.

14 Clinkard, comments part 3 on Mackrell.

15 Collingwood, Boucher and Smith, *R. G. Collingwood*, 106

16 Peter Brinson and Peggy van Praagh, *The Choreographic Art*, (London: A & C Black, 1963), 173.

17 Martha Graham, 'The American Dance', In Virginia Stewart and Merle Armitage, eds, *The Modern Dance*, 53–58 (New York: Privately Published, 1935; repr. Dance Horizons, 1970), 56.

18 Martha Graham, 'A Modern Dancer's Primer for Action', In Frederick Rand Rogers, ed., *Dance: A Basic Educational Technique*, 178–187 (New York: Macmillan, 1941), 180–181.

DOI: 10.1057/9781137439215.0010

A Select Bibliography
of Dancers' Writings

I list here sources written by dancers in the period, with a small number of later instances, that have been published. The majority was published at the time: a few were published later. The sources listed are those referred to in the text and in the case of republication the original source is cited too. Where writings have been further republished in edited collections that are current these are also included to aid the interested reader. All other sources cited in the text – both published and unpublished – are included in the notes section in the respective chapters.

Allan, Maud. *My Life and Dancing*. (London: Everett, 1908).

Bodenwieser, Gertrud. 'Dancing as a Factor in Education'. *The Dancing Times* (November 1926): 169, 171.

Bodenwieser, Gertrud. 'Aims of the Modern Dance'. In *Gertrud Bodenwieser and Vienna's Contribution to Ausdruckstanz*, edited by Bettina Vernon-Warren and Charles Vernon-Warren. 51–56. (Amsterdam: Harwood Academic, 1999) (first published in the Viennese Ballet Australian Tour 1940 Programme).

Burrowes, Leslie. 'The Modern Dance Movement in England'. *The Dancing Times* (January 1933): 452–453.

Burrowes, Leslie. 'Leslie Burrowes Answers Mr. Haskell'. *The Dancing Times* (March 1933): 699–701.

Burrowes, Leslie. 'Modern Dance'. *The Ling Association Leaflet* (July 1936): 331–332. NRCD: LB/E/3/7.

DOI: 10.1057/9781137439215.0011

Chilkovsky, Nadia, Anyon, Nell (pseud.). 'The Tasks of the Revolutionary Dance'. In *Dancing Modernism/Performing Politics*, Mark Franko. 113–115. (Bloomington: Indiana University Press, 1995) (first published in *New Theatre* September/October 1933).

Colby, Gertrude R. *Natural Rhythms and Dances*. (New York: A.S. Barnes, 1922).

Cunningham, Merce. 'The Function of a Technique for Dance'. In *The Dance Has Many Faces*, edited by Walter Sorell. 250–255. (New York: World Publishing Company, 1951).

de Laban, Juana. 'Basic Laban Principles and Methods'. In *Dance: A Basic Educational Technique*, edited by Frederick Rand Rogers. 193–213. (New York: Macmillan, 1941).

Dudley, Jane. 'The Mass Dance'. In *Dancing Modernism/Performing Politics*, Mark Franko. 119–122. (Bloomington: Indiana University Press, 1995) (first published in *New Theatre* December 1934).

Duncan, Elizabeth. 'Nature, Teacher of the Dance'. In *Revolt in the Arts*, edited by Oliver M. Sayler. 245–148. (New York: Brentano's, 1930).

Duncan, Isadora. *Der Tanz Der Zukunft*. [*The Dance of the Future*], edited by Karl Federn (Leipzig: Eugen Diederichs, 1903) (republished as *The Dance* (1909) by the Forest Press and as *The Dance of the Future* in *The Art of the Dance*, edited by Sheldon Cheney. 54–65. (New York: Theatre Arts Books, 1928, 1969). See also Selma Jeanne Cohen, ed. *Dance as a Theatre Art: Source Readings from 1581 to the Present*. 2nd ed. 123–129. (New York: Dodd Mead, 1992).

Duncan, Isadora. 'The Dance'. *Theatre Arts Magazine* (December 1917): 21–22.

Duncan, Isadora. 'The Dance and Its Inspiration: Written in the Form of an Old Greek Dialogue'. In *Isadora Speaks*, edited by Franklin Rosemont. 41–46. (San Francisco: City Lights Books, 1981) (first published in *The Touchstone* 5, no. 2 (October 1917)).

Duncan, Isadora. *My Life*. (London: Victor Gollancz Ltd, 1928).

Duncan, Isadora. 'I See America Dancing'. In *The Art of the Dance*, edited by Sheldon Cheney. (New York: Theatre Arts Books, 1928, 1969) (from the original Ms. Cheney, 145, first published in the New York *Herald-Tribune*, 2 October 1927).

Duncan, Isadora. *The Art of the Dance*, edited by Sheldon Cheney. (New York: Theatre Arts Books, 1928).

Duncan, Isadora. *Isadora Speaks*, edited by Franklin Rosemont. (San Francisco: City Lights Books, 1981).

DOI: 10.1057/9781137439215.0011

Dunham, Katherine. 'Thesis Turned Broadway'. In *Kaiso: Writings by and about Katherine Dunham*, edited by Veve A. Clarke and Sarah E. Johnson. 214–216. (Madison, WI: University of Wisconsin Press, 2005) (first published in *California Arts and Architecture*, August 1941).

Evan, Blanche. 'From a Dancer's Notebook'. *New Theatre* 3, no. 3 (March 1936): 16–17, 28–29.

Fuller, Loie. *Fifteen Years of a Dancer's Life*. (Boston: Small, Maynard, 1913).

Gert, Valeska. 'Mary Wigman und Valeska Gert'. *Der Querschnitt* 6, no. 5 (1926): 361–362.

Gert, Valeska. *Mein Weg*. (Leipzig: A.F. Devrient, 1931).

Gert, Valeska. 'Dancing (from a Talk Given at Radio Leipzig)'. In *Schrifttanz a View of German Dance in the Weimar Republic*, edited by V. Preston-Dunlop and S. Lahusen. (London: Dance Books, 1990) (first published as 'Tanzen', *Schrifttanz* 4, no. 1 (June 1931): 5–7).

Gleisner, Martin. *Tanz Für Alle: Von Der Gymnastik Zum Geneinschaftstanz*. (Leipzig: Hesse und Becker, 1928).

Graham, Martha. 'Seeking an American Art of the Dance'. In *Revolt in the Arts*, edited by Oliver M. Sayler. 249–255. (New York: Brentano's, 1930).

Graham, Martha. 'The Dance in America'. *Trend* 1, no. 1 (March/April/May 1932): 5–7.

Graham, Martha. 'The American Dance'. In *The Modern Dance*, edited by Virginia Stewart and Merle Armitage. 53–58. (New York: Dance Horizons, 1970) (first published 1935, New York: E. Weyhe).

Graham, Martha. 'Graham 1937'. In *Martha Graham*, edited by Merle Armitage. 83–88. (Los Angeles, CA: Armitage, 1937) (reprint, republished by Dance Horizons, New York, 1966). See also Jean Morrison Brown, Naomi Mindlin and Charles Humphrey Woodford. *The Vision of Modern Dance: In the Words of Its Creators*. 2nd ed. 50–53. (Hightstown, NJ: Princeton Book Co., 1998).

Graham, Martha. 'Affirmations 1926–1937'. In *Martha Graham*, edited by Merle Armitage. 96–110. (Los Angeles, CA: Armitage, 1937) (reprint, republished by Dance Horizons, New York, 1966).

Graham, Martha. 'This Modern Dance; Two Important American View-Points'. *The Dancing Times* (December 1938): 270–272.

Graham, Martha. 'The Future of the Dance'. In *Modern Dance in America: The Bennington Years*, Sali Ann Kriegsman. 288. (New York: Harper & Row, 1981) (first published *Dance* 6, no. 4 (April 1939): 9).

DOI: 10.1057/9781137439215.0011

Graham, Martha. 'A Modern Dancer's Primer for Action'. In *Dance: A Basic Educational Technique*, edited by Frederick Rand Rogers. 178–187. (New York: Macmillan, 1941). See also Selma Jeanne Cohen, ed. *Dance as a Theatre Art: Source Readings from 1581 to the Present*. 2nd ed. 135–143. (New York: Dodd Mead, 1992).

Graham, Martha. 'Dance Libretto: American Document'. *Theatre Arts* 26, no. 9 (1942): 565–574.

Graham, Martha. 'A Dancer's World'. *Dance Observer* 25, no. 1 (January 1958): 5.

H'Doubler, Margaret Newell. *A Manual of Dancing: Suggestions and Bibliography for the Teacher of Dancing*. (Madison, WI: Privately Published, 1921).

H'Doubler, Margaret Newell. *The Dance and Its Place in Education*. (New York: Harcourt, Brace and Company, 1925).

H'Doubler, Margaret Newell. *Dance: A Creative Art Experience*. (New York: F.S. Crofts, 1940). See also Margaret Newell H'Doubler. *Dance: A Creative Art Experience*. 2nd ed. (Wisconsin: University of Wisconsin Press, 1985).

Holm, Hanya. 'Mary Wigman'. *Dance Observer* 2, no. 8 (November 1935): 85, 91, 93.

Holm, Hanya. 'The German Dance in the American Scene'. *The Modern Dance*, edited by Virginia Stewart and Merle Armitage. 79–86. (New York: Dance Horizons, 1970) (first published 1935, New York: E. Weyhe).

Holm, Hanya. 'The Attainment of Conscious, Controlled Movement'. In *Dance: A Basic Educational Technique*, edited by Frederick Rand Rogers. 298–303. (New York: Macmillan, 1941).

Humphrey, Doris. 'Interpretor or Creator?' In *Doris Humphrey: An Artist First*, Selma Jeanne Cohen. 250–252. (Middletown, CT: Wesleyan University Press, 1972) (first published in *Dance Magazine*, January 1929).

Humphrey, Doris. 'What Shall We Dance About?' In Selma Jeanne Cohen. 252–254. (Middletown, CT: Wesleyan University Press, 1972) (first published in *Trend: A Quarterly of the Seven Arts*, June–July–August 1932).

Humphrey, Doris. 'New Dance'. In *Doris Humphrey: An Artist First*, Selma Jeanne Cohen. 238–241. (Middletown, CT: Wesleyan University Press, 1972) (document c. 1936). See also Selma Jeanne Cohen, ed.

DOI: 10.1057/9781137439215.0011

Dance as a Theatre Art: Source Readings from 1581 to the Present. 2nd ed. 144–148. (New York: Dodd Mead, 1992).

Humphrey, Doris. 'New Dance'. In *Modern Dance in America: The Bennington Years*, Sali Ann Kriegsman. 284–286. (New York: Harper Row, 1981) (document c. 1936).

Humphrey, Doris. 'What a Dancer Thinks About'. In *The Vision of Modern Dance*, edited by Jean Morrison Brown. (London: Dance Books, 1998) (Ms. from NYPL Dance Collection, 1937).

Humphrey, Doris. 'This Modern Dance; Two Important American View-Points'. *The Dancing Times* (December 1938): 272–274.

Humphrey, Doris. 'My Approach to the Modern Dance'. In *Dance: A Basic Educational Technique*, edited by Frederick Rand Rogers. 188–192. (New York: Macmillan, 1941).

Humphrey, Doris. *The Art of Making Dances.* (New York: Rinehart, 1959). See also the new edition. (London: Dance Books, 1997).

Humphrey, Doris and Love, Paul. 'The Dance of Doris Humphrey'. In *The Modern Dance*, edited by Virginia Stewart and Merle Armitage. 59–70. (New York: Dance Horizons, 1970) (first published 1935, New York: E. Weyhe).

Jooss, Kurt. 'Tanztheater Und Theatertanz'. *Singchor und Tanz* 45, no. 12 (June 1928): 154.

Jooss, Kurt. 'The Dance of the Future: In an Interview with Derra De Moroda'. *The Dancing Times* (July 1933): 453–455.

Jooss, Kurt. 'Tankünst'. In *Der Scheinwerfer. Ein Forumder Neuen Sachlichkeit 1927—1933*, edited by Erhard Schiitz and Jochen Vogt. (Essen, 1986) (first published in *Der Scheinwerfer* 1, no. 11/12 (March 1928): 23).

Jooss, Kurt. '[Untitled Statement]'. In *Ballet Jooss Dance Theatre USA Tour Programme.* 3. (New York City: Nicolas Publishing, 1938).

Jooss, Kurt and Hall, Fernau. 'An Interview with Jooss'. *The Dancing Times* (November 1945): 55–57.

Jordan, Diana. *The Dance as Education.* (London: Oxford University Press, 1938).

Jordan, Diana. 'Freedom through "Schwung" in Modern Dance'. *Ling Association Leaflet* (n.d.). NRCD: LB/E/5.

Kreutzberg, Harald. 'The Modern Dance'. In *The Modern Dance*, edited by Virginia Stewart and Merle Armitage. 29–34. (New York: Dance Horizons, 1970) (first published 1935, New York: E. Weyhe).

DOI: 10.1057/9781137439215.0011

Laban, Rudolf von. 'Symbole Des Tanzes Und Tanz Als Symbol' [Symbols of Dance and Dance as Symbol]. *Die Tat* (December 1919): 669–675.

Laban, Rudolf von. *Die Welt Des Tänzers* [The World of the Dancer]. (Stuttgart: Walter Seifert, 1920).

Laban, Rudolf von. 'Kultische Bildung Im Feste' [Religious Education in Festival]. *Die Tat* (June 1920): 161–168.

Laban, Rudolf von. 'Eurhythmie Und Rakorhythmie in Kunst Und Erziehung' [Eurhythmy and 'Rakorhythmie' in Art and Education]. *Die Tat* (May 1921): 137–139.

Laban, Rudolf von. *Die Welt Des Tänzers* [The World of the Dancer]. 2nd ed. (Stuttgart: Walter Seifert, 1922).

Laban, Rudolf von. 'Der Moderne Tanz [The Modern Dance]: Umschau [Review] Hans Brandenburg'. *Die Tat* 13, no. 2 (February 1922): 865–867.

Laban, Rudolf von. 'Festwille Und Festkultur' [Festival and Culture of Festival]. *Die Tat* (February 1922): 846–848.

Laban, Rudolf von. 'Aus Einem Gesprach Fiber Das Tanztheater' [From a Discussion about Dance Theatre]. *Die Tat* (December 1922): 676–680.

Laban, Rudolf von. 'Der Tanz Und Die Neue Generation' [Dance and the New Generation]. *Die Freude* 2, no. 9 (September 1925): 398–402.

Laban, Rudolf von. *Choreographie.* (Jena: Diederichs, 1926).

Laban, Rudolf von. *Des Kindes Gymnastik Und Tanz.* (Oldenburg: G. Stalling, 1926).

Laban, Rudolf von. *Gymnastik Und Tanz.* (Oldenburg: G. Stalling, 1926).

Laban, Rudolf von. 'Das Tanzerische Kunstwerk/Oder: Wie Es Leiben Und Leben Sollte' [The Dance Art Work/Or: How It Should Be]. *Die Tat* (November 1927): 588–591.

Laban, Rudolf von. *Schrifttanz.* (Wien: Universal-Edition, 1928).

Laban, Rudolf von. 'Dance Composition and Written Dance'. In *Schrifttanz a View of German Dance in the Weimar Republic*, edited by Valerie Preston-Dunlop and Susanne Lahusen. 38–39. (London: Dance Books, 1928, 1990) (first published in *Schrifttanz* 1, no. 2 (October 1928): 19–20).

Laban, Rudolf von. 'Die Deutsche Tanzbühne'. In *Deutsche Tanzfestspiele 1934*, edited by Deutsche Tanzbühne. 3–7. (Dresden: Carl Reissner, 1934).

DOI: 10.1057/9781137439215.0011

Laban, Rudolf von. *Ein Leben Für Den Tanz; Erinnerungen.* (Dresden: C. Reissner, 1935).

Laban, Rudolf. 'Extract from an Address Held by Mr Laban on a Meeting for Community-Dance in 1936'. *Laban Art of Movement Guild Magazine* no. 43 (November 1936, 1974): 6–11.

Laban, Rudolf. 'Dance in General'. In *Rudolf Laban Speaks about Movement and Dance*, edited by Lisa Ullmann. (Addlestone: Laban Art of Movement Centre, 1939, 1971).

Limón, José and Lubell, Naomi. 'José Limón: Interview'. *Dance Observer* (August–September 1937): 78.

McCaw, Dick, ed. *The Laban Sourcebook.* (Abingdon. Oxon.: Routledge, 2011).

Morris, Margaret. *Margaret Morris Dancing.* (London: Kegan Paul, Trench and Trubner, 1925).

Ocko, Edna. 'Letters: Anti-fascism'. *Dance Observer* 2, no. 8 (1935): 93, 95.

Ocko, Edna. In Stacey Prickett, 'Reviewing on the Left: The Dance Criticism of Edna Ocko Selected by Stacey Prickett'. In *Of, by, and for the People: Dancing on the Left in the 1930s*, edited by Lynn Garafola. 65–103. (Madison, WI: Society of Dance History Scholars at A-R Editions, 1994).

Palucca, Gret. 'My Dance'. In *The Modern Dance*, edited by Virginia Stewart and Merle Armitage. 25–27. (New York: Dance Horizons, 1970) (first published 1935, New York: E. Weyhe).

Sacharoff, Alexander. 'Bemerkungen Über Den Tanz'. *Programmzettel zum Tanz-Abend am 21 Jun 1910 in der Münchener Tanhalle.* (1910). In *Die Sacharoffs: Zwei Tänzer Aus Dem Umkreis Des Blauen Reiters.* [*Two Dancers within the Blaue Reiter Circle*], edited by Frank-Manuel Peter and Rainer Stamm. 46. (Köln: Wienand Verlag, 2020).

Selden, Elizabeth. *Elements of the Free Dance.* (New York: A.S. Barnes, 1930).

Selden, Elizabeth. *The Dancer's Quest.* (Berkeley: University of California Press, 1935).

Shawn, Ted. *Ruth St Denis: Pioneer and Prophet, Being a History of Her Cycle of Oriental Dances.* (San Francisco: John Howell, 1920).

Shawn, Ted. *The American Ballet.* (New York: Henry Holt, 1926).

Shawn, Ted. 'The "Modern" Dance'. In *Fundamentals of a Dance Education.* 25–27. (Girard, Kansas: Haldeman-Julius, 1937).

Shawn, Ted. *Dance We Must: Lectures Delivered by Mr Shawn at George Peabody College for Teachers, Nashville, Tennessee, from June 13th to July*

DOI: 10.1057/9781137439215.0011

2nd, 1938. (Pittsfield, MA: Eagle Printing and Binding Company, 1940).

Shawn, Ted. *Dance We Must.* (London: Dobson, 1946).

Soelberg, Louise. 'Modern Dance: What Is It?' TRT Publication, 1942. NRCD: LB/E/91.

St Denis, Ruth. 'The Dance as an Art Form'. *Theatre Arts Magazine* (February 1917): 75–77.

St Denis, Ruth. 'An Essay on the Future of the Dance: Ruth St Denis's Prophecy'. In *Ruth St Denis: Pioneer and Prophet, Being a History of Her Cycle of Oriental Dances,* edited by Ted Shawn. 101–116. (San Francisco: John Howell, 1920).

St Denis, Ruth. 'The Dance as Life Experience'. In *The Vision of Modern Dance,* edited by Jean Morrison Brown. 22–25. (London: Dance Books, 1998) (first published in *Denishawn Magazine* 1, no. 1 (1924): 1–3).

St Denis, Ruth. 'Dance as Spiritual Expression'. In *Dance: A Basic Educational Technique,* edited by Frederick Rand Rogers. 100–111. (New York: Macmillan, 1941).

St Denis, Ruth. 'My Vision'. *Dance Observer* (March 1940): 33, 42.

Stewart, Virginia and Merle Armitage, eds. *The Modern Dance.* (New York: Dance Horizons, 1970) (first published 1935, New York: E. Weyhe).

Tamiris, Helen. 'Dance Groups'. *Dance Observer* (May 1936): 49, 56.

Wiesenthal, Grete. *Der Aufstieg: Aus Dem Leben Einer Tänzerin.* [*The Ascent: From the Life of a Dancer*]. (Berlin: Ernst Rowohlt, 1919).

Wigman, Mary. 'Der Tänzer'. *Dresdner Neuester Nachrichten,* 29 February (1920).

Wigman, Mary. 'Rudolf Von Labans Lehre Vom Tanz'. *Die neue Schaubühne* 3, no. 5/6 (1921): 99–106.

Wigman, Mary. *Die Sieben Tänze Des Lebens – Tanzdichtung.* (Jena: Diedrichs, 1921).

Wigman, Mary. 'Der Tanz Als Kunstwerk'. *Deutsche Allgemeine Zeitung,* no. 60 (9 March 1921): 57.

Wigman, Mary. 'Kompositionen'. (Uberlingen: Seebote, 1925). 'Composition'. Translated by Walter Sorell. In *The Wigman, Mary Book: Her Writings Edited and Translated,* edited by Walter Sorell. 85–96. (Middletown, CT: Wesleyan University Press, 1925, 1975) (Sorell (1975, p. 85) refers to this as from a 'little brochure').

DOI: 10.1057/9781137439215.0011

Wigman, Mary. 'Weibliche Tanzkunst'. *Deutsches Musikjahrbuch* 4 (1926): 100–103.

Wigman, Mary. 'Tänzerisches Schaffen Der Gegenwart'. In *Tanz in Dieser Zeit*, edited by Paul Stefan. 5–7. (Wien: Universal-Edition, 1926).

Wigman, Mary. 'We Are Standing at the Beginning'. Translated by Walter Sorell. In *The Wigman, Mary Book*. 81–85. (first published in German in Stefan (1926) *Tanz in Dieser Zeit* [Dance in Our Time] as Tänzerisches Schaffen der Gegenwart pp. 5–7).

Wigman, Mary. 'The Dance and Modern Woman'. *The Dancing Times* (November 1927): 162–163.

Wigman, Mary. 'The Dance and Modern Woman'. In *The Mary Wigman Book*. 104–106. (this is an edited version of the 1927 *Dancing Times* article of the same name).

Wigman, Mary. 'Bühnentanz – Bühnentanzer'. *Die Magdeburger Tageszeitung*, 15 May 1927.

Wigman, Mary. 'Stage Dance – Stage Dancer'. Translated by Walter Sorell. In *The Wigman, Mary Book*, 107–115 (first published in *Magdeburger Tageszeitung*, 15 May 1927). See also Jean Morrison Brown, Naomi Mindlin and Charles Humphrey Woodford. *The Vision of Modern Dance: In the Words of Its Creators*. 2nd ed. 33–40 (Hightstown, NJ: Princeton Book Co., 1998).

Wigman, Mary. 'The Central European School of Dance (2)'. *The Dancing Times* (December 1928): 324.

Wigman, Mary. 'Tanz Und Gymnastik'. *Der Tanz* 1, no. 6 (April 1928): 6–7.

Wigman, Mary. 'Tanzerische Wege Und Ziele'. *Die schöne Frau* 4, no. 9 (1928): 1–2.

Wigman, Mary. 'Das "Land Ohne Tanz"'. *Tanzgemeinschaft* 1, no. 2 (April 1929): 12–13.

Wigman, Mary. 'Der Neue Künstlerische Tanz Und Das Theater'. *Tanzgemeinschaft* 1, no. 1 (1929): 1–9.

Wigman, Mary. 'Rudolf Von Laban Zum Geburtstag'. *Schrifttanz* 2, no. 4 (1929): 65–66.

Wigman, Mary. 'Der Tanzer Und Das Theater'. *Blätter des Hessischen Landestheater* 7 (1929/1930): 49–58.

Wigman, Mary. 'Wie Ich Zu Albert Talhoffs Totenmal Stehe'. *Der Tanz* 3, no. 6 (June 1930): 3–4.

Wigman, Mary. 'The Dancer'. In *The Mary Wigman Book: Her Writings Edited and Translated*, edited by Walter Sorell, 117–121 (first published

DOI: 10.1057/9781137439215.0011

as 'Die Tänzerin'. *Tanzgemeinschaft: Vierteljahrschrift für tänzerisches Kultur* 2, no. 2 (1930): 1–2).

Wigman, Mary. 'Composition in Pure Movement'. *Modern Music* 8, no. 2 (January/February 1931): 20–22.

Wigman, Mary. 'Wer Kann Tanzen, Wer Darf Tanzen?' *Der Tanz* 5, no. 11 (1932): 3–4.

Wigman, Mary. 'Das Tanzerlebnis'. *Die Musik* 11 (1933): 801–802.

Wigman, Mary. 'Der Tänzer Und Das Theater'. *Völkische Kultur, Dresden* (June 1933): 26–32.

Wigman, Mary. 'The Philosophy of Modern Dance'. In *Dance as a Theatre Art*, edited by Selma Jeanne Cohen. 149–153. (New York: Harper & Row, 1992) (first published in *Europa* 1, no. 1 (May–July 1933)).

Wigman, Mary. 'Composition – Dance and Music – the Mask – the School – Group Dance/Choreography', translated by Walter Sorell. In *The Wigman, Mary Book*, 121–131. (Sorell (p. 121) says that these extracts are from Bach (1933) *Das Wigman, Mary-Werk*. They are substantially edited sections).

Wigman, Mary. *Deutsche Tanzkunst*. (Dresden: Carl Reisner, 1935).

Wigman, Mary. 'The New German Dance'. In *The Modern Dance*, edited by Virginia Stewart and Merle Armitage. 19–24. (New York: Dance Horizons 1970) (first published 1935, New York: E. Weyhe).

Wigman, Mary. 'Die Wigman-Schule'. *Der Tanz* 13, no. 8 (August 1940): 103–108.

Wigman, Mary. 'Der Tanz in Seiner Beziehung Zu Den Übrigen Künsten'. *Hamburger Jahrbuch fur Theater und Musik* (1947): 160–173.

Wigman, Mary. *Die Sprache Des Tanzes*. (Stuttgart: Ernst Battenberg, 1963).

Wigman, Mary. *The Mary Wigman Book: Her Writings Edited and Translated*, edited by Walter Sorell. (Middletown, CT: Wesleyan University Press, 1975).

A number of books included in this select bibliography have been digitised and may be available for on-line consultation/download from the following websites in particular:

Hathi Trust Digital Library, last accessed, 21 November 2014, http://www.hathitrust.org/home.

Internet Archive, last accessed, 21 November 2014, https://archive.org.

Project Gutenberg, last accessed, 21 November 2014, http://www.gutenberg.org/wiki/Main_Page.

DOI: 10.1057/9781137439215.0011

Index

A Dancer's World (film)
(Graham 1957), 3, 92
Allan, Maud, 4, 7, 17, 19
Alston, Richard, 4
America, *see* United States of
America
America Dancing (Martin 1936),
8
American dance, 4, 8, 34–37,
42, 53–54, 56–59, 69,
72–74, 87, 90
American Document (ch.
Graham 1938), 6, 73, 75
*American Modern Dancers: The
Pioneers* (Maynard 1965),
3, 9
Armitage, Merle, 8, 54
The Art of Making Dances
(Humphrey 1959), 35,
82 n. 32, 88–89, 92
Ascona, 21, 23
Atkinson, Madge, 27 n. 27
Aurel, Rita, 18
Australia, 45 n. 16, 72
Austria, 4, 31, 33

ballet, 2, 3, 7–8, 9, 16, 17, 24,
33–34, 36, 41–42, 49 n. 71,
54, 56, 72, 75, 87–88, 90,
98–101
Ballets Jooss, 42, 52, 70
Ballets Russes, 16, 18
Banes, Sally, 4, 6
Barr, Margaret, 51

Bauhaus, 26 n. 18
Beaumont, Cyril, 7
being (dancer's), 33, 35, 36, 44
n. 8, 56, 70
BellyFlop, 102
Bennett School, Millbrook,
New York City, 47 n. 43
Bennington College Summer
School of the Dance, 6, 51,
52, 54, 69, 71, 73, 74, 75, 76,
88, 89, 91, 101
Bereska, Dussia, 23
Berlin Press Club, 11 n. 1
Bildungsanstalt Jaques-
Dalcroze, Hellerau
Dresden, 26 n. 22
Bodenweiser, Gertrud, 31, 33,
72
*The Borzoi Book of Modern
Dance* (Lloyd 1949), 6, 9
Boston University dance
seminar series, 74–76
Bourne, Matthew, 4
Bradley, Karen, 23
Brandenburg, Hans, 17, 18, 21,
26 n. 21–23
Bremser, Martha, 4
Brinson, Peter, 7, 9, 100
Burrowes, Leslie, 8, 37–40, 51,
59, 78
Burt, Ramsay, 43 n. 4

Caffin, Caroline and Charles,
18

DOI: 10.1057/9781137439215.0012

Central European Dance, 42, 49 n. 70
Chilkovsky, Nadia, 60
choreographer
 change by modern dancers to using
 term choreographer, 6, 57, 88–90,
 92–93
 use of term, 2–9, 33, 36, 37, 57–58, 70,
 71, 73, 86, 88–93
choreography, 5–8, 28 n. 46, 35–36,
 70–72, 75, 88–89, 98–100, 101,
 see also co-creator; dancer/
 choreographer; modern dance
 choreography; modern dance
Clinkard, Theo, 98–100
co-creator, 36
Colby, Gertrude, 19
von Collande, Jutta, 18
Collingwood, R.G., vii, viii, ix n. 1, xi,
 54, 97, 99
Communist Party (USA), 66 n. 57
composition, 5, 8, 21, 32, 35–36, 40, 42,
 53–54, 59, 61, 75, 79, 87, 89, 92, 101
Contact Quarterly, 102 n. 6
contemporary dance, 4, 98
Cunningham, Merce, 91
Curl, Gordon, 20

Daily Worker (USA), 60
Dance: A Creative Art Experience
 (H'Doubler 1940), 76–78
Dance Centre, London, 78
dance critics, viii, x, 3, 5, 8, 39, 60, 86,
 88, 98–100
dance education, 19, 21, 22, 29 n. 48, 32,
 33, 70, 71, 74–79, 82 n. 38, 83 n. 54,
 86, 92
Dance: Four Pioneers (film) (1966), 7
Dance in Our Time [Tanz in Dieser Zeit]
 (Stefan ed. 1926), 31
Dance Magazine, 35, 46 n. 26
Dance Observer, 64 n. 30, 71
Dance Repertory Theatre, 34
dance writers, 102 n. 5–7, *see* modern
 dancers' writings
dancer/choreographer
 relationship, 4, 5, 7, 98, 100

as a term, 33, 73
dancers, *see also* modern dancers
as how dancers talked of themselves,
 2, 3, 5, 8, 16, 17, 19, 20, 21, 22, 23,
 24, 31, 32, 33, 35, 36, 37, 38, 39,
 40–41, 51, 53–54, 54–59, 61, 70, 71,
 72, 73, 74–76, 76–78, 79, 86, 89, 91,
 92, 93, 101
dancer's world
 changing sense of, 2, 3, 43, 51, 52–53,
 57, 60–62, 75, 86–93, 97, 98, 100
dancers' writings, 2, 5, 8, 10–11,
 11 n. 4, 19, 21, 32, 52, 60–61, 69, 75,
 82 n. 38, 86–88, 90–91, 93 n. 2, 97,
 98, 100, 101, 102 n. 6, 7, 104–113,
 see also modern dancers'
 writings; individual modern
 dancers
dances, *see also* individual titles
dancing (as an activity), 2, 3, 4, 5, 8, 10,
 16, 17, 18, 19, 21, 22, 23, 24, 31, 32,
 33, 34, 35, 37, 38, 39, 41, 53, 54, 56,
 61, 72, 74, 78, 79, 86, 87, 88, 89, 92,
 97, 100
Dartington Hall, Devon UK, 38, 42, 51,
 78, 88
De Laban, Juana, 75
Denby, Edwin, 9
Denishawn Magazine, 19, 32
Denishawn School, California, 19
Deutsche Tanzkunst (German dance
 art), 52, 55, 57, 61
Deutscher Tanz, see German dance
Die Freude, 19
Dudley, Jane, 51, 60, 61, 65 n. 52, 87
Duncan, Elizabeth, 18, 34
Duncan, Isadora, 2, 3, 4, 5, 6, 7, 8, 16,
 17, 20, 21, 24, 31, 32, 33, 34, 38, 42,
 53, 69, 87
Dunham, Katherine, 4, 71

Elements of the Free Dance (Selden
 1930), 38
Elizabeth Duncan School, 34
emotion and dance, 17, 22, 32, 35, 36,
 41, 42, 58, 72, 78

England, *see* United Kingdom
Enters, Agna, 34
Europa, 40, 49 n. 64
Europe, 2, 3, 16, 18, 19, 26 n. 18,
 31, 32, 34, 51, 54, 56, 69, *see also*
 Austria; Germany; Switzerland;
 United Kingdom
Evan, Blanche, 59

Falke, Gertrud, 18
Ferguson, Niall, 44 n. 5
Festlicher Rhythmus (Wigman 1929),
 35
Flitch, J.E. Crawford, 3, 18, 19
Fokine, Mikhail, 7
Foster, Susan Leigh, 7
Franko, Mark, 11 n. 5, 90, 97
Frauentänze (*Women's Dance*) (ch.
 Wigman 1934), 57
free dance, 19, 38, 53
Free School Community Wickersdorf,
 27 n. 22
Frontier (ch. Graham 1935), 57
Fuller, Loie, 4, 7, 16, 17, 19, 24

Gardner, Sally, 7
German Dance Festival (1934), 51–52
Germany, 18–19, 22–23, 31, 33, 37,
 39–40, 42, 43 n. 4, 5, 51–52, 54,
 55–56, 58, 60, 61–62, 62 n. 4,
 69–70, 75, 86–87, 89, 92
German dance, 33–34, 40, 42, 51–62,
 69–70, 87–89
 *see also Deutscher Tanz; Deutsche
 Tanzkunst*
Gert, Valeska, 18, 31, 37
Guilbert, Laure, 52, 62 n. 4
Gleisner, Martin, 67 n. 65
Goddard, S., 20
Goebbels, Josef, 51
Graff, Ellen, 66 n. 58
Graham, Martha, 3, 4, 4–6, 7, 8, 31, 34,
 36, 39–40, 51, 55–57, 60, 69, 71,
 73–75, 77, 87–92, 97–100
Great War, 11 n. 3, 16, 18, 19,
Greek dancing, 18, 19, 34, 38

H'Doubler, Margaret, 19, 22, 76–79
history
 of dance, vii, 2, 6–9, 97–101
 in the general sense, vii–viii
 historiography of modern dance, vii,
 6, 10
Haskell, Arnold, 7
Hitler, Adolf, 31, 44 n. 5
Hodgson, John, 20, 23
Holm, Hanya, 7, 8, 36, 51, 55, 58–60, 65
 n. 52, 69, 71, 72, 74, 75, 76, 86, 87,
 89, 90, 91
Humphrey, Doris, 4, 7, 8, 9, 31, 34,
 36–37, 42, 51, 52, 55–56, 60, 61,
 69–71, 73, 74–78, 79, 86, 87, 88–91,
 92–93
Huschka, Sabine, 41
Hutchinson-Guest, Anne, 49 n. 71

Immediate Tragedy (ch. Graham 1937),
 73
Introduction to the Dance (Martin 1939),
 8

Jaques-Dalcroze, Émile, 16, 18, 26 n.
 18, 37
Jooss-Leeder School, 49 n. 71, 51, 78
Jooss, Kurt, 42, 70, 72, 87, *see also*
 Ballets Jooss; Jooss-Leeder School
Jordan, Diana, 78–79
Jowitt, Deborah, 4

Kanaille [*The Dregs*] (ch. Gert 1915), 37
Kandinsky, Wassily, 16, 26 n. 18
Kant, Marion, 23, 40, 52
Kinney, Troy and Margaret, 18, 19
Kloepper, Louise, 59, 89
Koegler, Horst, 63 n. 9
Koritz, Amy, 7
Kowal, Rebekah, 11 n. 5, 90
Kreutzberg, Harald, 34, 39–40, 52,
 55–56

Laban, Rudolf, 3, 8, 16, 17, 18, 19, 20–23,
 24, 31, 32, 36–37, 52, 61, 67 n. 65,
 70, 75, 78, 79, 87, 90

DOI: 10.1057/9781137439215.0012

The Laban School [*Die Labanschule*], 18
lay dance, 61
Lederer, Maja, 23
Leistikow, Gertrud, 18
Lewitan, Josef, 52
Limón, José, 7, 69, 89, 90
Lloyd, Margaret, 6, 8–9, 88
London, 37, 42, 78, 102 n. 6, 7
Love, Paul, 56, 64 n. 27, 70, 75

M'Ahesa, Sent, 18
Mackrell, Judith, 98–100
Manning, Susan, 24, 40, 52, 62 n. 4,
 63 n. 9, 59
Manual of Dancing (H'Doubler 1921), 19
Margaret Morris School, 47 n. 51
Martin, John, 3, 8, 9, 54, 55, 74, 88, 89
Martin, Randy, 7
Marxist-Leninist dance, 60
Massine, Leonide, 7
Maynard, Olga, 3, 6, 9, 88
McCaw, Dick, 20, 21, 23
McDonagh, Don, 4, 6, 7
Mensendieck, Elizabeth, 18
modern dance after World War II, 79,
 90–93
modern dance
 and creation, 36, 55, 57
 and creativity, 19, 36, 41, 55, 76–78,
 79, 80 n. 4, 99
 and democracy, 34, 42, 52, 60, 70–71,
 74, 79
 and emotion, 17, 22, 32, 35, 36, 41, 42,
 58, 72, 78
 and freedom, 2, 18, 52, 74, 79, 91, 100
 and the individual/individualism, 8,
 18, 19, 34, 40, 53, 56–58, 71, 75, 78,
 79, 92
 and the inner state/experience/
 feeling/life, 22, 35, 36, 37, 38, 39,
 40, 41, 42, 56, 72, 77, 78, *see also* as
 experience
 and music, 24, 26 n. 18, 33, 35, 36
 and revisionist accounts, 7
 and visual arts and artists, 16,
 26 n. 18

modern dance
 as an art form, 20, 21, 33, 55, 77, 100
 as experience, 2, 16, 17
 as expression, 8, 17, 18, 19, 37, 38, 39,
 41, 52, 55, 56, 59, 75, 77, 78, 79
 as a term, 3, 6, 19, 21, 32, 38, 61, 79,
 86, 93 n. 2
 as a term to describe social dance
 forms, 19
modern dance books, *see* individual
 titles
modern dance choreographer, 2–9, 33,
 36, 37, 57–58, 70, 71, 73, 86, 88–93
modern dance choreography, 5, 6, 8,
 28 n. 46, 35, 36, 70, 72, 75, 88, 89, 101
modern dance composition, 5, 8, 21, 32,
 35, 36, 40, 42, 53, 54, 58, 61, 75, 79,
 87, 89, 92, 101
modern dance companies/groups, 23,
 31, 34, 52, 71, 72, 75, 86, 89, 91, 92
modern dance education, 19, 21, 22,
 29 n. 48, 32, 33, 70, 71, 74–79,
 82 n. 38, 83 n. 54, 86, 92
modern dance films, *see* individual
 titles identified as (film)
modern dance forms
 absolute dance, 23, 56
 choric dance/mass dance/movement
 choir, 52, 57, 60, 61, 67 n. 65, 71, 75
 concert dance, 34, 78
 group dance, 23, 24, 35–36, 42, 57,
 60, 61, 69, 70, 71, 75, 86, 89
 solo dance, 16, 17, 23, 36, 41, 70, 71, 86
 theatre dance, 5, 32, 37, 40, 74
modern dance genealogy and
 generational accounts, 3–4, 6–7
modern dance improvisation, 40, 49, 59
modern dance pioneers, 3, 6, 7, 9, 16,
 34, 93 n. 2
modern dance performance practice, 5,
 17, 19, 24, 41, 72, 76
modern dance schools and summer
 schools, 6, 16, 18, 19, 23, 26 n. 22,
 31, 34, 37, 38, 39, 47 n. 43, 49 n. 71,
 51, 52, 53, 54, 58, 59, 74, 76, 77, 78,
 88, 89, 91

DOI: 10.1057/9781137439215.0012

modern dance technique, 5, 6, 39, 40, 56, 58, 59, 60, 71, 72, 75–77, 79, 87, 89, 91

modern dance training, 33, 35, 39, 42, 59, 75, 76, 77, 78, 100

Modern Dancing and Dancers (Flitch 1912), 3

modern dancers
see individual entries for: Allan, Maud; Aurel, Rita; Barr, Margaret; Bereska, Dussia; Bodenweiser, Gertrud; Burrowes, Leslie; Chilkovsky, Nadia; Colby, Gertrude; von Collande, Jutta; Cunningham, Merce; Dudley, Jane; Duncan, Elizabeth; Duncan, Isadora; Dunham, Katherine; Enters, Agna; Evan, Blanche; Falke, Gertrud; Fuller, Loie; Gert, Valeska; Gleisner, Martin; Graham, Martha; H'Doubler, Margaret; Holm, Hanya; Humphrey, Doris; Jooss, Kurt; Jordan, Diana; Kloepper, Louise; Kreutzberg, Harald; Laban, Rudolf; De Laban, Juana; Lederer, Maja; Leistikow, Gertrud; Limón, José; M'Ahesa, Sent; Morris, Margaret; Ocko, Edna; Oesterreich, Laura; Palucca, Gret; Perrottet, Suzanne; Primus, Pearl; Sacharoff, Alexander; St Denis, Ruth; Selden, Elizabeth; Shankar, Uday; Shawn, Ted; Soelberg, Louise; Starks, Mary; Stewart, Virginia; Tamiris, Helen; Tels, Ellen; Von Derp, Clothilde; Weidman, Charles; Wiesenthal, Grete; Wiesenthal Sisters; Wigman, Mary; Wulff, Käte

modern dancers talk of themselves as dancers, 2, 3, 5, 8, 16, 17, 19, 20, 21, 22, 23, 24, 31, 32, 33, 35, 36, 37, 38, 39, 40–41, 51, 53–54, 54–59, 61, 70, 71, 72, 73, 74–76, 76–78, 79, 86, 89, 91, 92, 93, 101

modern dancers talk of themselves as choreographers, 6, 88–90, 92–93

modern dancers' writings, *see* select bibliography and individual dancers' entries

dancers' books, 3, 17, 19, 20, 21, 22, 24, 33, 35, 38, 51, 52, 53, 54–60, 69, 70, 76, 77, 78, 86, 88, 92–93, 98
see also individual titles

dancers' essays, 17, 34–36, 41, 49 n. 65, 53, 54–60, 69, 71–73, 74–76, 91

dance journals, 19, 32, 33, 35, 39, 40, 42, 52, 71–73, 74, 98, 102 n. 6

other journals, 17, 19, 20, 23, 32, 35, 37, 40, 41, 60, 71, 98

twenty-first century new media, 98

unpublished writings, 27 n. 27, 37, 38, 39, 40, 47 n. 51, 59, 79, 102 n. 7

Modern Music, 35

modernism and modernity, 16, 19, 33

modernist dancers, 8, 38, 40

Mohr, Ernst, 23

Moments from Famous Dancers (film) (Baribault 1932/3), 93 n. 2

Monotonie I and *II* (*Drehmonotonie*) (ch. Wigman 1926), 41

Morris, Gay, 7, 11 n. 5, 90

Morris, Margaret, 19, 38

movement choirs, 75

Movement Research, 102 n. 6

Müller, Hedwig, 52, 62 n. 4

Munich, 23, 26 n. 21

National Socialist [Nazi] State, 8, 26 n. 21, 52, 68, *see also* Nazism and NSDAP

National-Socialist Teachers' Federation, 63 n. 8

natural dancing, 18, 19, 38, 53

Nazi Germany, 40, 58, 63 n. 9, *see also* Nazism; Nazi party; NSDAP; National Socialist State

Nazi party, 40

Nazism, 42, 43 n. 4

DOI: 10.1057/9781137439215.0012

new dance
as modern dance, 20, 23, 31, 37, 38,
54, 55, 69, 72, 79
as post-modern dance, 102 n. 6
New Dance (ch. Humphrey 1935), 8, 52,
60, 70–71, 88, 90
New Dance, 102 n. 6
New Dance Group, 51–52, 60
new media, 98
New Theatre, 60
New York, 53, 55, 58, 59, 77, 81 n. 19
New York Herald-Tribune, 33
Nijinsky, Vaslav, 23
Noverre, Jean Georges, 7
NSDAP Nationalsozialistische
Deutsche Arbeitpartei [National-
Socialist German Workers Party]
(Nazi party), 31, 44 n. 5

Ocko, Edna, 60, 61
Oesterreich, Laura, 18
Olympic Youth (1936), 52

Palucca, Gret, 55–56
Pastorale (ch. Wigman 1929), 35
Pavlova, Anna, 18
Periodicals, *see* dancers' writings;
individual italicised entries
Perrottet, Suzanne, 23
post-modern dance, 6, 98–99
Preston-Dunlop, Valerie, 23
Prickett, Stacey, 62 n. 4
Primus, Pearl, 9, 90

Reichsinstitut für Bühnentanz, 69
Reichskulturkammer (Ministry of
Culture), 52
Reynolds, David, 44 n. 5
Rogers, Frederick Rand, 74, 90, 91
Ross, Janice, 77, 83 n. 49, 50

Sacharoff, Alexander, 16, 18, 23
Sachsenmaier, Stephanie, 20–22
Sayler, Oliver, 34
Schlemmer, Oskar, 26 n. 18
Schrifttanz, 101 n. 5

Selden, Elizabeth, 3, 8, 31, 36, 37–38,
47 n. 43, 53–54, 87
Shankar, Uday, 9, 51
Shawn, Ted, 6, 7, 69, 72
Singchor und Tanz, 52
Siobhan Davies Dance, 102 n. 7
*Sixteen Dances For Soloist and Company
of Three* (ch. Cunningham 1951),
91
skirt dancers, 25 n. 4
Soelberg, Louise, 78–79
Sorell, Walter, 24, 36, 41, 90
St Denis, Ruth, 4, 6, 7, 18, 20, 24,
44 n. 8, 75, 90, 93 n. 2
Starks, Mary, 74
Stefan, Paul, 31
Stewart, Virginia, 8, 51, 53, 54–55, 60,
61, 74, 86
Strike (ch. Dudley 1934), 61
students
dance students, vii–viii, x, 98, 101
Switzerland, 17, 21, 23, 31

Talhoff, Albert, 40
Tamiris, Helen, 34, 71, 90
Der Tanz, 32, 52
Tanzgemeinschaft, 40
Die Tat, 19–21
Tels, Ellen, 18
Terry, Walter, 74
Theatre Arts, 73
Theatre Arts Magazine, 19
Theatre Piece (ch. Humphrey 1936)
The Dance (Martin 1946), 8
The Dance and Its Place in Education
(H'Doubler 1925), 19, 22
The Dance of the Future (Duncan 1903),
2, 17
The Dancer's Quest (Selden 1935), 3, 8,
53
The Dancer's World see *The World of the
Dancer* (Laban 1920)
The Dancing Times, 19, 32, 33, 39, 44, 72,
73, 74
The Green Table [*Der grüne Tisch*] (ch.
Jooss 1932), 42, 52, 70, 72

DOI: 10.1057/9781137439215.0012

The Modern Dance [*Der Moderne Tanz*]
 (Brandenburg 1913, 1917, 1921), 18,
 21, 26 n. 22
The Modern Dance (Martin 1933), 3, 8
The Modern Dance (Armitage and
 Stewart 1935), 53–60
The Seven Dances of Life [*Die Sieben
 Tänze Des Lebens – Tanzdichtung*]
 (ch. Wigman 1921), 23, 24
The Touchstone, 19, 20
The Vision of Salomé (Allan 1903), 17
The World of the Dancer [*Die Welt des
 Tänzers*] (Laban 1920), 8, 16,
 20–23, 90
thINKingDance, 102 n. 7
Third Reich, 27 n. 23, 44 n. 5, 52, 57, 60,
 63 n. 9, 87
Toepfer, Karl, 23, 25 n. 4
Totenmal (ch. Wigman 1930), 35, 40
transatlantic, 7, 37, 43, 43 n. 4, 53, 86,
 87, 88
transnational dance discourse, 51

United Kingdom, 19, 22, 31, 37, 38, 39,
 42, 43, 51, 52, 59, 70, 73, 78, 79, 86,
 87, 90, 98–101
United States of America, 2, 3, 8, 16,
 18, 19, 22, 31, 32, 34, 37, 39, 40,
 41, 42, 43, 51, 52, 53, 55, 56, 58,
 60, 61, 69, 74, 77, 79, 87, 88,
 89, 90, 92
University of Wisconsin, 29 n. 48, 76
Urlin, Ethel, 18

van Praagh, Peggy, 7, 9, 100
Volk, 40, 53, 63 n. 13
Völkische Kultur, 40

Vom Tauwind und der neuen Freude
 (1936), 52
Von Derp, Clotilde, 18, 26 n. 21

Weaver, John, 7
Weidman, Charles, 4, 7, 9, 31, 34, 51,
 55, 56, 60, 61, 69, 70, 71, 73, 74, 88,
 89, 90
Weimar Republic, 19
Wiesenthal, Grete, 17, 19
Wiesenthal Sisters, 4, 18
Wigman School, Dresden, 37, 38, 39,
 43, 53, 59
Wigman School, New York, 59
Wigman, Mary, 4, 6, 8, 10, 13 n. 27, 17,
 18, 23, 24, 31, 32, 33, 34, 35, 36, 38,
 39, 40, 41, 42, 43, 48 n. 57, 51–53,
 55, 56, 57, 58, 59, 60, 61, 69, 70, 72,
 73, 77, 87, 90
Witch Dance [*Hexentanz*] (ch. Wigman
 1926), 32
With My Red Fires (ch. Humphrey
 1936), 70
women
 freedom, 2, 18
 of the future, 2
 liberation, 17, 34
 modern, 32, 33, 41, 87
 pioneer, 34, 57
 of today, 32, 33
 suffrage campaigns, 3
Work and Play (1935), 60
Workers Dance League, 51, 60
World War I, *see* Great War
World War II, 3, 69, 73, 78, 79, 90, 91,
 100
Wulff, Käte, 23

DOI: 10.1057/9781137439215.0012

Lightning Source UK Ltd.
Milton Keynes UK
UKOW02n0920210515

251939UK00004BD/25/P